COWBOYS *of the* AMERICAS

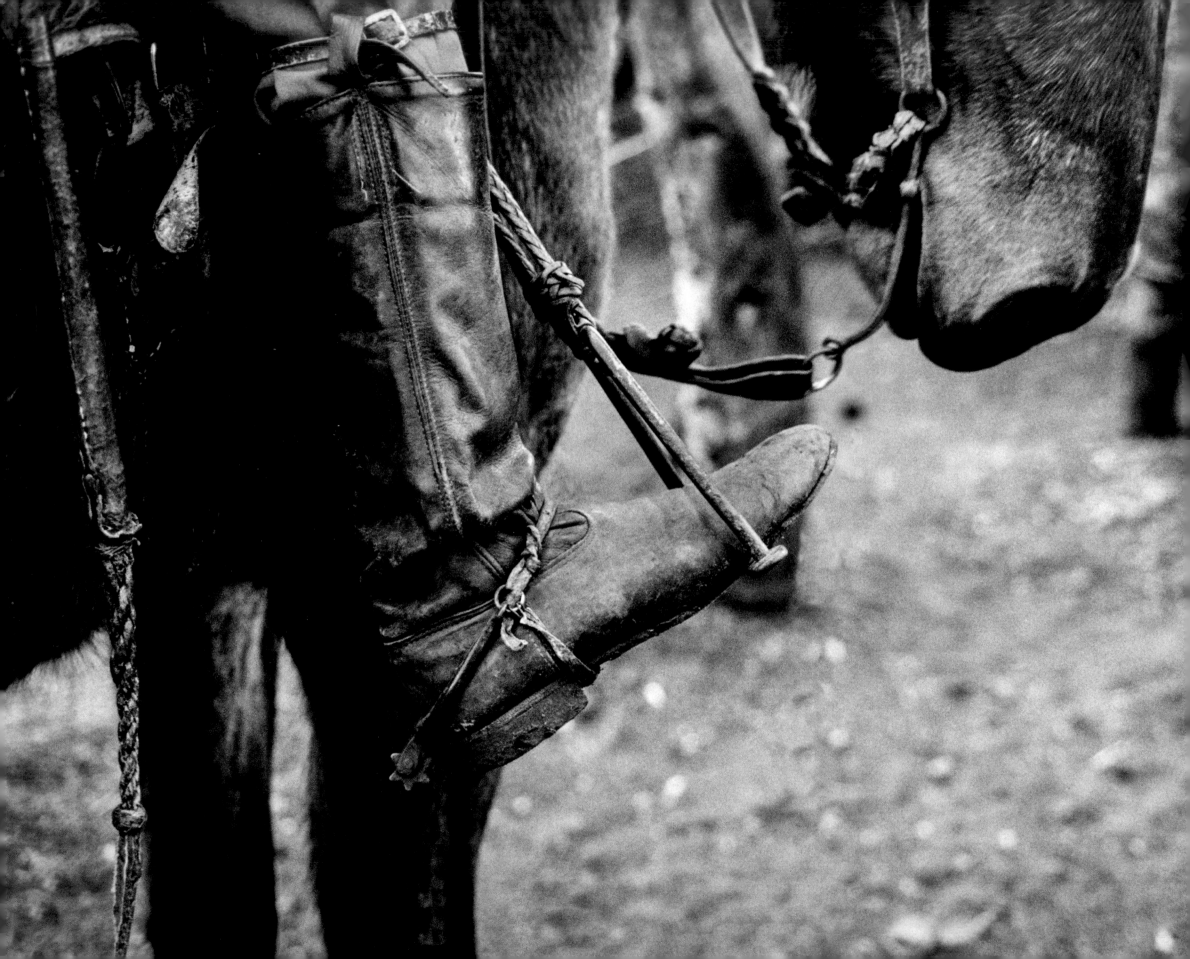

COWBOYS *of the* AMERICAS

Luis Fabini

text by Wade Davis

GREYSTONE BOOKS
Vancouver/Berkeley

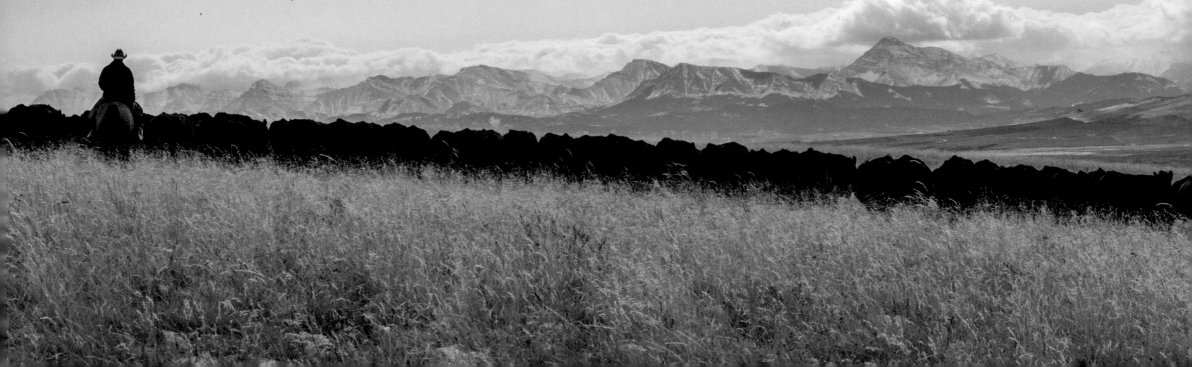

Greystone Books Ltd.
www.greystonebooks.com

Cataloguing data available from Library and Archives Canada
ISBN 978-1-77164-116-6 (cloth)
ISBN 978-1-77164-117-3 (epub)

Editing by Nancy Flight
Copy editing by Jennifer Croll
Jacket and text design by Nayeli Jimenez
Map by Natalia Valenti
All photographs by Luis Fabini
Printed and bound in China by 1010 Printing International Ltd.
Distributed in the U.S. by Publishers Group West

Canadä

We gratefully acknowledge the support of the Canada Council
for the Arts, the British Columbia Arts Council, the Province of
British Columbia through the Book Publishing Tax Credit, and
the Government of Canada through the Canada Book Fund for
our publishing activities.

Greystone Books is committed to reducing the consumption of
old-growth forests in the books it publishes. This book is one step
towards that goal.

Waldron Ranch, Alberta
(Cowboys, Canada)

PREVIOUS SPREAD
Artigas, Uruguay
(Gauchos)

I dedicate this book to my daughter Ula, the most graceful rider.

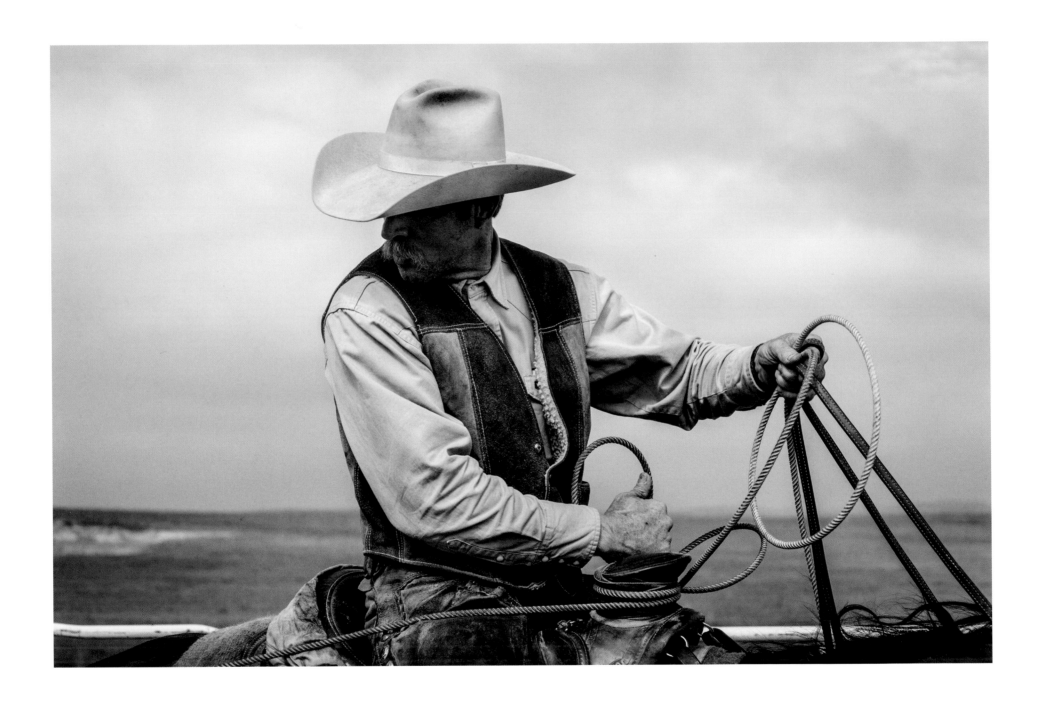

Haythorn Ranch, Nebraska
(Cowboys, US)

CONTENTS

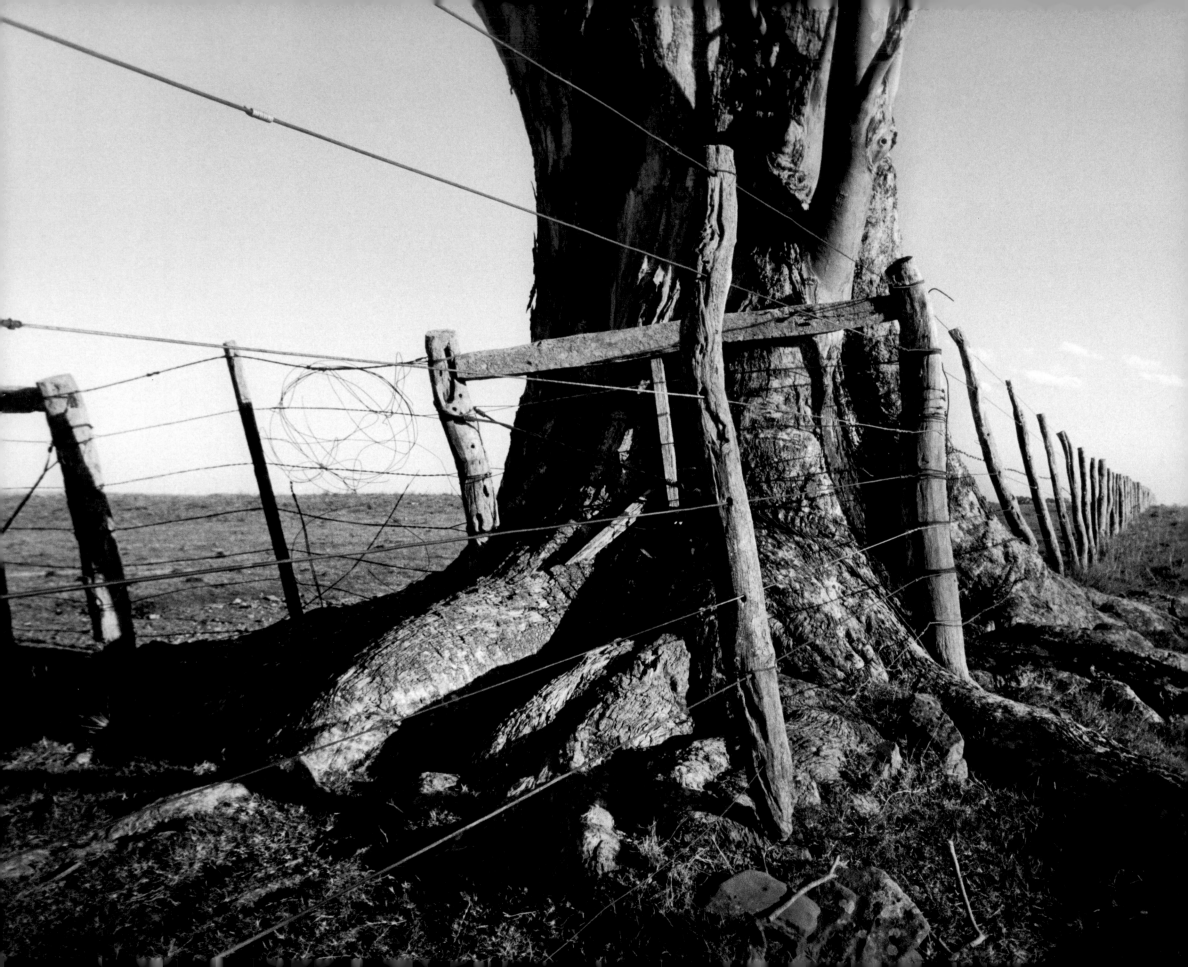

PHOTOGRAPHER'S
PREFACE

IT IS MIDDAY and I have been walking along a dusty road in northern Uruguay for hours. The heat is asphyxiating. Pushing me onward is my desire to discover the spirit of the gaucho, the legendary horseman of these vast stretches of grassland.

Today is Saturday, and everyone is headed into town; no one is going my way. In the distance I see smoke rising from a small campfire near the one tree in sight, a fig tree— the only shade for miles around. A gaucho with his *tropilla*, or herd of horses, waves for me to approach. I do so cautiously. We introduce ourselves and shake hands; he is Luis Alberto Fonseca, a horse tamer and cattle driver but above all an *andante*, a wanderer. As is customary, he invites me to share *mate*, the traditional South American beverage. He is straightforward when he speaks. He tells me that he lives alone and that every once in a while, he will approach an *estancia* looking for a few days' work as a cowhand.

The gaucho came into existence after the Spanish conquerors arrived in the New World and released a few head of cattle into the sea of grasslands that lay before them. Originally, gauchos did not work but wandered continuously. Food was no problem, since the European cattle had multiplied over the years and were plentiful and available for all. A hundred years after the arrival of the conquerors, the now-wild cattle numbered in the millions, and local horsemen began to round them up and slaughter them for their hides and tallow. This became the basis of a regional economy.

Through the centuries, the gaucho proved surprisingly adaptable to changing times. History books claim the original gaucho ceased to exist around 1870 after fences went up throughout the land. In a strict sense that is probably so, but though wire fencing inhibited the gaucho's movements, it did not render him extinct; it merely obliged him to adapt in order to survive. Today we find the gaucho as a wanderer, horse tamer, cattle driver, and fence builder, doing jobs that give him autonomy and require minimal obedience to civilized society.

Luis Alberto and I drink several *mates* together, and then I ask him, "Who is the gaucho?" After a long silence, he replies, "The gaucho is the land he treads upon." I understand instantly: a man grows to resemble what he does as well as where he lives.

His words had a lasting impact on me and would become the cornerstone of my work and my guiding compass as I embarked on a ten-year journey through South and North America photographing different groups of cowboys. In Uruguay and Argentina, these men are called gauchos. In Chile, they are huasos; in Brazil, pantaneiros and vaqueiros. Ecuador has its chagras, and Mexico its charros. In the United States and Canada, these horsemen are known as cowboys.

I went in search of the cowboys of the Americas and found extraordinary "centaurs" who share a powerful bond with the land and with their animals—and whose only allegiance is to hard work and absolute freedom.

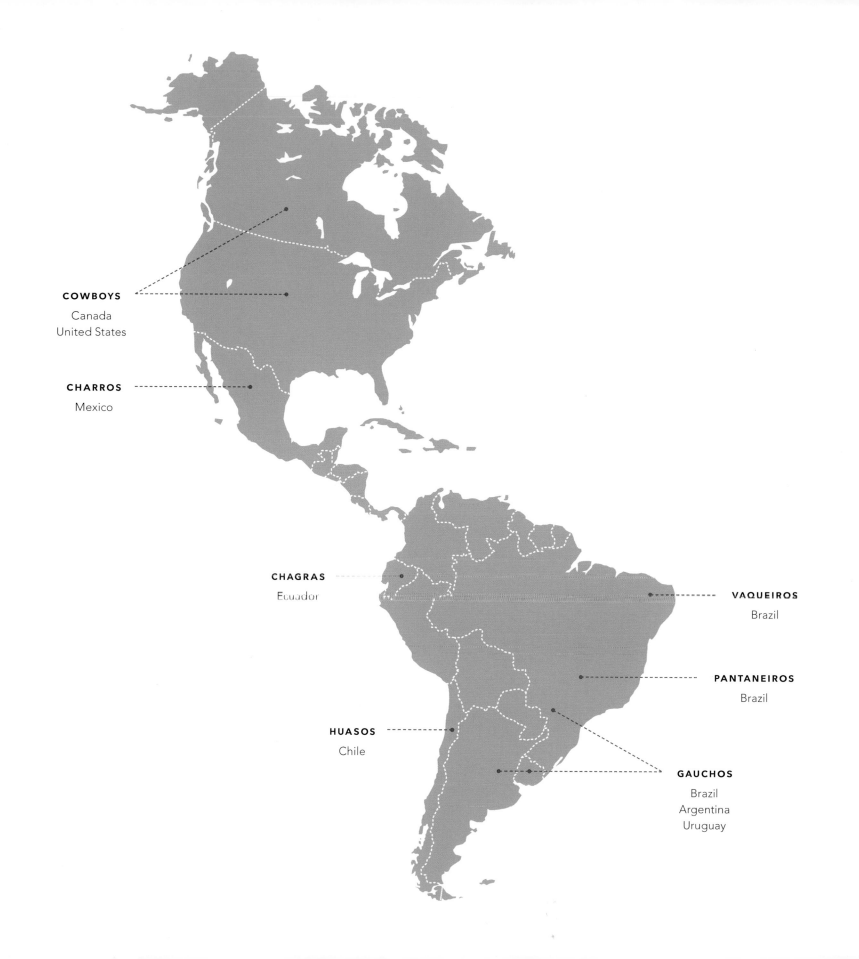

COWBOYS
Canada
United States

CHARROS
Mexico

CHAGRAS
Ecuador

VAQUEIROS
Brazil

PANTANEIROS
Brazil

HUASOS
Chile

GAUCHOS
Brazil
Argentina
Uruguay

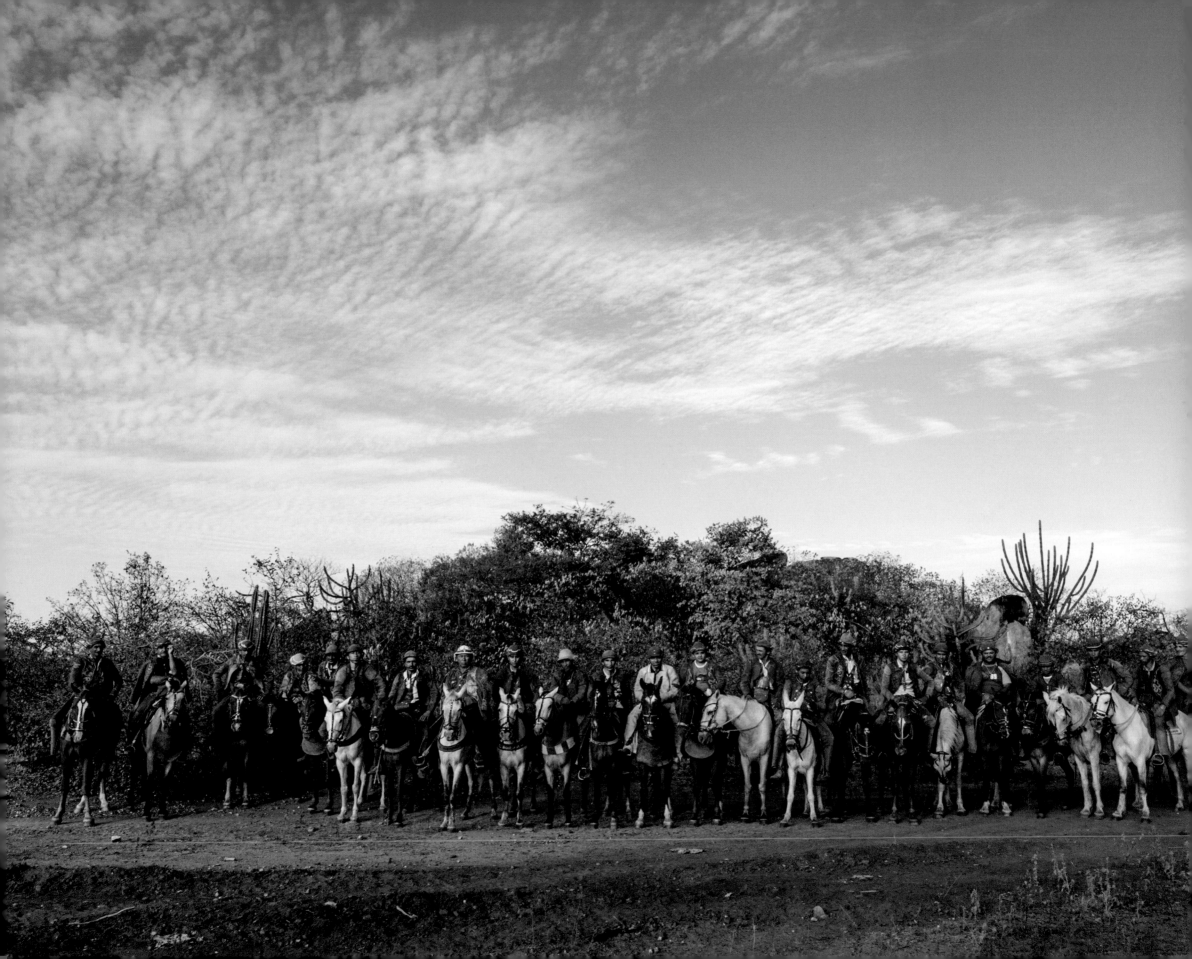

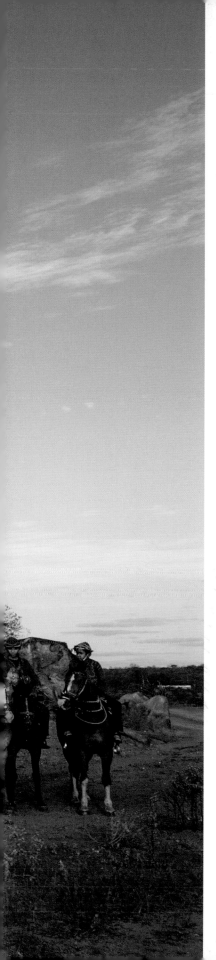

OF HORSES AND MEN

SOME YEARS AGO I spent a long season in northern British Columbia, working much of the time for Reg and Ray Collingwood, guide outfitters whose territory included the Spatsizi, a vast expanse of wilderness in scale similar to that of the far reaches of Patagonia or the wetlands of the Pantanal. It was then that I came to know the men portrayed in this book. Not literally, of course, but certainly in spirit. Today, the Collingwoods run a sophisticated, high-end operation, perhaps the finest wilderness destination in western Canada. But forty years ago when the brothers started out, things were simple, and their crew were cowboys—men who lived where their hats fell, rough-cut diamonds who worked the hunting camps all fall, drank away their earnings in a weekend, and retreated to the line cabins of the Chilcotin far to the south to tend cattle through the long and impossible winters of the Interior.

Many of them, including a lanky wrangler named Lester Miller, came from Clinton, which was not an ordinary town. In the late 1960s a Vancouver motorcycle gang named Satan's Choice made a habit of roaring into unsuspecting communities, terrifying the local populace, and retreating to the coast. One summer they foolishly selected Clinton as a target. Emerging from the old Cariboo Hotel, having been thrown out of the bar, they were greeted by a semicircle of rifles. Slack-jawed, they watched in horror as the cowboys

blew apart their Harley-Davidsons. To get home, the entire gang had to take the Greyhound bus.

Lester rode bulls in the Clinton rodeo and one day ruptured his scrotum during a ride. When whiskey failed to quell the pain, he entered the hospital and was sewn up, but not before the loss of a testicle. Years later I was with him when he and Reg Collingwood confronted a Greenpeace party that had parachuted into the Spatsizi in a vain attempt to shut down the outfitter camps, even though hunting was legal and, more importantly, the essential gesture that still linked the Tahltan native guides to the land. Greenpeace was represented by a journalist from Vancouver who wrote a column on fine wines. Lester represented himself and resented the Greenpeace banner flying over a camp that outfitters had built. When he took an ax to the flagpole, the journalist beseeched Reg to get his man under control. Reg, short like his brother Ray, with a cowboy hat that shadowed his moustache, leaned over the table in the cookhouse and said to the wine expert, "Listen, you son of a bitch. Let me tell you something about Lester. First, he comes from Clinton. Second, he rides bulls. Third, he's got one nut. You get him under control."

Lester was just one of a cast of characters in the Collingwood operation. Others were Shawn Boot, whose mother once beat back a grizzly with a frying pan, and Jack Cherry and Teddy Elison, cowboys like Lester from the Cariboo and Chilcotin. Teddy was with Reg on the fateful night when the Collingwood crew, keen for libation after a season in dry camps, slipped into Hyder, Alaska, for a few drinks at a hotel bar. On their way south they had picked up a hitchhiker, a loner standing by the road with nothing but a saddle, a duffel, and a .30-06 rifle. His name was Bernie.

Close to midnight, with the bar about to close, Reg took notice of an American miner playing cards at a nearby table. Beside him was a little boy, clearly his son, who kept asking

to go home. The father, having ignored the lad all evening, finally whacked him. Reg walked over and told the man that the kid should be in bed, and that if he wanted to pick on someone, he ought to pick on somebody his own size.

"And I'm ready."

The miner slowly stood up, as did his friends, and every one of them was a foot taller than Reg.

"Just a minute," he said, excusing himself to take stock of his men. Six months in the bush and four hours of drinking had left them pretty wobbly. He turned to Bernie, the hitchhiker.

"Bernie," he said, "we haven't known each other that long. But if you want a ride out of here, I need a little backup."

"No problem," Bernie said. "It was nice of you to pick me up. But I think we need an equalizer."

Reg backed up toward the door of the bar with a half-dozen angry Americans in pursuit. Suddenly gunfire broke the night. Reg and his boys stumbled out of the hotel and into the street, where Bernie stood, .30-06 in hand, shooting out the windows of the hotel.

Bernie is still going strong, as is Lester. But many, too many, have passed on. Guiding on the coast, Jack Cherry took a plane that hit a mountain in the fog. Shawn Boot died in a crash that also took the lives of his young children. Mike Jones, Ray's closest friend, went through the ice on his trapline, and it was six months before the Mounties could recover the body. Ray's son Chad was killed in another crash that also took down the pilot, his son, and two others. Only Ray's daughter, Carrie, survived, cushioned by the family dog, which died in her lap, protecting her from the impact.

"It's hard work," Reg said when I once asked him how he and his brother kept going after so many personal losses, setbacks, and freak accidents, like the time Ray's arm was broken in sixteen places when the prop kicked back on him as he tried to jump-start the plane engine on a cold autumn morning.

"But then there are those days when you're up on a ridge looking into some basin and there's a bull caribou over there and a sheep over there, there's goats up there and an eagle flying across the sun, and everything is going okay and you think, this is pretty good. You've got to strive for those good days because life—life is tough, period."

When I look back at my time in the Spatsizi with these men, sharing a small tent with Lester as he "polished his eyeballs" every dawn with clouds of tobacco smoke, watching old Charlie Abou stub out a cigarette on the foot of a hunter who had insulted a native cook, I am struck by how raw and authentic they all were and by how little they resembled the cowboy stereotype of American lore. There was not a John Wayne or a Marlboro Man among them. All they had in common with these icons of pop culture was the way they moved. They all walked as if their feet hated to touch the ground. That came from a lifetime spent on the back of a horse, and it is with that splendid animal that any story of real cowboys must begin.

THE OLDEST KNOWN primate fossil, the earliest evidence of our evolutionary lineage as human beings, dates to around 55 million years ago, about the same time, give or take a few million years, that the primordial ancestor of the horse makes its first appearance in the fossil record. You would be hard pressed to detect any physical resemblance to modern forms. The earliest primate was a mouse-sized creature weighing about an ounce that could rest in the palm of a human hand. The ancestor of the horse was a hippo-like animal

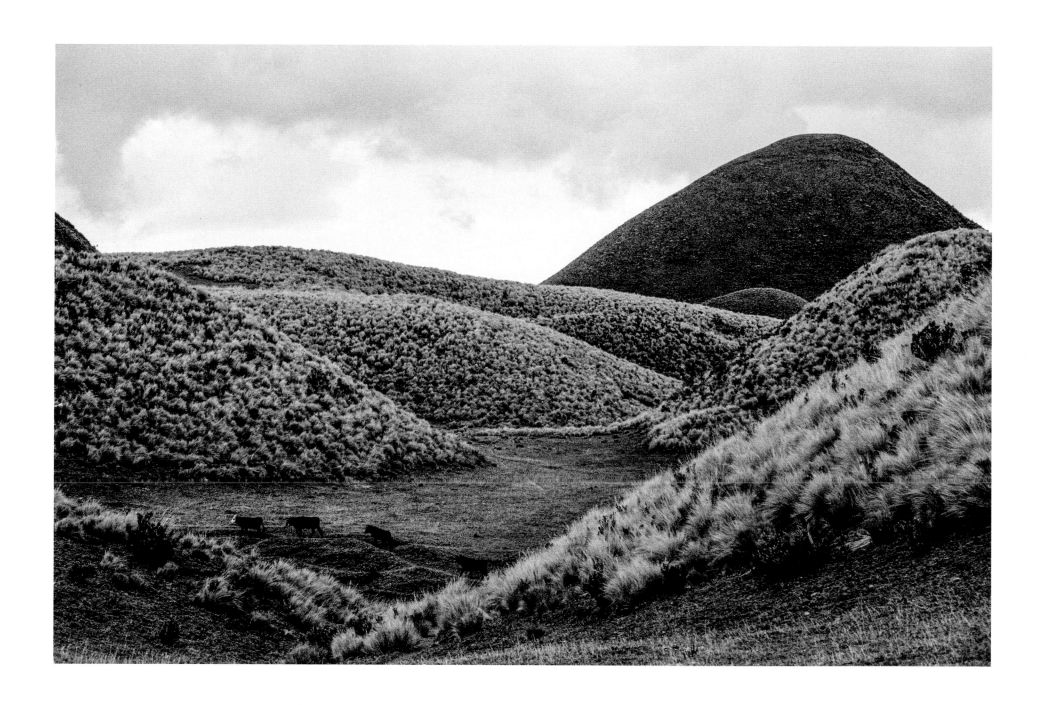

the size of a small dog, with curious toes that splayed wide to cushion its movements. It lived in swamps and humid forests when flowering plants were just establishing their supremacy in a flora long dominated by ancient orders of conifers, seed ferns, club mosses, and giant horsetails the height of redwoods.

But as the climate changed over the eons, and tropical forests gave way to dry grasslands in many parts of the world, the lineage that ultimately gave rise to *Equus*, the genus of the modern horse, adapted to a new life on the open steppe. Its diet shifted from foliage to grasses, resulting in larger and more durable teeth. And away from the sheltering forest, it sought protection in numbers and speed. The need to outrun predators created evolutionary pressures that over time favored longer limbs and a transformation of the foot as two of the three toes became vestigial, leaving the full weight of the creature to rest on just one toe, the third and longest, which in time became the hoof.

By the late Pleistocene, roughly a million years ago, the modern forms of both horses and humans were slowly coming into being. The grasslands of what is now North America supported no fewer than fifty species of *Equus*, many of which radiated south, north, and west, eventually crossing the land bridge to Asia to populate the continents of the Old World. Even as *Equus* was crossing to Asia from the Americas, our immediate ancestor, *Homo erectus*, was also setting off, becoming the first hominid to walk out of Africa. In time it reached much of Europe and Asia, empowered by an elementary understanding of fire and stone tools, knowledge acquired many tens of thousands of years before the birth of our species, *Homo sapiens*.

Like that of *Equus*, our hominid lineage had descended from progenitors that had left the forests for the open grasslands. They too had evolved into new physical forms, becoming erect, with bipedal locomotion, features of great value to their new life on the African

savannah. But unlike *Equus*, their key adaptive trait was not a capacity to flee but rather the ability through stealth, intelligence, and cooperation to come together to kill. For well over a million years before the rise of the human species, our hominid predecessors were fully engaged with the ancestors of the modern horse in a dance of life and death, as predator and prey, hunter and hunted.

With the emergence of *Homo sapiens* and the birth of language, the rhythm of the dance only became more intense as our ability to kill became more refined. Consciousness and awareness transformed death into a mystery, the edge beyond which life ended and wonder began. Hunting inspired metaphysical thought. Religion and mythology were born of the need to rationalize the terrible fact that for our Paleolithic ancestors to live they had to kill the creatures they loved most, the animals that gave them life.

The place to witness this primordial flash of the spirit lies beneath the ground in southwest France and beyond the Pyrenees in Spain. There, some 35,000 years ago, our direct ancestors ventured deep into the earth, moving through narrow passages that opened into chambers illuminated by the flicker of tallow lamps, where they drew with stark realism the animals they revered, singly or in herds, using the contour of the stone to animate forms so dramatically that entire caverns come alive even today with creatures immediately familiar to the contemporary eye.

Of great interest is not just what is depicted on the rock but what is missing. The images float in isolation; there are no backgrounds or ground lines. Images of people are few, and there are no displays of fighting, no scenes of hunting, no representation of physical conflict, and very few images of carnivores or other predators. Among the animals most commonly portrayed is the horse, a creature of rare power and grace. It is the focal point of the existential drama, and its depiction in the cave of Chauvet represents the

Páramo, Ecuador
(Chagras)

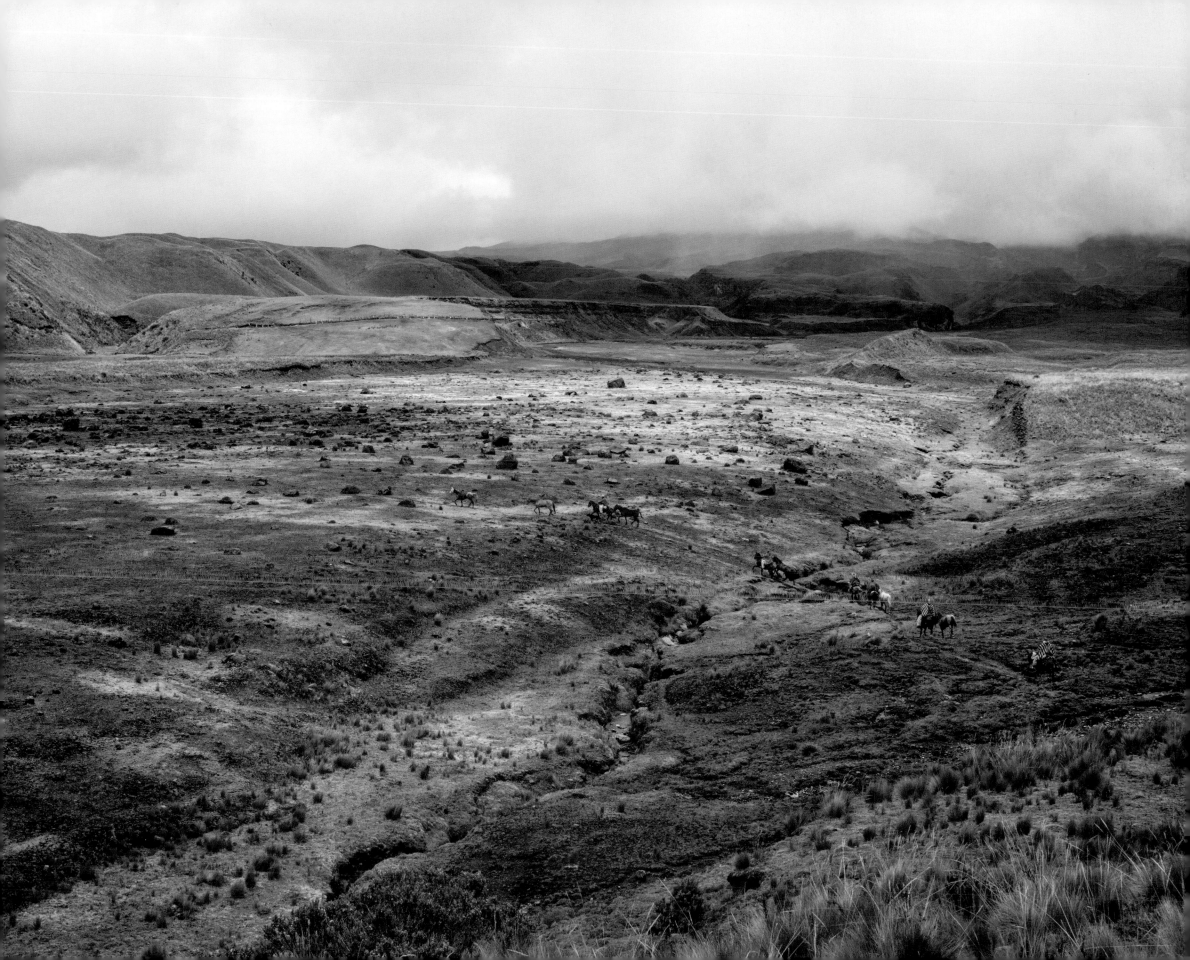

most highly sophisticated and indeed transcendent expression of the artistic spirit of the upper Paleolithic.

Through all these years, the horse remained prey, eagerly sought for its meat, blood, and hide. Hunting pressure, along with climate change, was clearly responsible for its disappearance from the Americas, where all species of *Equus* were swept away in a wave of extinction that climaxed some 12,500 years ago.

But something of the original connection remained, a reverence that had been expressed in art for a thousand generations. Perhaps it was this bond that brought human and horse together in Asia in a singular act that transformed the world. The so-called Neolithic revolution was in fact a slow transition over many centuries as the ways of the hunter were displaced by the cult of the seed, as nomadic life led to sedentary entrapment.

The domestication of animals—no trivial achievement—was as important as the development of agriculture. To this day less than a dozen of the four thousand extant mammalian species have been truly domesticated. Cows and pigs, goats and sheep have made a mark, but none has shaped human destiny as significantly as the horse. And no other animal has derived more from its association with humans. Domestication was the singular development that allowed the Asian horse to avoid the fate of its American cousins. When this occurred is uncertain. Skeletal remains of teeth, clearly worn down by a bit, found in Ukraine, have been dated to 4000 BCE, long before the invention of the wheel. Some scholars have suggested that the horse entered the human circle much earlier, quite possibly as long ago as ten thousand years.

To be sure, the animal is perfectly suited for domestication. It reproduces well in captivity, and colts are born fully developed and thus less susceptible to predation than the offspring of, say, a dog or a pig. Horses are easy to feed as long as grass is plentiful.

They graze seventeen hours a day, consuming twenty pounds of feed, 2 percent of their body weight. Gluttons for water, they drink ten gallons a day, and they know how to find it, readily divining sources beneath the stones of dry creek beds and abandoned ponds. Unlike cattle and goats, which in winter must use their noses to work through the snow to feed, horses scrape away the crust with their hooves.

While cats and other predators sleep away their lives, horses remain alert twenty hours a day, resting only for a few hours, often in short sessions of ten to fifteen minutes. Highly social, they communicate with great precision through body language, be it ears snapped back in anger or a head held high in flight. Nocturnal by nature, they give birth at night and feed by choice in the shadow of darkness. They are most vulnerable when their heads are down. When a horse wants to display submission to the dominant mare in the herd it stoops low, pretending to eat and drink, even as it snaps its mouth as a sign of weakness and subordination.

Everything about a horse is a consequence of its adaptation. It is the only domesticated animal whose primary defense in the wild is to flee. Out of this emerged two remarkable traits. First is an astonishing ability to sense danger. Every prey species must be more perceptive than its predators. But the horse takes this to another level of intensity. With an acute sense of smell, hearing far better than that of humans, with ears that move independently to listen in all directions, horses have the fastest response time of any domesticated animal. On top of this they have superb night vision. Their eyes, the largest of any mammal, can detect the slightest of movements. They sleep with their eyes wide open.

Horses are extremely sensitive to touch, and second only to sight, they respond to what they feel. What humans can sense in our fingertips, horses feel with their entire bodies, allowing them to pick up a solitary blade of grass with their lips or be spooked by a fly

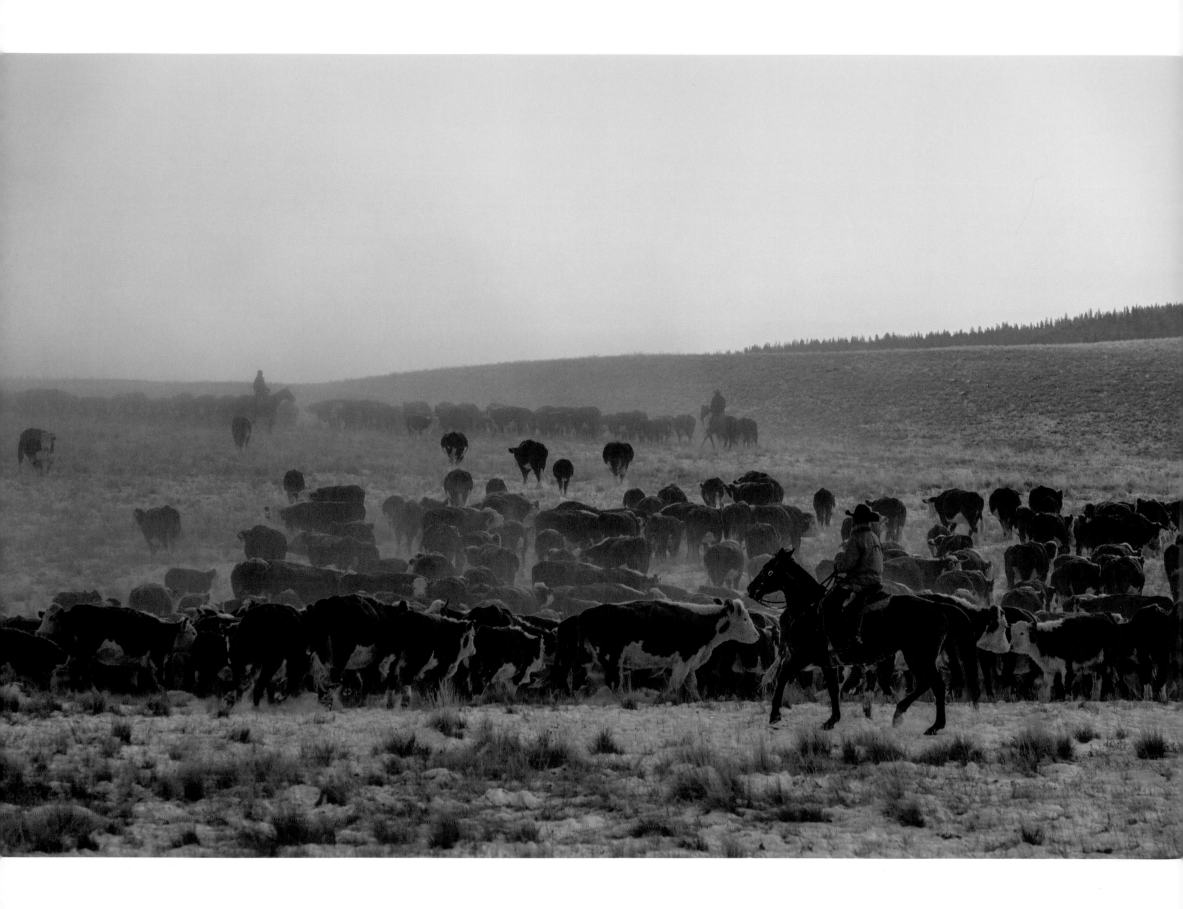

landing on a single hair of their coat. They can sense the slightest movement. If a rider merely looks in a certain direction, without any conscious body movement, the horse will know. Relaxation in the saddle is the key attribute of a fine rider.

Detecting danger is one thing, escaping it quite another. Every element of a horse's anatomy and physiology, its nervous and cardiovascular systems, its skeletal structure, is geared toward supporting a running machine. For short stretches horses have been clocked at better than forty miles per hour. In Mongolia and Kazakhstan, it is not uncommon for horses to cover a hundred miles at a consistent pace twice that of the fastest human runner.

That the horse had potential did not imply that domestication would be easy, for at the core of the effort was a paradox. Everything we most eagerly wanted horses to do ran against their nature. They fled in the face of danger; we sought to train them, in battle, to run directly to the source. They could not bear to have anything resting on their backs, the place where feline predators in particular tended to land during an attack. Yet to mount we had to drop ourselves as dead weight onto this most sensitive area of a horse's body.

The key was to work with and not against their essential nature, allowing the flight instinct to be both suppressed and channeled by taking advantage of two traits in particular. First, horses are fast to react but equally quick to become desensitized once they know something is not a danger, be it the din of battle, a tree branch snapping in the wind, or the weight of a rider perched calmly in a saddle. Second, they have tremendous powers of recollection, a completely forgiving temperament, and a reflexive instinct to follow the lead of a dominant individual. As social animals in the wild they find safety in numbers, but as domestic captives they readily transfer allegiance from the oldest mare of a herd to the steady authority of the horseman. They find comfort in the cadence of an individual human voice and respond accordingly.

Like all herding animals, horses are stoic. To show physical weakness in nature is to be singled out by a predator for death. But horses also possess a deeper strength, a generosity of the heart that allows them to surrender to a partnership that brings about a true symbiosis of the spirit. This is the essence of the bond that has existed between humans and horses for all of our history. It accounts for why every culture has shown this creature such respect and why the horse is the only domesticated animal in the entire ethnographic record that is universally revered.

This may come as no surprise. From the beginning horses have been weapons of war, partners in life and death struggles. The Scythians, possibly the first to domesticate the creatures, came out of the Altai Mountains in Central Asia, all warriors, men and women alike, destined to be buried in military dress, with swords and bows, and as many horses as they had managed to capture in life. No Scythian woman could marry unless she had killed an enemy. According to Herodotus, women fared as well as men in the carnage of battle.

The Hittites and Assyrians, the ancient Egyptians and Sumerians—all forged empires based on the strength of the horse. King Solomon possessed no fewer than forty thousand head for his chariots alone. Four centuries before Christ, Alexander the Great conquered the entire known world, relying largely on the speed and mobility of his cavalry. Through every conquest he rode a black horse, Bucephalus, which he loved as a brother. When, after two decades of service, the stallion was killed in battle at the far reaches of empire, Alexander named a city in its memory. In time tens of thousands would die defending a landmark in the remote reaches of Pakistan, a place named for a horse.

For two thousand years horses loomed large over every pivotal moment in history. In Britain the Norman Conquest succeeded because William overwhelmed Harold at

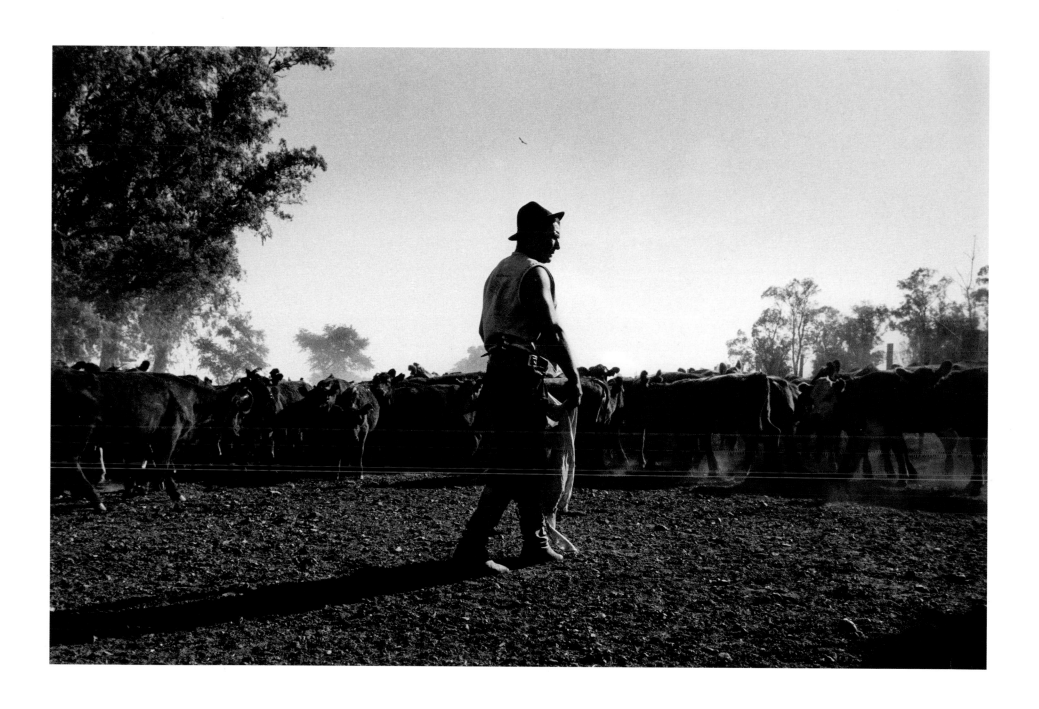

Hastings with warhorses carried across the channel, 10 to a boat, 3,500 altogether. The Mongols under Genghis Khan marched across Asia in vast armies that, on the move, lived by drawing blood from the necks of stallions and ate horsemeat, which they tenderized by placing it beneath their saddles as they rode. Once they had conquered their world, establishing in twenty-five years an empire larger than what the Romans had achieved in four centuries, they built a communication network that spanned the empire and included ten thousand staging posts, each with four hundred horses, half of which were ready at all times. Messages reached Damascus from the Mongol capital of Karakorum, a distance of more than 3,500 miles, in just two weeks.

For the Mongols, as for so many cultures, the horse in time became a symbol of the divine. Their name for the creature is *takh*, meaning spirit. A man's personal power is his *hii*, wind, or *hiimori*, his windhorse. A person's innermost being is a heavenly horse flying on the wind. In death the windhorse ascends to the sky, while the soul that resides in the flesh and blood seeps back into the earth.

Similar devotion appears in the Norse sagas, in the guise of the god Odin, who crosses the heavens on an eight-legged horse called Sleipnir. In the *Bhagavad Gita*, Krishna, incarnation of Vishnu, rides a cart drawn by two perfect white horses. In Islam, according to the Qur'an, in death Mohammed rode to heaven on a horse. In 12th-century Ireland a king's inauguration entailed copulating with a dead mare and then eating soup made from its body. Rituals involving bathing in horse blood, eating horse flesh, and drinking horse blood persisted in Europe until CE 732, when Pope Gregory III outlawed the consumption of horse flesh, largely out of concern for the value of the creatures as work animals.

IF HORSES DOMINATED the vanguard of history, the arrival of the Spanish in the New World inverted history itself by returning the creatures to the Americas, the land of their

origins. Columbus brought with him twenty-four stallions and ten mares, all Andalusians, a cross between the Bedouin horses of the Barbary Coast and Arabian mounts that traced their lineage to Ishmael, son of Abraham. Hernán Cortés had but sixteen mounts as he contemplated the conquest of Mexico. These few horses, and the few score that followed, would give rise to the Appaloosa and the mustang, the pinto, the palomino, and the ultimate cowboy companion, the American Quarter Horse.

The Spaniards who crossed an ocean to vanquish the New World were the ones that Europe, for all its depravity, could not kill. They were men of violent ideas, veterans of religious wars that had soiled their homelands with blood. Their church embraced all of their deeds—the violation of women, the murder of children, the destruction of all that was sacred to those who they slaughtered. All was condoned by the halo of their faith.

As their forces marched north and south, with the followers of Cortés piercing the heart of Mexico, and those with Francisco Pizarro relishing the rape of Peru, the Spaniards recognized the immense power they held as they confronted civilizations that had never seen a horse, let alone done battle with one. The Aztec and the Inca, already ravaged by smallpox and measles, diseases that had swept far ahead of the invaders, dispatched what remained of their armies as if against the very demons of hell.

At first both the Aztec and Inca generals believed that horse and rider were one, a single creature, and in a sense they were right. Clothed in mesh and armor, equipped with weapons forged from Toledo steel, the conquistadors rode down their enemies, striking from on high at hapless native foot soldiers with a speed and maneuverability that no infantry could counter any more than a modern rifleman might be expected to confront and overcome an advancing tank.

Inca armies that had walked the length of a continent, conquering all chieftains and empires they encountered on their march, scattered at the sight of mounted Spaniards. In

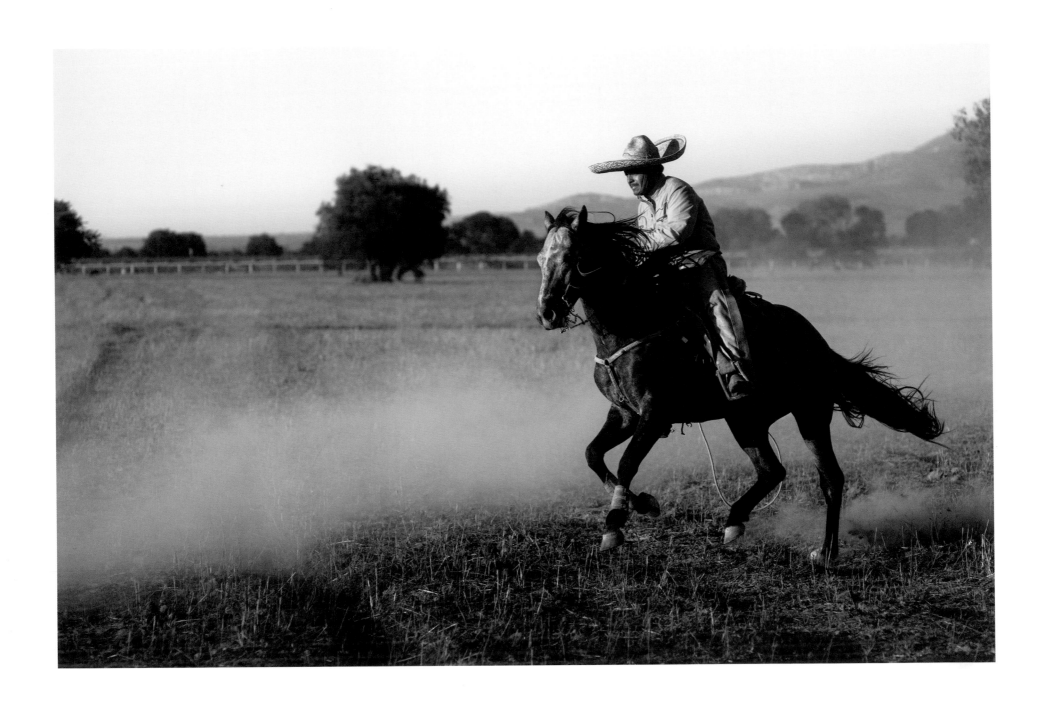

1532, at Cajamarca, in northern Peru, 168 Spanish soldiers, with just 62 on horseback, launched a surprise attack against the Inca emperor Atahuallpa, who at the time was surrounded by 80,000 of his finest soldiers. The massacre ended with 7,000 Inca dead, all victims of Spanish steel, which sliced easily through the quilted armor of the imperial guard. Reflecting on his equally astonishing triumph over the Aztec, Cortés wrote simply, "After God we owed our victory to the horses."

Bernal Diaz del Castillo, who served under Cortés, recorded the name, pedigree, color, and qualities of every horse that landed in Mexico in 1519. Each was worth a fortune, for a mounted horseman was automatically entitled to a higher share of the stolen treasures. Those Spaniards left behind in Hispaniola to raise horses and cattle did all that they could to restrict the delivery of brood mares to Mexico, fearful that they might lose their monopoly on the supply of stock to the growing number of Spanish settlements. Cortés himself had to intervene with King Charles V to have the restrictions lifted. His top priority was to open the new lands to cattle as a source of meat for his men. In 1521, even as Cortés set fire to the Aztec capital of Tenochtitlan, Gregorio de Villalobos, later lieutenant governor of New Spain, landed livestock along the Pánuco River near Tampico. These were the first cattle to reach the Americas, the famed longhorns, which in time would spread north along the coast to Texas.

In the wake of the conquest, as a reward for his services, Cortés was given the title of Marqués and granted the first hacienda in Mexico, a vast empire of land that encompassed the entire valley of Oaxaca. He and his brother Fernando had no higher ambitions than to become wealthy cattlemen. For a true son of Spain to become an *hacendado* was the highest calling. Land was power. As Cortés settled upon the soil of his new holdings, his eyes looked back in glory to those in Spain who had frustrated and denied his ambitions.

FACING
Jalisco, Mexico
(Charros)

At last free of the constraints of class and tradition, he looked forward to limitless wealth from selling beef, hides for leather, and tallow for candles to the towns and cities of the new colony.

The only challenge was the hot, dry climate, which yielded sparse grasslands. Vast amounts of land were required to provide sufficient forage for expanding herds. This implied distances too great for a man to cover on foot. What was needed was the vaquero, literally "the one of the cows," who covered ground on the back of a horse. Thus from the very beginning cattle, along with horses and men to tend them, became the story of Mexico.

In time Mexican traditions spread both south and north, influencing settlement patterns and land management from California to the grasslands of Patagonia. Cattle and horses that had fared poorly in the tropical regions of Hispaniola and Panama flourished with abandon once liberated on the pampas and the plains of temperate America.

Initially the Spaniards made every effort to keep horses out of the hands of the natives. In Peru descendants of the Inca were forbidden to ride. In 1541, when Francisco Vásquez de Coronado, along with some 200 men and 588 horses, set out from Guadalajara, heading north in search of Cibola, one of the legendary cities of gold, only two of his horses were mares. Some sixty years later, however, in 1598, when Don Juan de Oñate dispatched an expedition with seven thousand head of cattle across the Rio Grande into New Mexico, his horses included both brood mares and stallions. Not a few escaped and went feral.

The first indigenous people to acquire the horse were most likely the Apache, who encountered the Spanish as early as Coronado's expedition of 1541. By the mid-17th century, the Navajo and Comanche were actively raiding Spanish settlements, even as the Apache enjoyed a thriving trade, exchanging captives from other tribes—to be used

as slaves by the colonists—for horses. With the great Pueblo Revolt of 1680, any pretense of Spanish control literally went up in smoke. Four hundred Spaniards were killed, and two thousand settlers were forced to flee the province of New Mexico, leaving behind all of their livestock. Twelve years later the Spaniards returned and reoccupied Santa Fe with little opposition. By then horses had dispersed throughout the southern Plains, certainly as far north and east as the Texas panhandle. Within a century travelers along the Rio Grande in 1777 reported that there were so many wild horses that the land, though empty of people, appeared to be the most densely populated place in the world.

For the tribal cultures of the Great Plains, the horse implied the end of one life and the beginning of another that would flourish as one of the greatest cultural expressions in the history of the Americas, only to collapse into misery and death within a century of its birth.

Until the arrival of the horse, tribes such as the Cheyenne, Arapaho, and Sioux were sedentary farmers living mostly in what is today Minnesota, Wisconsin, Illinois, and Iowa. On the prairie men had long hunted buffalo on foot, driving small herds over bluffs or into natural cul-de-sacs where a handful of animals might be dispatched by spear. But they did so almost as whalers setting out to sea, still dependent on food grown at home. The horse transformed the nature of the hunt, allowing the tribes to commit to a nomadic life fully dependent on the ocean of grass of the limitless prairie. Buffalo meat dried and powdered and mixed with fat and berries could last almost indefinitely. In a single day an extended clan could secure food for a year, generating the surplus upon which the development of all high civilization is based.

Never in history has the introduction of a single domesticated animal had a more immediate or transformative impact on culture. The classic Indian civilization of the

American West, so timeless in memory and perception, in fact came into being within a mere forty years. The Comanche, among the earliest to adopt the horse, had sufficient numbers by 1730 to allow all of their people to ride. They were the first to commit to a fully nomadic hunting existence, mounted on horseback and dependent on the buffalo for food, clothing, and shelter.

Others soon followed. The Arapaho, Crow, and Shoshone acquired the horse around 1700. The Blackfoot, who in time would have over a hundred words just to describe the color of a horse's coat, adopted the new way of life around 1730, roughly the same time as the Sioux, originally corn farmers, learned of the horse from the Cheyenne. With guns secured through the fur trade, the Lakota Sioux became, by the mid-19th century, the most powerful of all tribes in the northern Plains.

Perhaps the most remarkable cultural transformation of all occurred with the Kiowa, originally hunters and gatherers from the headwaters of the Missouri River. Slowly, beginning around 1700, they moved south and east, leaving the mountains for the grasslands of the Dakotas. There, beneath an immense sky, they met the Crow, who gave them the religion and culture of the Plains. They acquired the horse and the *Tai-me*, the sacred image of the Sun Dance. They learned to hunt buffalo. Liberated from the crude struggle for survival, they became a society of warriors whose raiding parties ranged for a thousand miles across the open prairie.

In the late 18th century, pushed out of the Black Hills by the combined strength of the Cheyenne and Lakota, the Kiowa moved south across the headwaters of the Arkansas River. There they met and made war upon the Comanche, but in time the two tribes joined forces and took control of the southern Plains. The Kiowa never comprised more than 1,500 men, women, and children, but their warriors were among the most feared of all the nations. Adorned with feathers, their skin shining in ochre and chalk, pigments of

the earth, their warriors rode into battle utterly fearless, hurling themselves beneath the protection of their horses' necks even as they discharged their arrows at their enemies.

In the summer of 1834, a new enemy appeared on the frontier of the Kiowa territory—white soldiers dressed in blue, bearing steel weapons that flashed in the sunlight and guns that killed at distances far beyond the range of even the most celebrated of arrows. Cautiously, through Sauk and Fox interpreters, the Kiowa agreed to a treaty of friendship. But then, in the winter of 1839, a plague of unknown origin killed tens of thousands and exterminated tribes such as the Mandan, even as it left all survivors ravaged and disfigured for life. Another wave of smallpox arrived in 1841, and not a decade later settlers bound for California introduced cholera, which, in a matter of months, killed hundreds of Kiowa and led scores of desperate men and women to commit suicide. By then the migration of settlers from the east had driven the Sauk and Fox into the Kiowa homeland. War erupted, and in a pivotal battle in 1854 a small party of Sauk and Fox warriors, armed with rifles, defeated a thousand Kiowa, Comanche, Apache, and Cheyenne.

In the winter of 1861, as the blue coats abandoned the plains and headed east to fight in the Civil War, smallpox once again swept through all the tribes. This was the final indignity. The Kiowa called for a general uprising, and with the Dakota, Cheyenne, Arapaho, Comanche, and Apache, they set out to drive the white invaders from the Plains. Preoccupied by the Civil War, the U.S. Cavalry initially had little response to the uprising. In the wake of the Union victory, however—reinforced by scores of battle-scarred veterans incapable of settling down after four years of bloodshed and killing—the American forces in the west were given explicit orders to "kill every Indian in the country."

This, of course, was easier said than done, for the tribes inhabited lands that stretched the length and breadth of the new nation. Military strategists concluded that they could at the very least starve them by destroying their primary source of food. In 1871, six years after

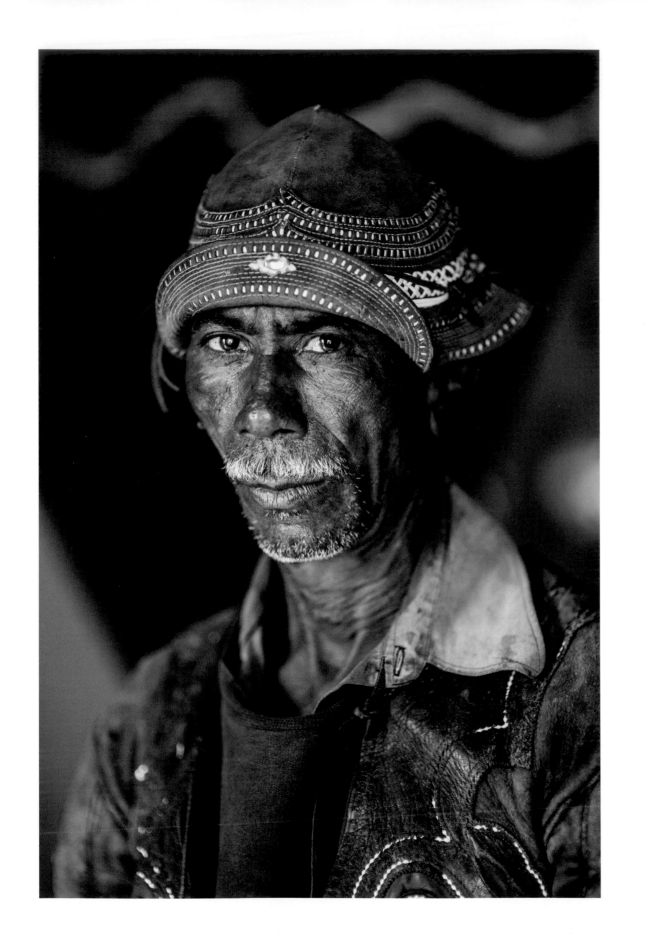

Serrita, Brazil
Francisco de Assis
(Vaqueiros)

the end of the American Civil War, there remained more buffalo on the Great Plains than there were people living in all of the United States. Herds of a million bison, with grazing areas the size of small European kingdoms, were common in the grasslands of the west.

Within less than a decade, the buffalo had vanished from the Great Plains. Government policy was explicit: exterminate the bison and destroy the native cultures whose way of life was based upon the hunt. In the thirty years leading up to 1880 some 75 million buffalo hides were sold. Tens of thousands of creatures were simply slaughtered, their tongues extracted and their corpses left to rot in the searing prairie sun. After a decade of slaughter the buffalo had become a mere shadow on the prairie, and the last of the great chiefs had been hounded into captivity. An outbreak of measles and influenza in the spring of 1892 struck the final blow. General Philip Sheridan, the Civil War hero who ran the campaign, recommended to an elated U.S. Congress that a commemorative medal be issued with a depiction of a dead buffalo on one side and a dead Indian on the other.

As it emerged on the American frontier, cowboy culture did not develop in conflict with Indian nations any more than cattle competed with buffalo for forage on the open prairie. It flourished in the wake of a campaign of genocidal fury, in a void created by the elimination of entire populations of tribal peoples and the reduction of the buffalo to a zoological curiosity.

As a way of life it had its beginnings in the most remote reaches of the Spanish colonial realm, in lands that in time would be known as Texas, a name of both native and Spanish origins. An expedition sent to investigate the massacre of a party of French traders had been greeted by peaceful natives calling out the word *thechas*, meaning "friend" in their language. In Spanish this came out as *Tejas*, which was later anglicized to Texians and finally Texans.

The region was a backwater, with little economic activity save that of the cattle ranches set up by the scattered Franciscan missions. With Mexican independence, the priests refused to renounce their loyalty to Spain, and the missions were largely abandoned. This opened the door for new possibilities as the government of revolutionary Mexico welcomed thousands of American immigrants, mostly farmers from the south looking for cheap land. By Mexican law, a farmer was granted 277 acres, but a man willing to augment his crops with livestock earned title to an additional 4,338 acres. A great many farmers discovered the enchantment of animal husbandry. Their challenge was to learn how to do it. What most of the immigrants knew of livestock had been learned on small Jeffersonian parcels, 125-acre tracts that made sense in the east but lost all relevance on the open range of the west, where rainfall in a year scarcely reached levels that could fall in Miami or Memphis in an afternoon.

Americans lacked even the words to describe what they were attempting to do, and so they conflated the language of the Mexicans and made it their own. What was called a farm in Spanish, a *rancho*, took on new meaning. The semiannual roundup of cattle was a *rodeo*. "Cowboy" was a direct translation of vaquero, a Spanish word derived from *vaca*, meaning cow. A saddle was strapped to a horse by a cinch, from the Spanish *cincha*. In brush and thorn scrub a cowboy wore chaps, from *chaparejos*. Those who worked horses, as opposed to cattle, were wranglers, again from the Spanish, *caballerango*. The word "lariat" was the anglicized expression of *la reata*. "Bronco," "stampede," even "buckaroo," a bastardization of vaquero, were all derived from Spanish terms.

Indeed, virtually everything we know and think about cowboy culture originated in Mexico. Cattle drives, branding, lassos, saddles, spurs, broad-rimmed hats, bandanas, well-heeled boots, both to fit the stirrup and to provide purchase when roping a calf—all

these elements and tools of the trade came from a tradition honed by conquest and rooted in practices that went back long before Columbus to the medieval economy of the Iberian world. And it was in that glorious past that Mexico rested, distracted as always by events at the core of the nation, even as Americans exercised their God-given right of expansion and Manifest Destiny. The American annexation of Texas in 1845 led to war and a U.S. victory that obliged Mexico to cede more than half its national territory, from Texas to California—all in exchange for a payment of $15 million. Significantly, all the land later to be infused with the myth of the American cowboy was in American hands for only a decade before the nation became completely consumed by the Civil War.

The golden age of the American cowboy lasted but twenty years, from 1866 to 1886, and it began with a straightforward business opportunity. The Union armies had exhausted the supply of beef throughout the northern states. Texas alone had some five million range-fed and feral cattle. A calf worth four dollars in San Antonio could sell for sixty dollars in Chicago. All a man had to do was round up the cattle and find a way to deliver them to the market, which meant getting them to Wichita, Dodge City, Cheyenne, or any of the cattle towns that had sprung up along the line as the railroads inched their way west. The Chisholm Trail, first scouted in 1867, ran fully 1,500 miles, from San Antonio and the Rio Grande to Abilene, Kansas. Feeding on good grass, with plenty of water, cattle could travel fifteen miles a day. The drives took as long as three months, with hired hands responsible for two to three thousand animals, night and day, even as they coped with drought and dust, rattlesnakes, and summer storms that shook the sky with thunder as lightning split open the heavens, stampeding the entire herd.

Those who found work on the open range or on the long cattle drives bore little resemblance to the cowboy of popular imagination. At least a quarter of them were black, and

even more were of Mexican descent. As working days were long, fifteen hours in the saddle, the most desirable ranch hand was short and slim in order to minimize strain on the horse. Few were marksmen; skill with a lariat, not a handgun, was the measure of a good drover. Death by gunshot was exceedingly rare. Between 1870 and 1885 the total number of such fatalities in Wichita, Abilene, Dodge City, and Ellsworth, four of the larger cattle towns, was but forty-five, an average of about 1.5 gun deaths per cattle-trading season. The local newspapers of the time reported not gunfights and barroom brawls but news about property values, business ventures, sales of goods and services, and whatever politics and celebrity gossip filtered in from the east. More cowboys were trampled by cattle or killed by lightning than ever died from a gun.

While the men on the trail might have occasionally chased off the odd native cattle thief, they almost never came into conflict with tribal warriors. The big cattle trails cut wide swaths around any territory known to be hostile. What's more, as we have seen, by 1880 the great cultures of the Plains had been largely reduced to a shadow on the prairie. The Comanche, at one time the most powerful warring tribe in the west, could field in 1874 no more than three hundred fighting men. In all the southern Plains, there remained no more than three thousand native men, women, and children who still strived to live free and independent lives. By 1880 the remnants of the Kiowa and Southern Cheyennes, the Kiowa Apaches, and the Comanches, nations that once ruled lands half the size of Mexico, together could muster perhaps eight hundred warriors, scattered across the prairie in small renegade bands. In time these too would be hunted down and killed.

By the time the wagon trains reached the west in great numbers, they moved through a landscape that had been largely depopulated by disease, starvation, and slaughter. Of the thousands of pioneers who crossed the continent, fewer than four hundred died in clashes

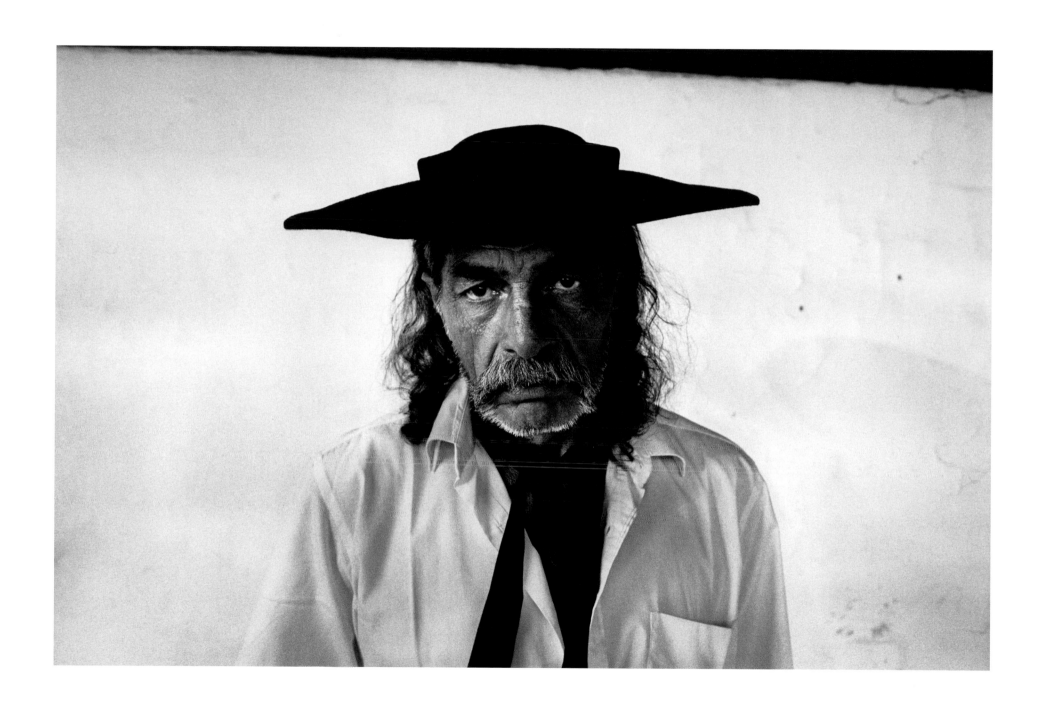

with Indians. Fatalities from other causes on the Oregon Trail alone reached as high as thirty thousand. The native people—Cheyenne, Kiowa, Apache, and Comanche as well as Sioux, Arapaho, and all the other great nations—accounted for just over 1 percent of the mortality suffered by the many tens of thousands of newcomers who trudged across their lands. The popular image of beleaguered settlers struggling in panic to circle the wagons in defense rarely if ever happened. Wagons were strung out for miles on a trail. The only time they formed a circle was at night, and only to fence in their own livestock.

In truth, while fur traders and mountain men earned their reputation as explorers, the life of the cowboy was relatively mundane, much like that of a modern truck driver, who works long hours delivering valuable goods along well-mapped routes. And cowboys labored not as silent loners but rather as members of a highly interdependent team. No one man could stop a stampede. Life on the trail meant long hours in the saddle, pushing cattle at a snail's pace to keep them from losing weight, breathing in the dust kicked up by eight thousand hooves dragging through the dirt. A few hours of sleep at night, huddling in the rain and sleet beneath a wool blanket, eating the same grub morning and night, arriving finally in some clapboard town exhausted, filthy, and saddle sore—this was the reality of a cowboy's existence.

The glory days of the long cattle drives lasted for little more than a decade. By the early 1870s, the railroads had reached deep into Texas. The invention of barbed wire killed the open range. Overproduction led to overgrazing and falling prices. A drought in the summer of 1886 followed by the coldest winter on record left thousands of cattle dead and the industry in a state of collapse. None of this helped the image of the drovers. By the 1880s, in Tombstone, the word "cowboy" was used to describe those who had been implicated in various crimes. Indeed, by the 1880s, to be called a cowboy at all was a serious insult,

somewhat like being labeled an outlaw or horse thief. As the *San Francisco Examiner* noted in an editorial: "Cowboys are the most restless class of outlaws in that wild country… infinitely worse than the ordinary robber."

Such language provokes images of the Dalton Gang, Jesse James, Cole Younger, or Butch Cassidy. But here we run up against another modern cowboy myth. The only reason we remember these names is because their exploits were so unusual. Bank robberies were exceedingly rare; over the last forty years of the 19th century only eight occurred across fifteen states. Banks were tough to knock over. Often built of stone, with reinforced walls, flanked on both sides by other buildings and situated at the center of town next to the jail, robbers had but one way out, and that generally ran right into the barrel of a sheriff's gun. There was certainly lawlessness on the frontier, and trains and stagecoaches were occasionally robbed. But there is nothing in the records to suggest that the cowboy ought to have been pilloried as if a dangerous deviant—except that in some sense they really were deviant. That fully a quarter of ranch hands were black in the immediate wake of emancipation suggests something of the profession's status in the south and west in the wake of the Civil War.

The reinvention of the American cowboy took place gradually as a broken and divided nation grew nostalgic for the closing of the frontier, even as it sought a unifying myth as it moved forward into what would become known as the American Century. The sanitized image that we know well from the television shows of the 1950s—*The Virginian*, *Bonanza*, *Have Gun—Will Travel*, *Gunsmoke*, *Rawhide*, *The Rifleman*, *Wagon Train*, and many others— emerged largely from the imagination of western writers such as Owen Wister, Zane Grey, and Walter Van Tilburg Clark. All were serious students of British medieval history and the mythology and popular literature it had inspired. Just as knights and chivalry provided

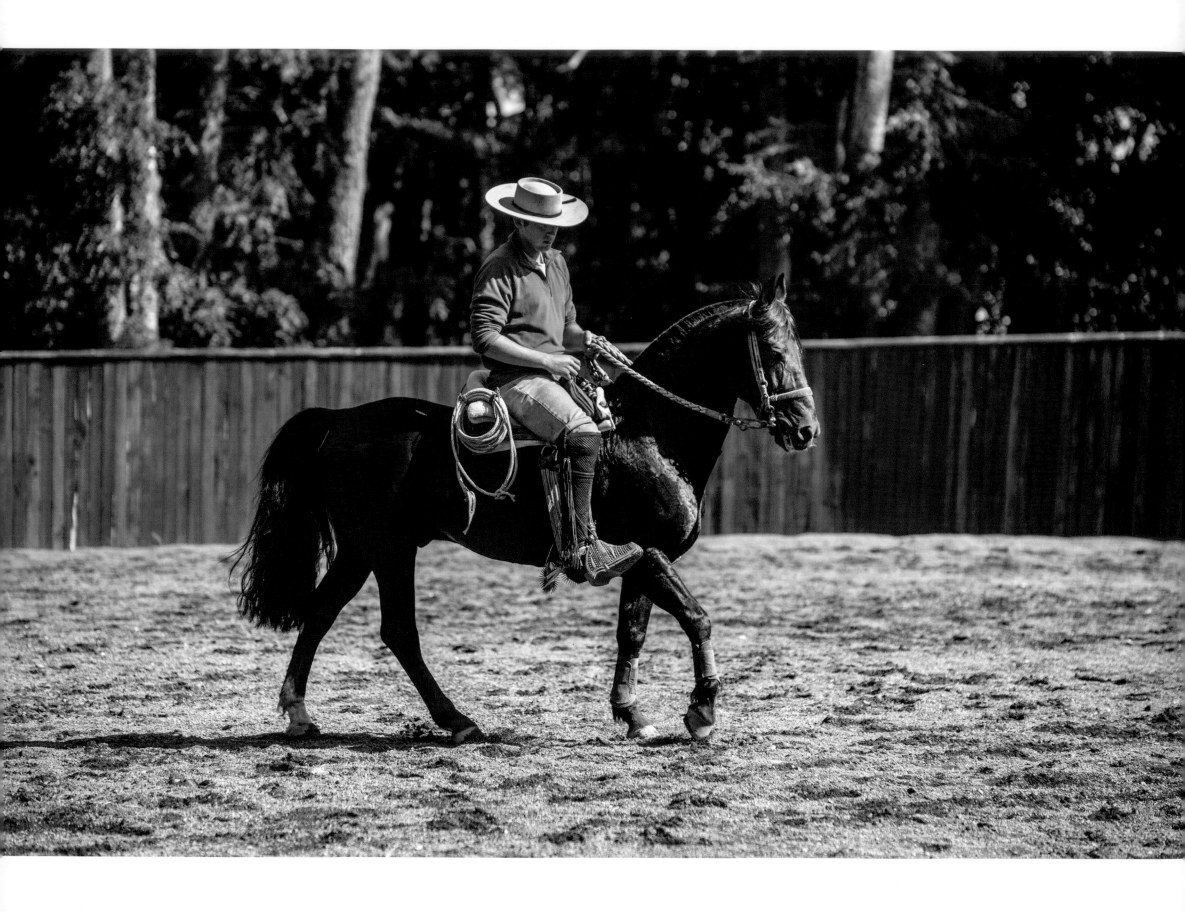

England with its foundational myth, so the cowboy and his struggles came to inform a new dream of America.

Naturally, this mythic cowboy would have to be white, a man of impeccable character with a soul loyal only to God. He would have to grow in physical stature, becoming tall and lanky, bronzed by the sun. He would be a person not of words but of action and deed, a lone avenger who would give his life for his beliefs or to save the innocent from evil and treachery. If he didn't really kiss his horse, he certainly loved it as much as he bashfully adored the pretty maidens of the few settlements he passed through, young women whose honor he would never betray. As an archetype this re-imagined cowboy embodied what the country thought itself to be—tall in the saddle, rugged, independent, powerful, self-reliant, fearless in the face of danger, loyal to friends, an ally of righteousness and a daunting adversary to the forces of darkness. The new cowboy was in every way the American incarnation of Lancelot, save that he would never go after the wife of the president.

Thus out of the west rode the new embodiment of the national soul, a taciturn loner oblivious to all the tortured contradictions of the American reality. It was soon forgotten that every symbol of the cowboy cult was of Mexican origins. Also expunged from the record was the rich contribution that African-Americans had made to the west, particularly after the Civil War, when they made up a good part of every ranch crew and cattle drive. In their place we were given *Shane*, the classic Hollywood western, which starred Alan Ladd, an actor so short that film crews had to dig trenches on the set so that his female co-stars might walk with him eye to eye. The Marlboro Man was a con, the product of a Madison Avenue advertising campaign conceived to persuade men to smoke a fading cigarette brand that had originally been marketed to women. John Wayne preferred sailing to riding on the range. Ronald Reagan was born in Illinois and learned to ride on a Hollywood film set.

Pitchfork Ranch, Texas
Colt Ellis
(Cowboys, US)

Happily, as this glorious book reminds us, real vaqueros still thrive throughout the Americas, from the Sertão and Pantanal of Brazil to the heights of the Andes, from the endless expanses of Patagonia to the deserts of Peru, from the broken-down haciendas of Mexico to the ice and snow of northern Alberta. Theirs is not a romantic existence, and not many of them would consider what they do a noble calling. It is just work, the only way they know to live.

But there is much to admire in simple lives that are honest, authentic, and true. Men who become one with their work have a dignity that is revealed in their every gesture—the way they walk, the way they ride, and, in the case of the gauchos, the way they wield a knife. The lives of the vaqueros portrayed in this book are not about money or fame but rather about honor, freedom, and the luxury of open space. They dwell in the thin places between the civilized and the wild, loyal to everywhere and nowhere, finding shelter within a triangle of mutual devotion—man, horse, and the wild. They are, as the gauchos say, the land upon which they tread. It is this that makes them truly and uniquely American, products of the New World, cowboy sons of all the Americas.

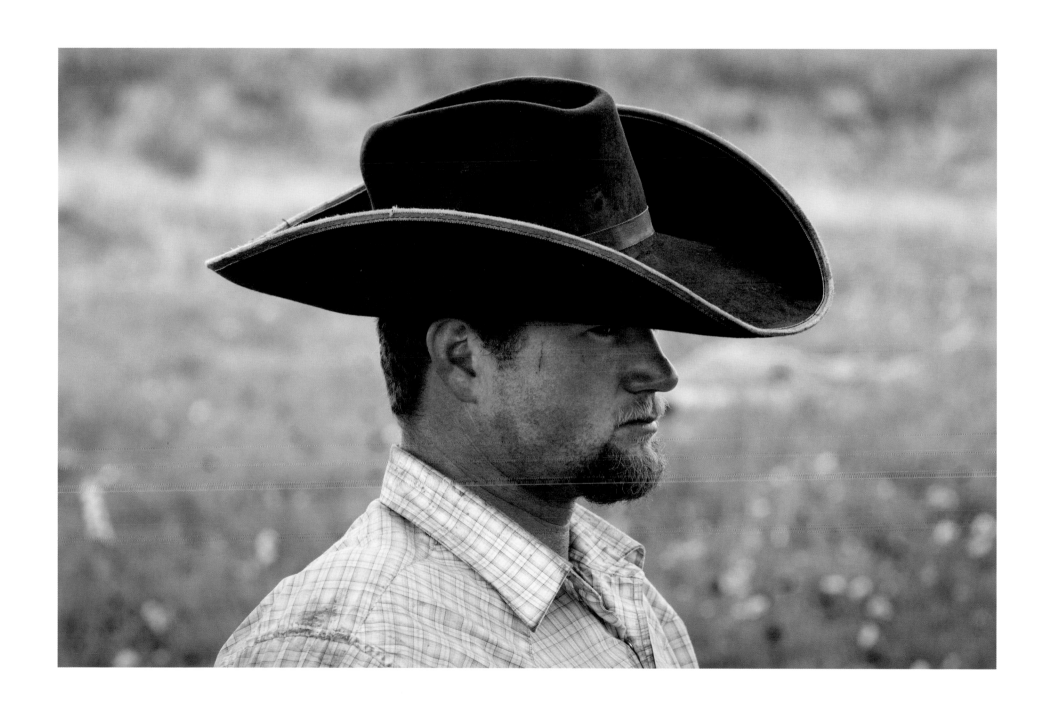

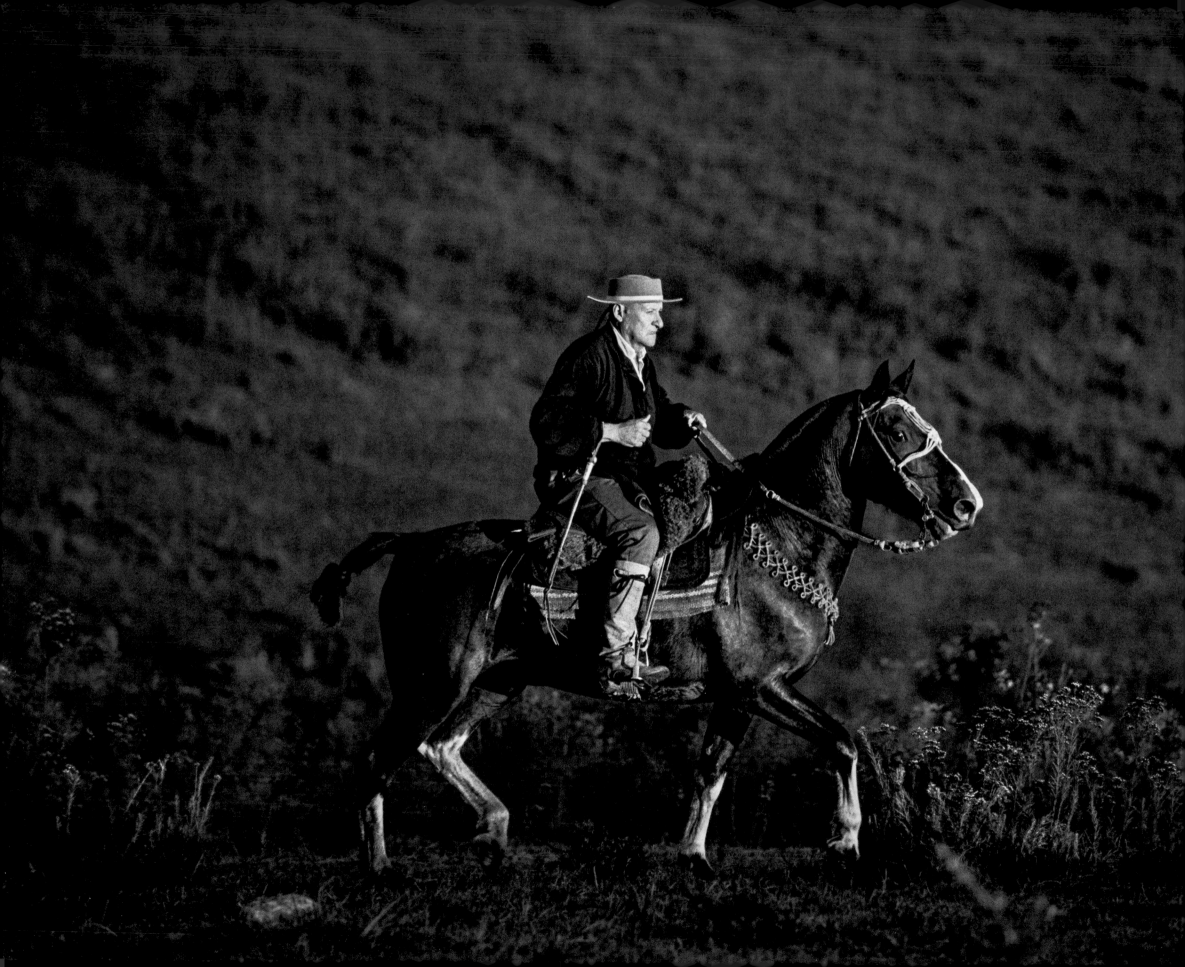

GAUCHOS

Uruguay

IN THE MID-19TH century in the lush grasslands of the Rio de la Plata basin—the vast and humid pampas sweeping over Uruguay, neighboring Argentina, and adjacent regions of southern Brazil—tens of thousands of feral cattle roamed free. Safe from predation, they bred prodigiously, achieving such numbers that settlers in need of leather or fat for candles might kill hundreds in an hour, slicing the tendons with lances, cutting away the desired flesh, and abandoning the carcasses to the raptors and wild dogs. Any impact on the herds from native tribes in Argentina ended in 1879 when General Julio Argentino Roca launched the Conquest of the Desert, a military campaign of extermination that left few natives alive.

Between 1860 and 1930, the exploitation of the pampas, facilitated by the invention of refrigeration, the spread of railroads, and the benefit of inverted seasons, with Argentinian meat coming to market just as beef supplies fell in the Northern hemisphere, created a flash of wealth that was mesmerizing. Argentina outgrew Canada and Australia both in population and in total income, becoming by 1913 the world's tenth-richest nation, with the fastest rate of growth. European immigrants flocked to the country, seeking work on the fertile pampas. In 1914 half of the population of Buenos Aires was foreign born.

But then came the Great War and the collapse of European markets and, in the wake of the war, a global depression from which Argentina never fully recovered. A country

that had been one of the most conservative and stable in Latin America became cursed by instability and political chaos.

Watching all of this from afar, the gaucho, the cowboy of the pampas, has endured all to emerge as a national symbol of continuity and hope. Celebrated in literature, evoked in nostalgia, the gaucho is above all a free man, a wanderer, taciturn and solitary, loyal not to the state but to the land upon which he treads. His race matters little. His possessions are few: the clothes on his back and the tools he needs to work cattle. A saddle that doubles as a pillow, a poncho for the rain, a lasso, and at one time a set of *boleadoras*, three stones or iron balls wrapped in leather to be thrown around the legs of an animal to immobilize it. The most essential tool is a long knife, a *facón*, used to eat meat, skin and geld livestock, trim the manes of horses, or intimidate any man who challenges one's honor.

The gaucho cuts a dashing figure, with trousers, or *bombachas*, baggy and gathered at the ankle; a poncho; and traditionally girding the waist, a skirt known as a *chiripá*. Yet his tastes are simple. In the morning he takes *mate* in a time-honored ritual and eats *asado*, meat grilled on an open fire. In the evening perhaps a basic stew or *guiso* of mutton, potatoes, onions, and squash, again shared by all. If he has children, they most likely have different mothers, for attachments are few in the lives of such wanderers. Marriages are seldom solemnized, and religious beliefs, such as they are, tend to be a mixture of ancient superstitions and the simplest of Roman Catholic convictions.

Above all, gauchos live by a code of honor, never spoken about and never forgotten. They know no laws and obey no authority, save perhaps that of another who has earned the name *caudillo*, having demonstrated through action a quality of strength fully deserving of respect. In any gathering of gauchos there is a pecking order of silence, an ethic of grace and decorum. Ultimate allegiance is not to any man, but rather to freedom, the essence of a gaucho's identity.

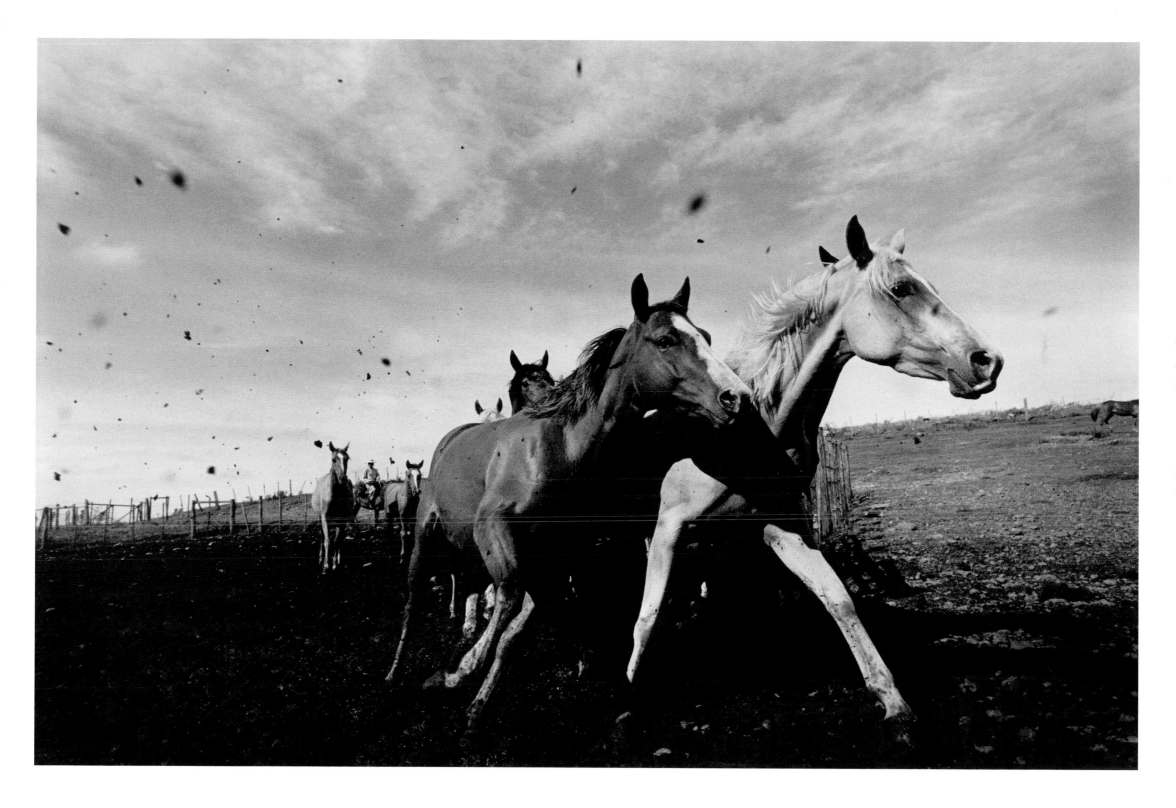

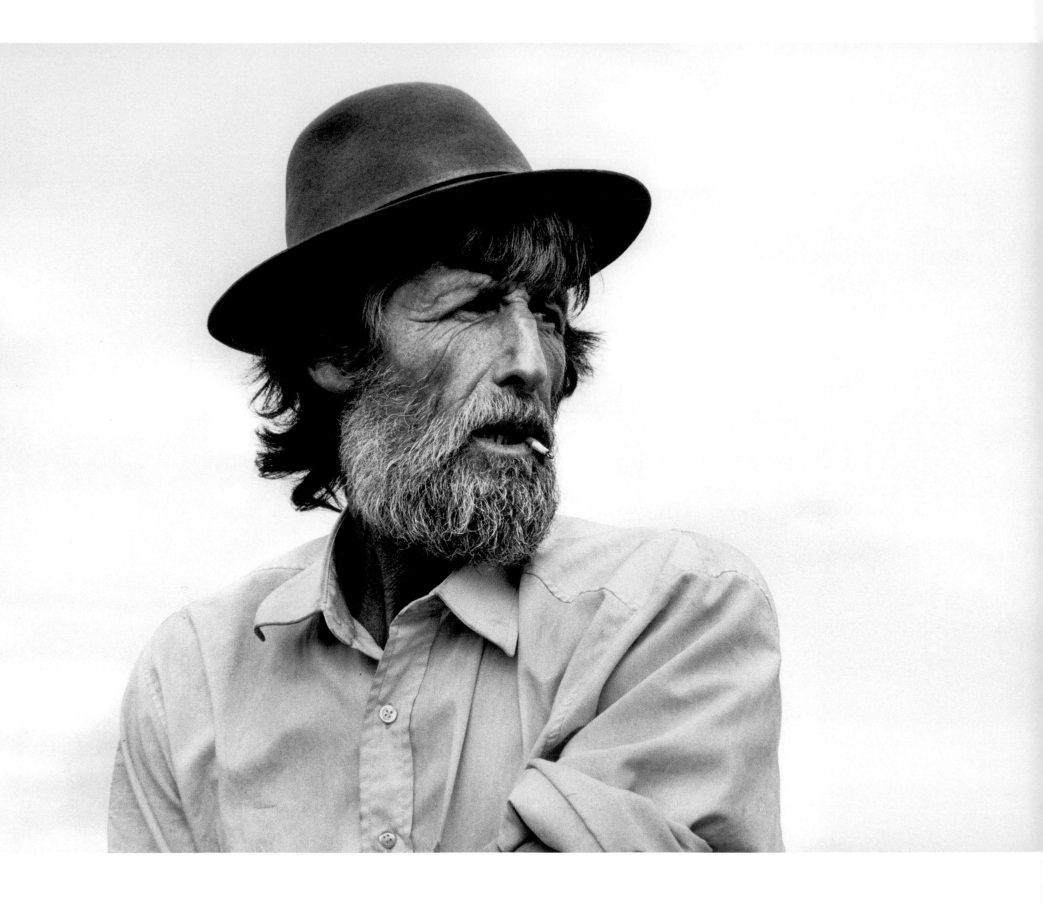

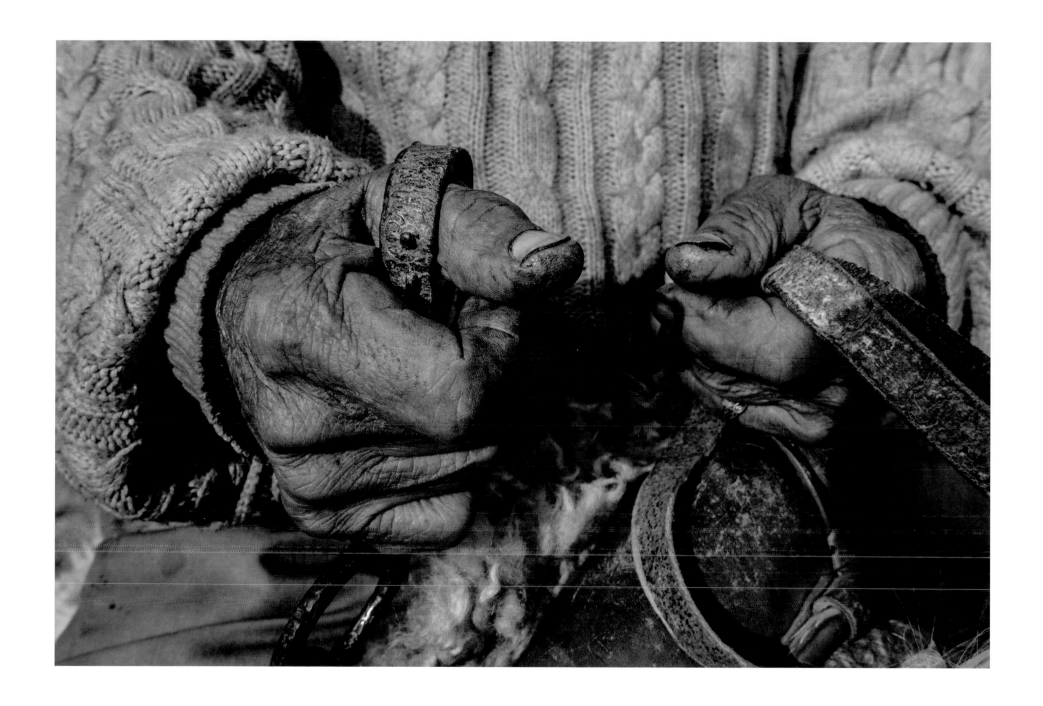

Tacuarembó, Uruguay

Cerro Largo, Uruguay

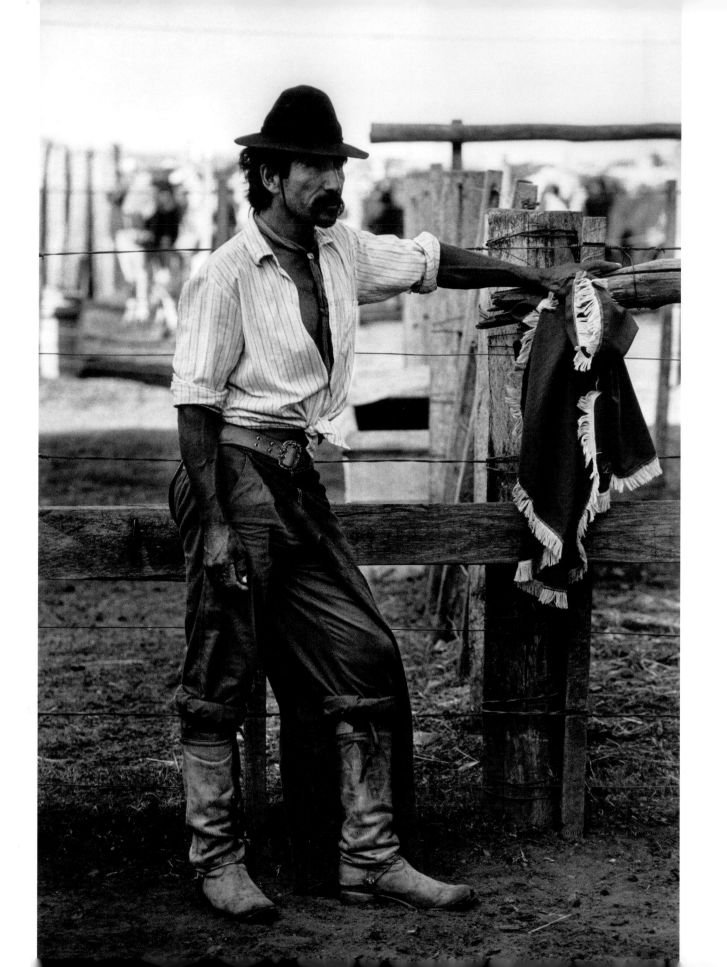

LEFT

Artigas, Uruguay

FACING

Estancia La Invernada, Uruguay

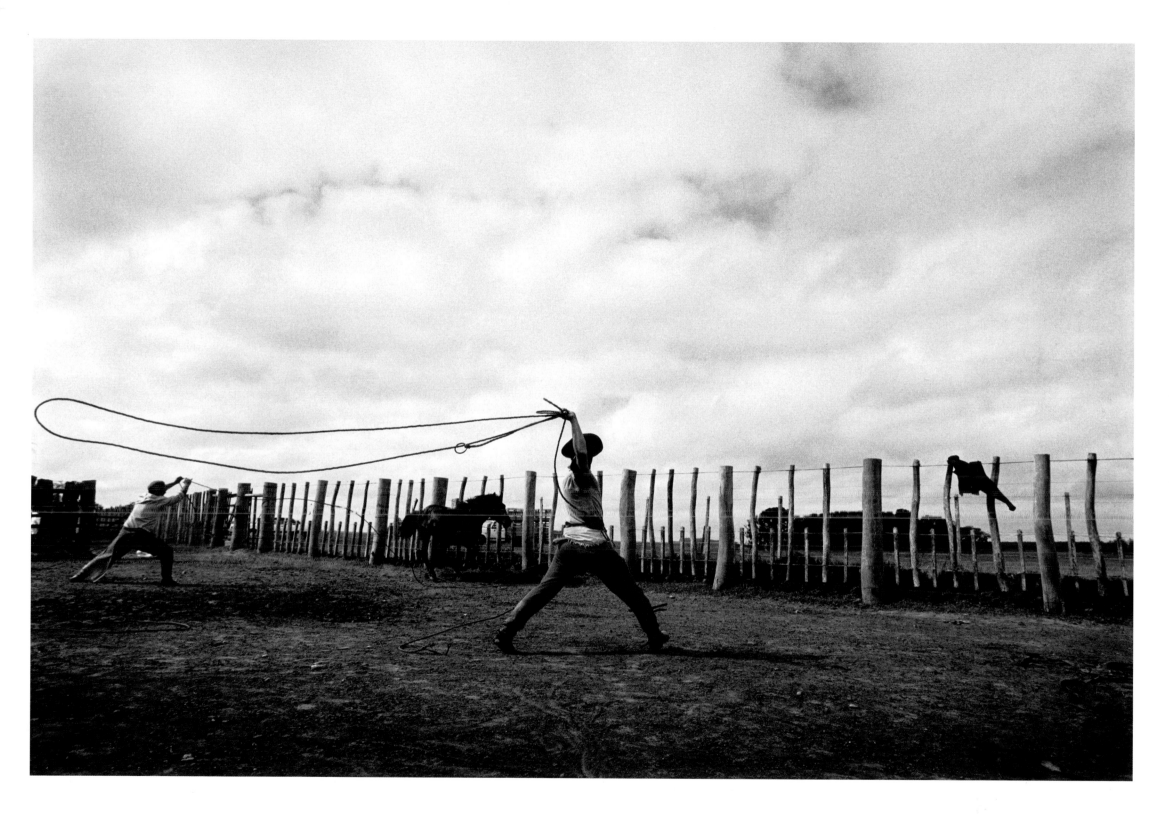

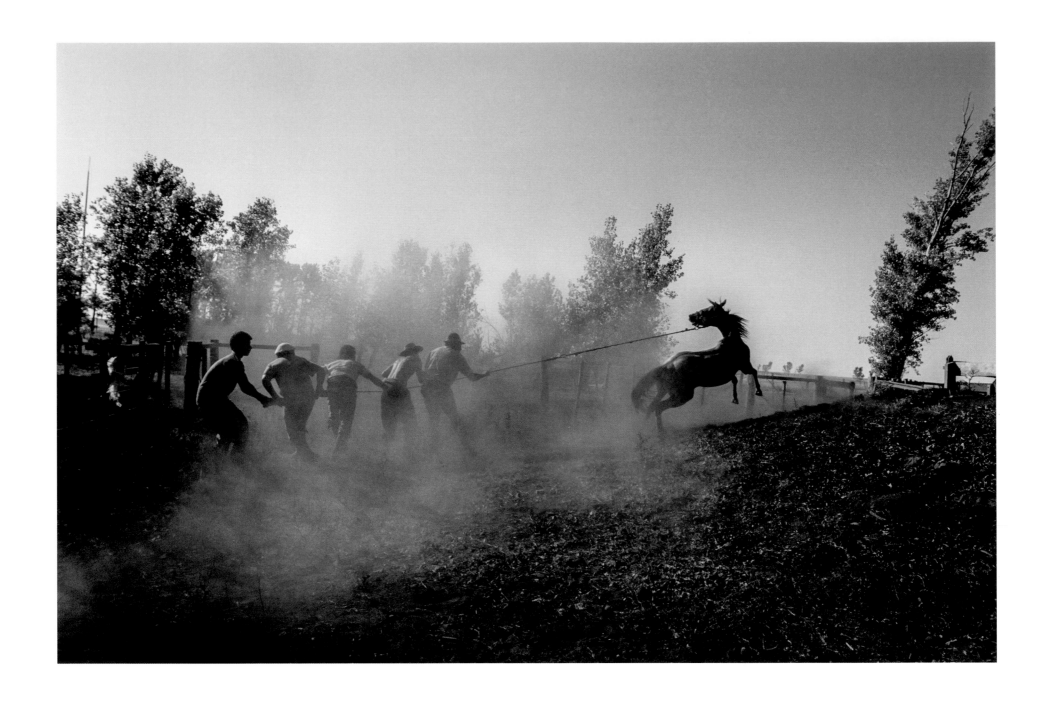

Estancia Santa Beatriz, Uruguay

Estancia a Tala, Brazil

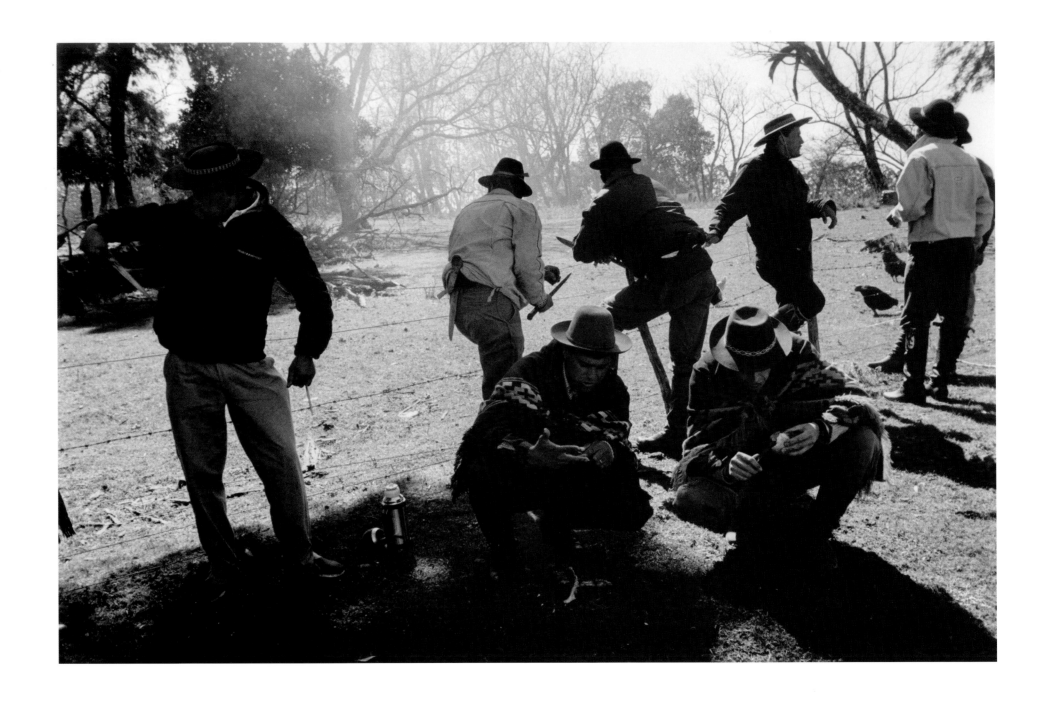

Tacuarembó, Uruguay

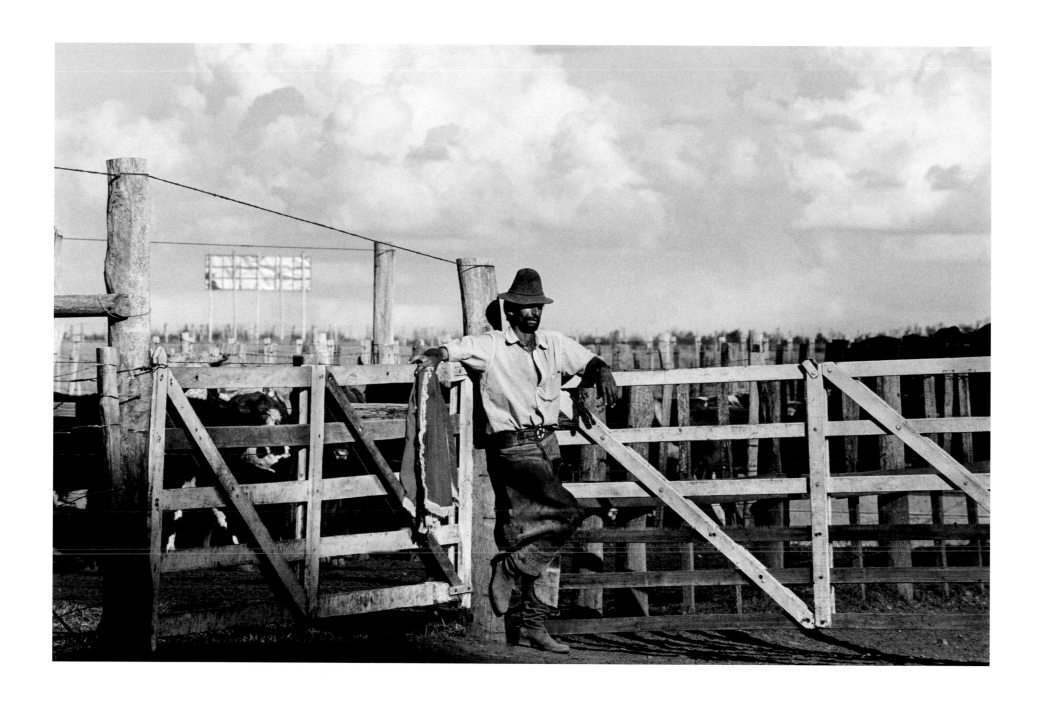

Cerro Largo, Uruguay

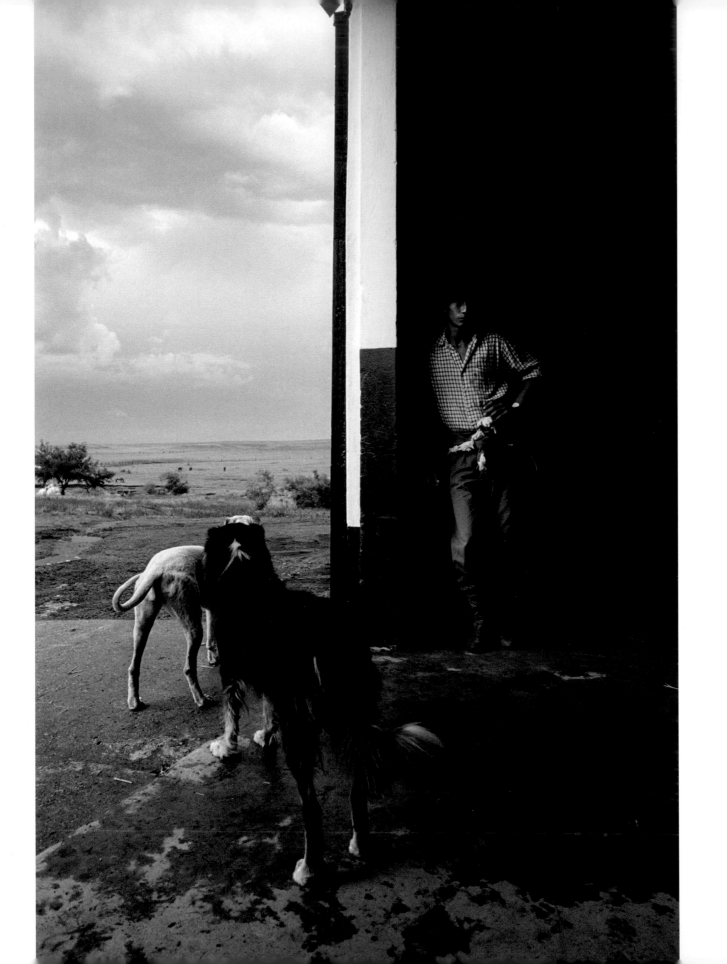

Estancia Santa Beatriz, Uruguay
Gustavo Texeira

Estancia La Fe, Uruguay
Foreman Don Esteban Bonin
and his son Jorge

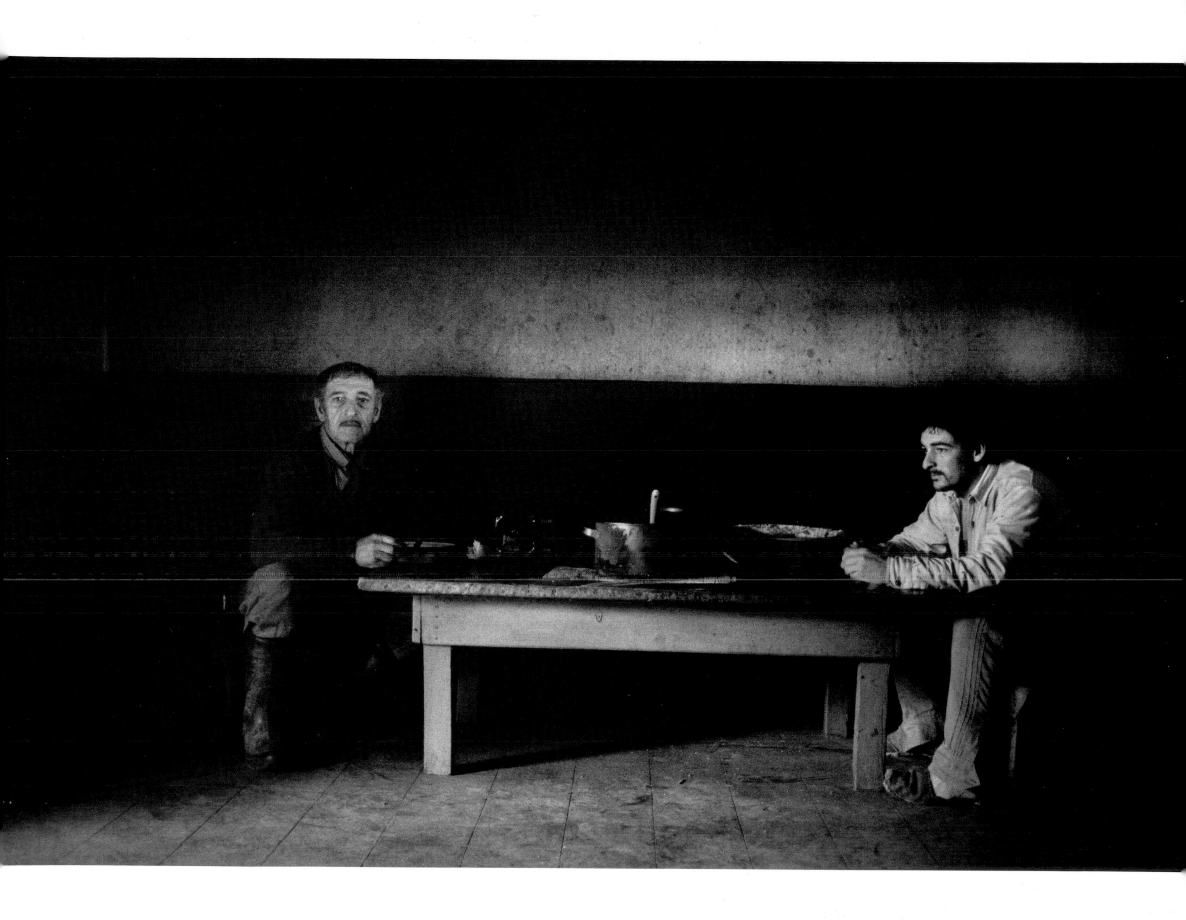

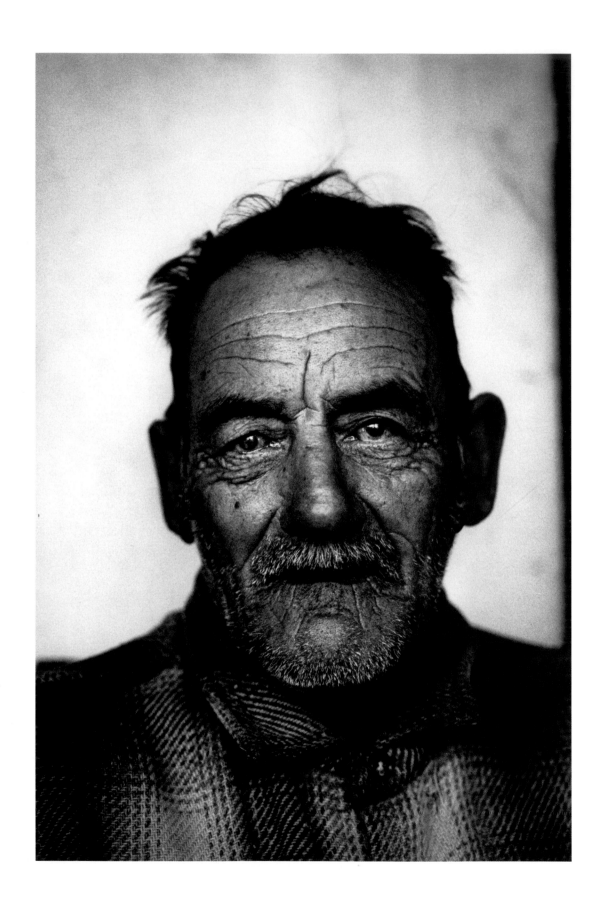

LEFT

Estancia El Hervidero, Uruguay
Don Napoleón Pintado

FACING

Estancia Yacuy, Uruguay

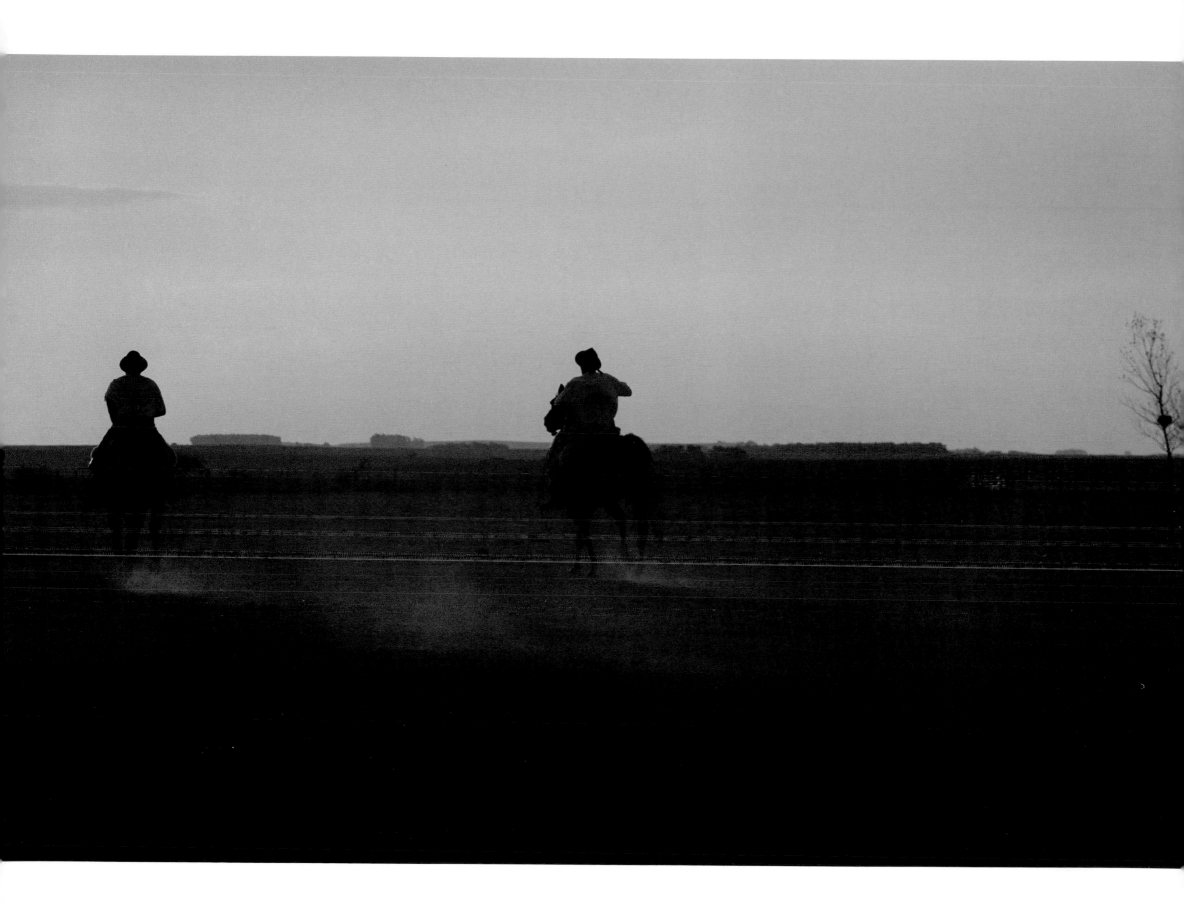

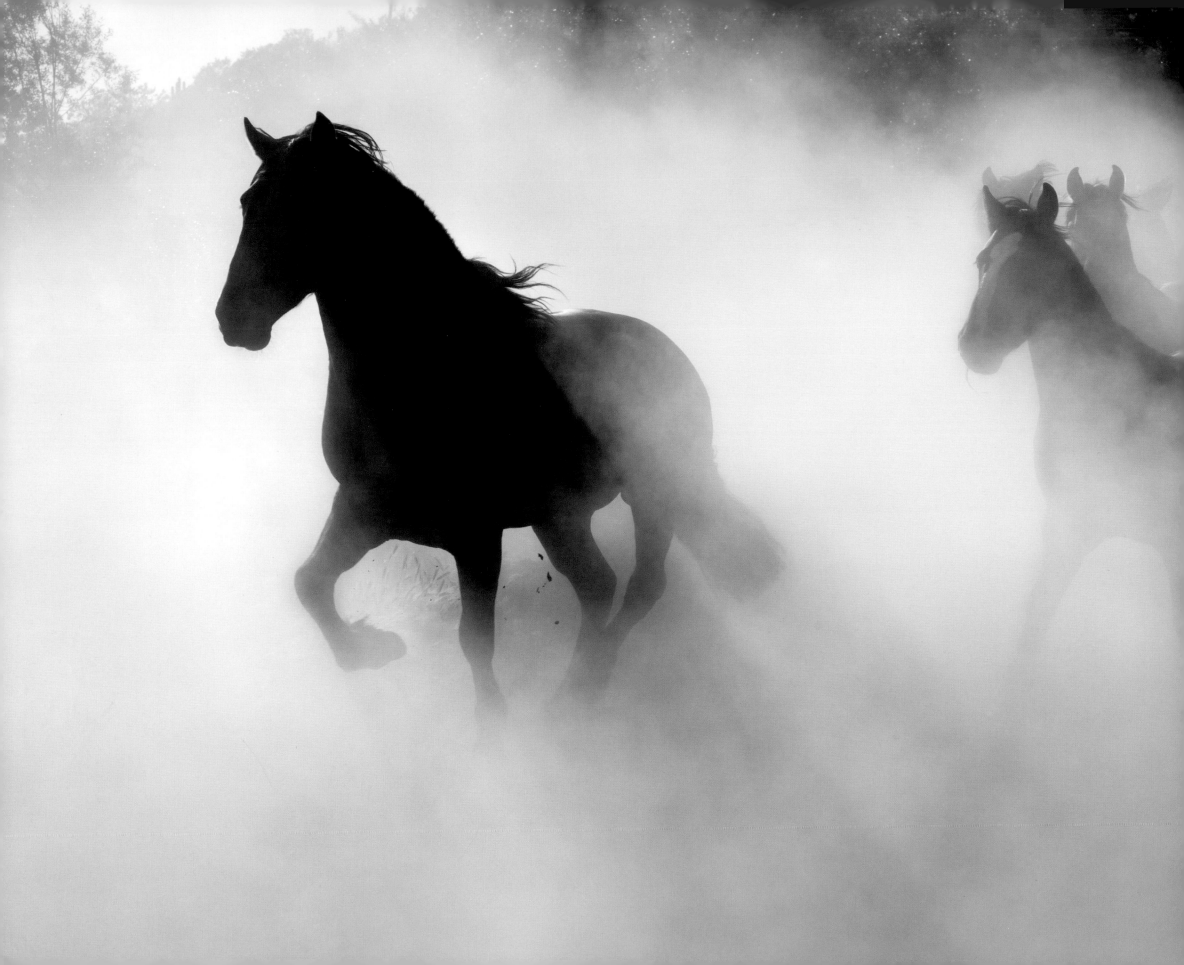

HUASOS

Chile

SOME WOULD SAY that a Chilean huaso is just a gaucho with one foot firmly planted in the rich soils of the central valley south of Santiago. The origin of the term is uncertain, though it dates to at least the mid-18th century. Some suggest it comes from the Quechua word *wakcha*, Hispanicized as *huacho*, meaning orphaned or homeless and free. Another possible derivation is *wasu*, or *huasu*, suggesting in the language of the Inca something rustic, coarse, or crude. Today in Ecuador the word *huazo* refers to a person who is especially uncouth and vulgar. Still another possibility links the words *huaso* and *huasa* to terms in both the Mapuche and Quechua languages relating to a person's back or the back of an animal laden with cargo.

In contemporary Chilean slang the word *huaso* or *ahuasado* can also imply someone lacking in urban elegance and sophistication, a usage similar to that of the term "redneck" in American English. The most likely derivation, however, is not American but Andalusian, for in the Spanish province of Andalusia, home of so many drifters and dreamers who came to the New World, the colloquial word *guaso* describes someone who is without grace, benign but slow-witted.

Certainly in the early history of Chile the huaso was a rough-cut character, dressed in baggy trousers with a long knife tucked into his belt behind his back, leather boots and heavy iron spurs, a coarse poncho, and an Andalusian conical hat—a peasant cowboy if

ever there was one. Riding the borderlands between Chile and Argentina, across mountain passes populated only by bandits, cattle rustlers, and smugglers, the huaso lived outside the law, independent and free. Men such as these survive to this day, huasos who still drive herds high into the mountains to summer pastures. Known also as *arrieros cordilleranos*, they are a mix of native and mestizo blood, as hard as granite, as relentless as the glaciers that slowly carve away the flanks of the Andean Cordillera.

Living in considerably greater comfort are the so-called *huasos de salón*, the huasos of gentility. These are the great landowners, many of them direct descendants of the ranchers who became a powerful force during the war of independence (1810–1818), harassing Royalist strongholds and then fleeing back into the mountains they knew so well. They earned a heroic reputation, which in the new nation of Chile resulted in a level of respectability that transformed their identities. They emerged as the gentleman cowboys they are known as today, bulwarks of law and order, responsible, faithful, deeply conservative, and fiercely loyal to Church, family, and State.

On the haciendas it was difficult to distinguish owners from cowboys, for like the *hacendados* the hired hands were themselves fanatically attached to the land. Both owners and cowboys wore essentially the same refined costume—a straw hat, or *chupalla*, with a round, ironing-board-flat brim, knee-high leather boots with spurs at the heel, a wide red or black sash around the waist with a fringed length always hanging to the left, a short Andalusian waist jacket and leather leggings, and a multicolored *manta*, a poncho, covering the shoulders. They rode the same kind of horses, dwelt in houses built of the same simple materials, and shared the same passion for rural life and the same love of discipline and order.

Impeccable in his dress, intensely nationalistic, proud, and true, the huaso has emerged as the symbol of modern Chile, a folkloric figure that invokes all that is generous

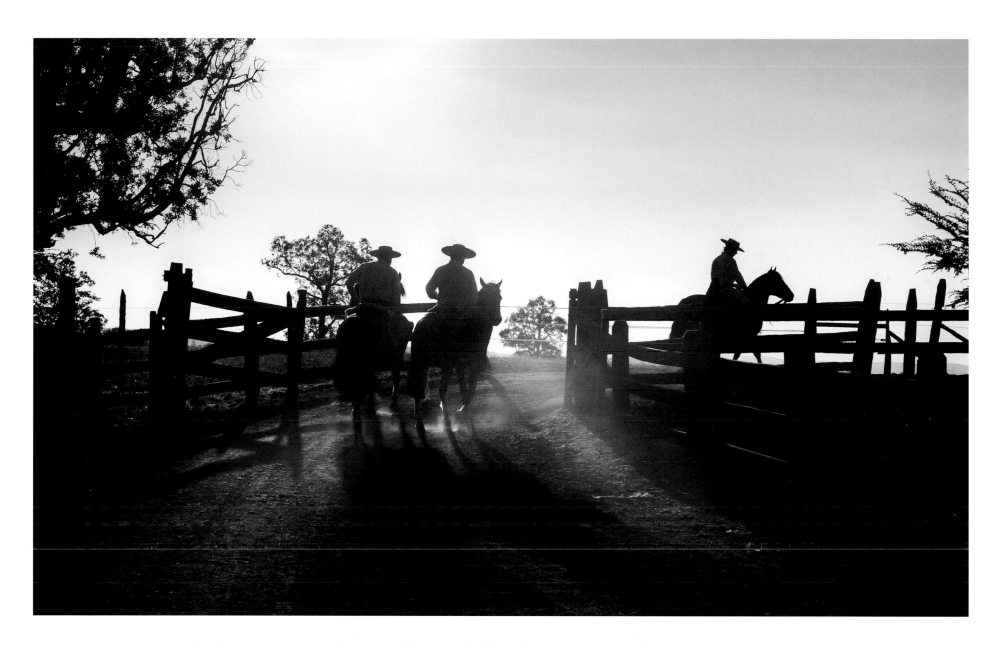

and good in the country. As such he is a vital feature of public life, appearing in parades and festivals and serving as the central attraction at the great rodeos that are Chile's second most popular sport, surpassed only by football. When, dressed in all his finery, the huaso takes to the floor to dance the *cueca*, the national dance of the country, he becomes the embodiment of a nation's past, the symbol of its present, and the emblem of all that Chile and its people hope to become.

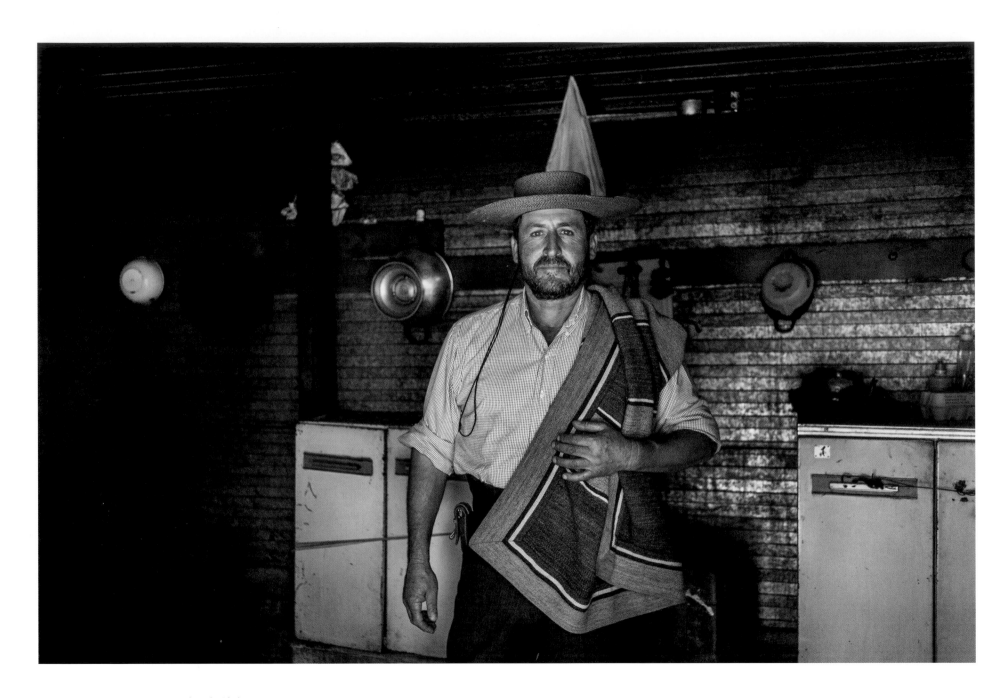

Cajón Cortaderal, Chile
Luciano Miranda

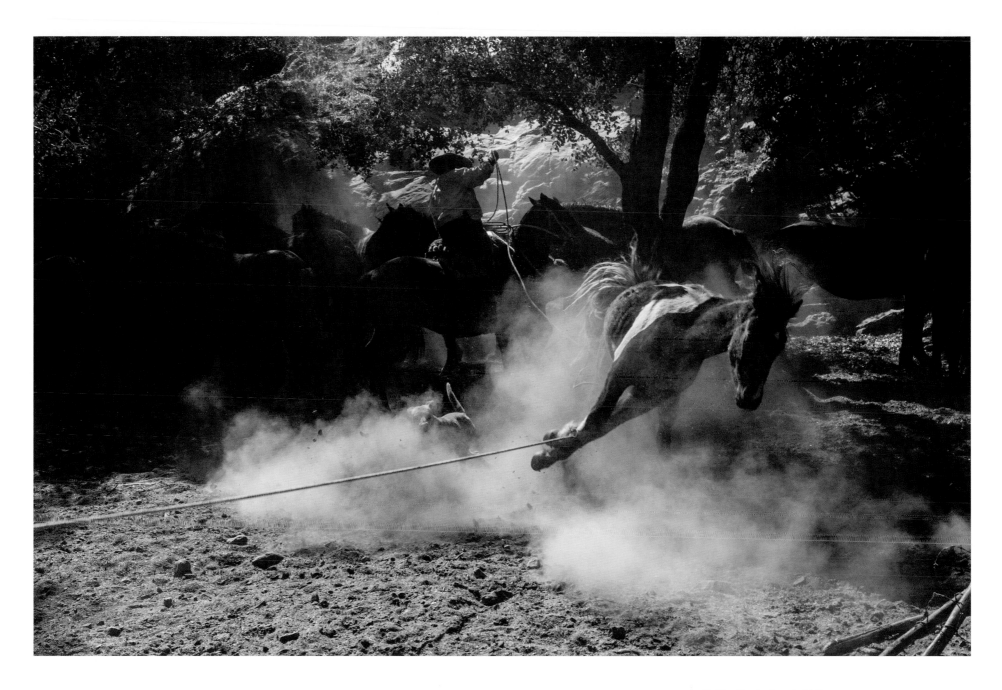

Cajón Cortaderal, Chile

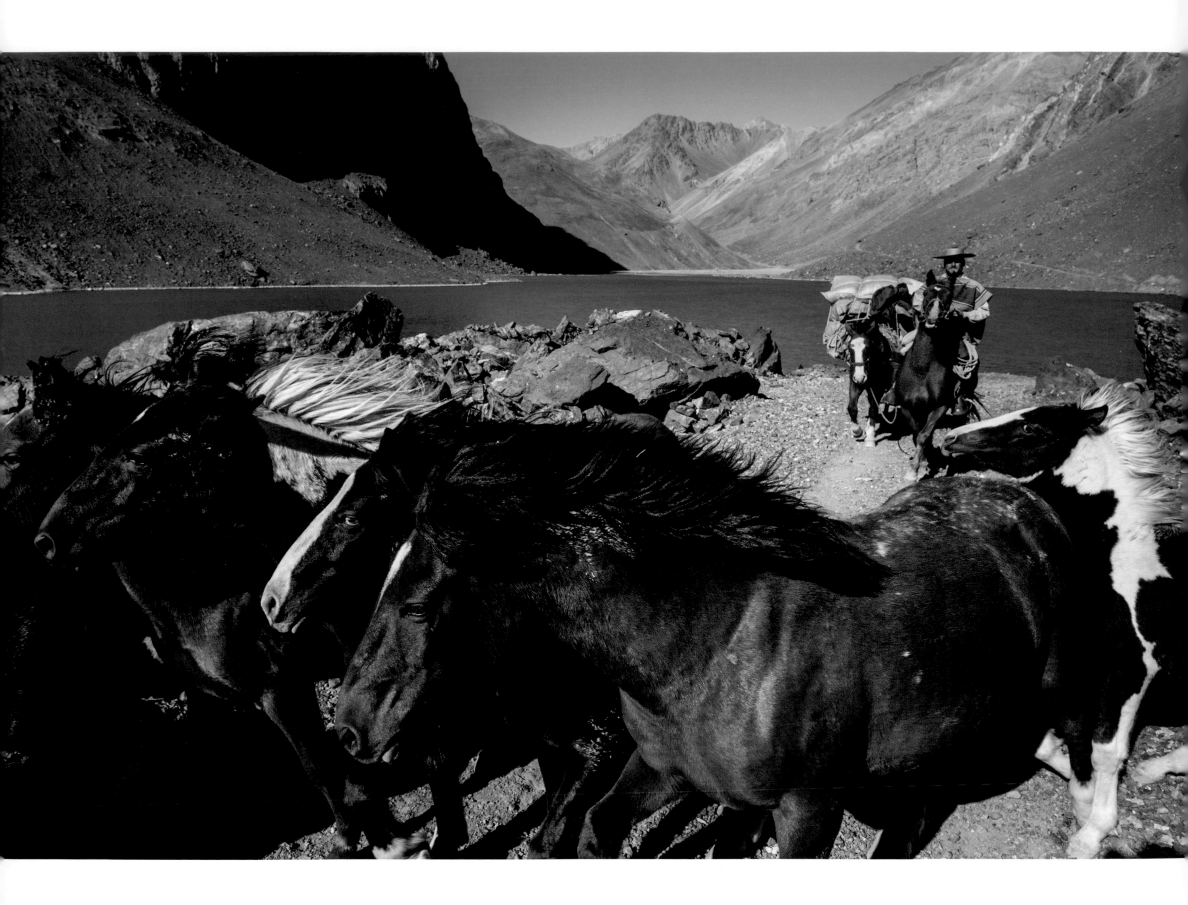

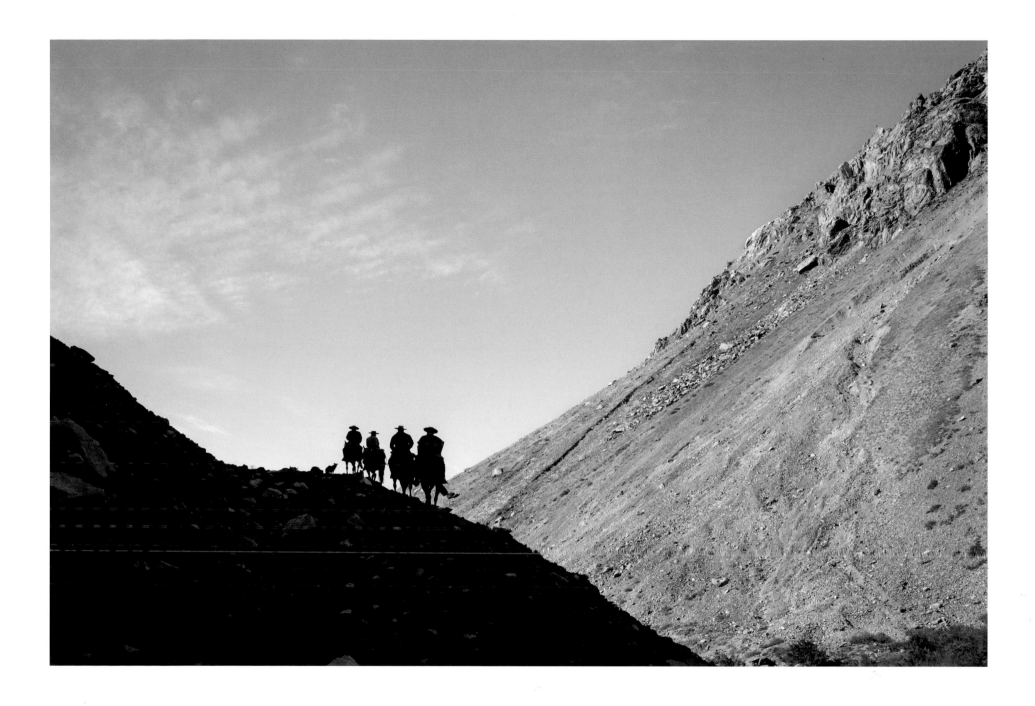

Los Gorgollones, Chile

Cajón Cortaderal, Chile

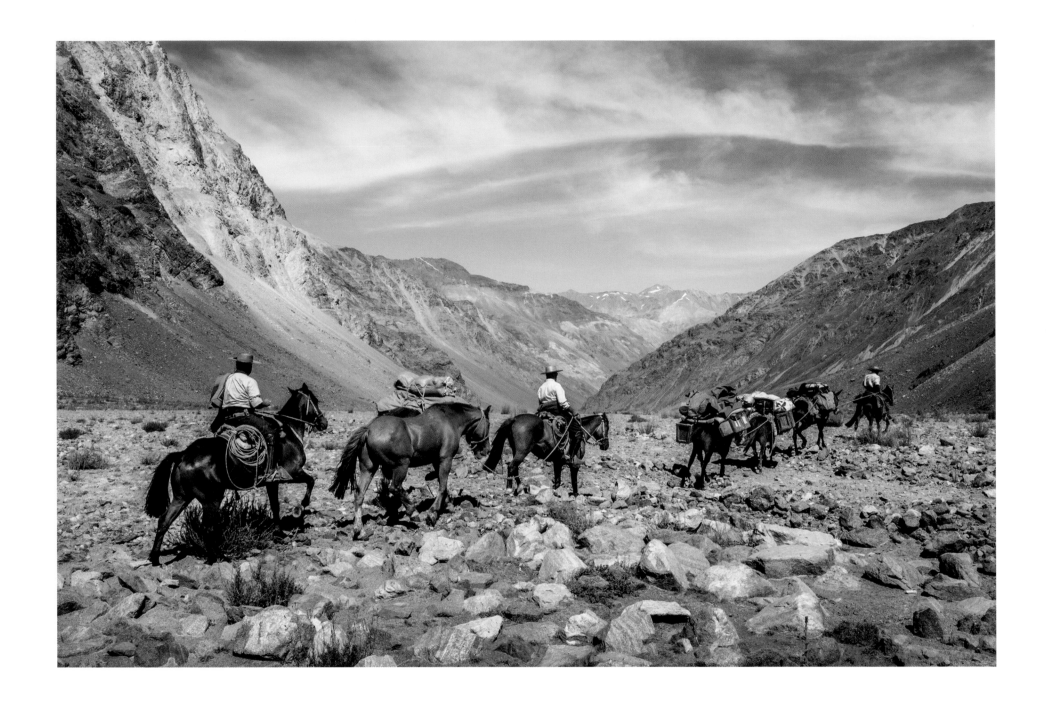

Rio Cortaderal, Chile

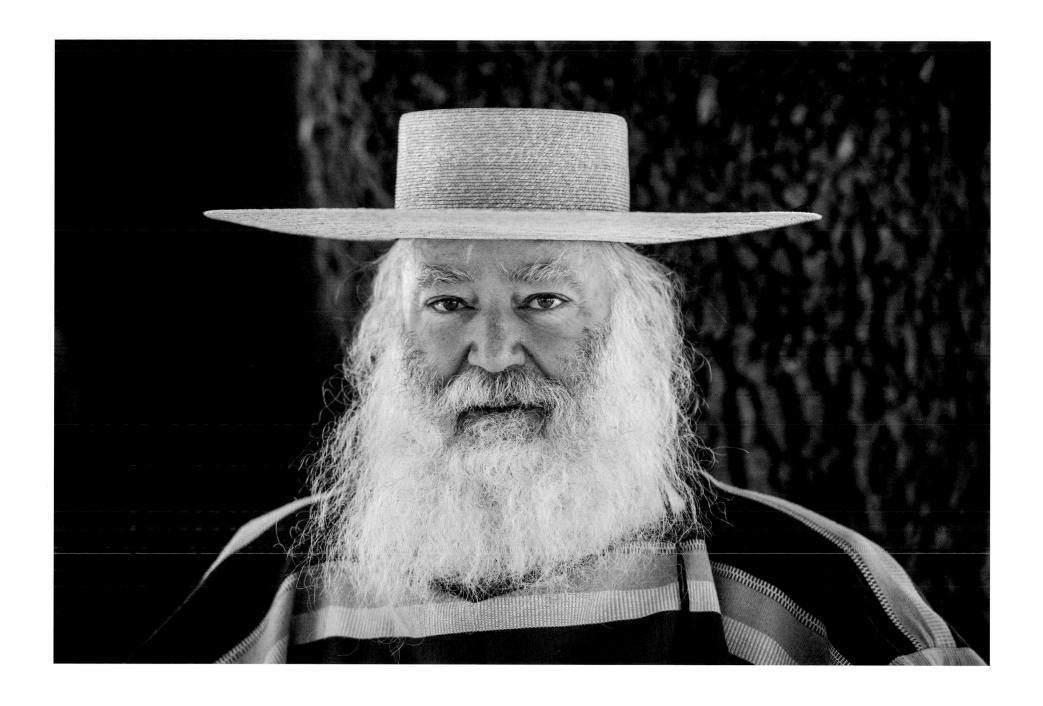

Osorno, Chile

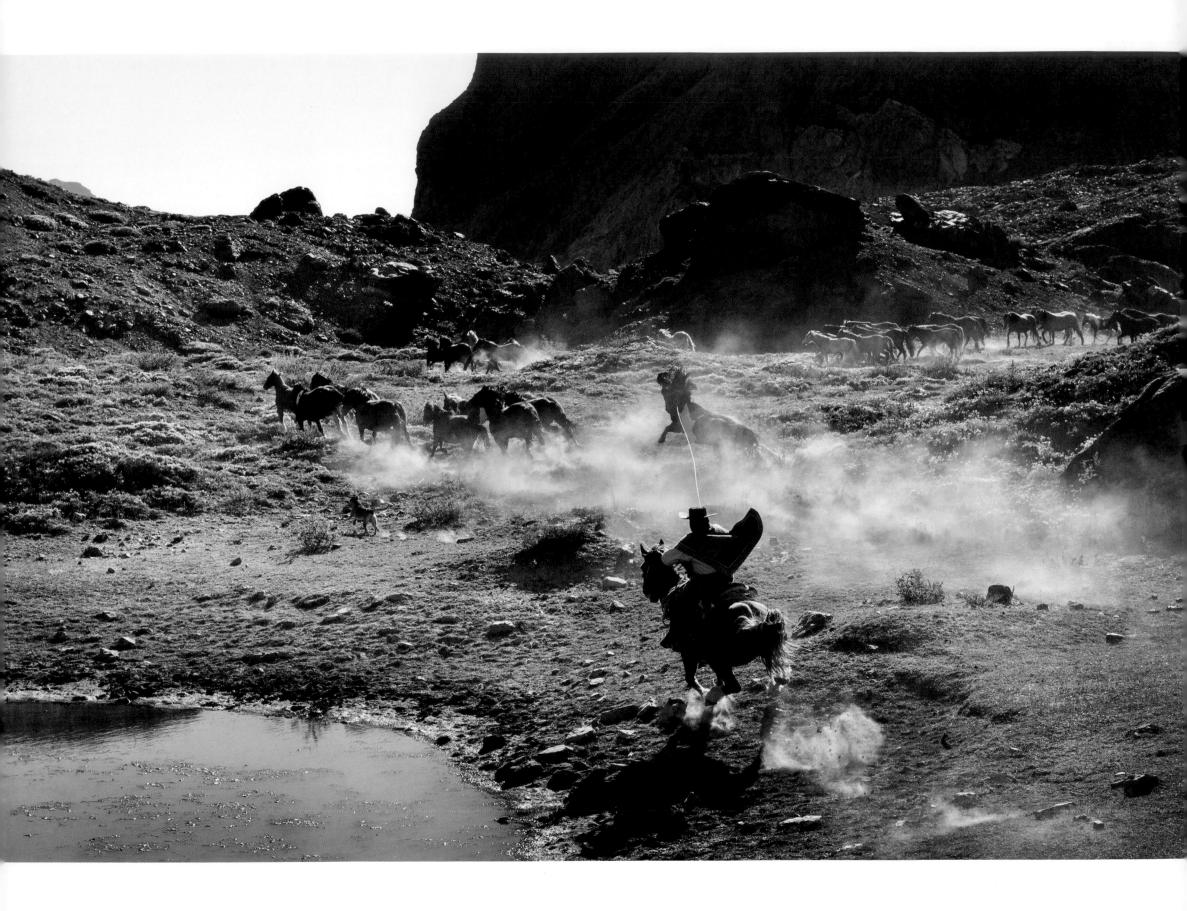

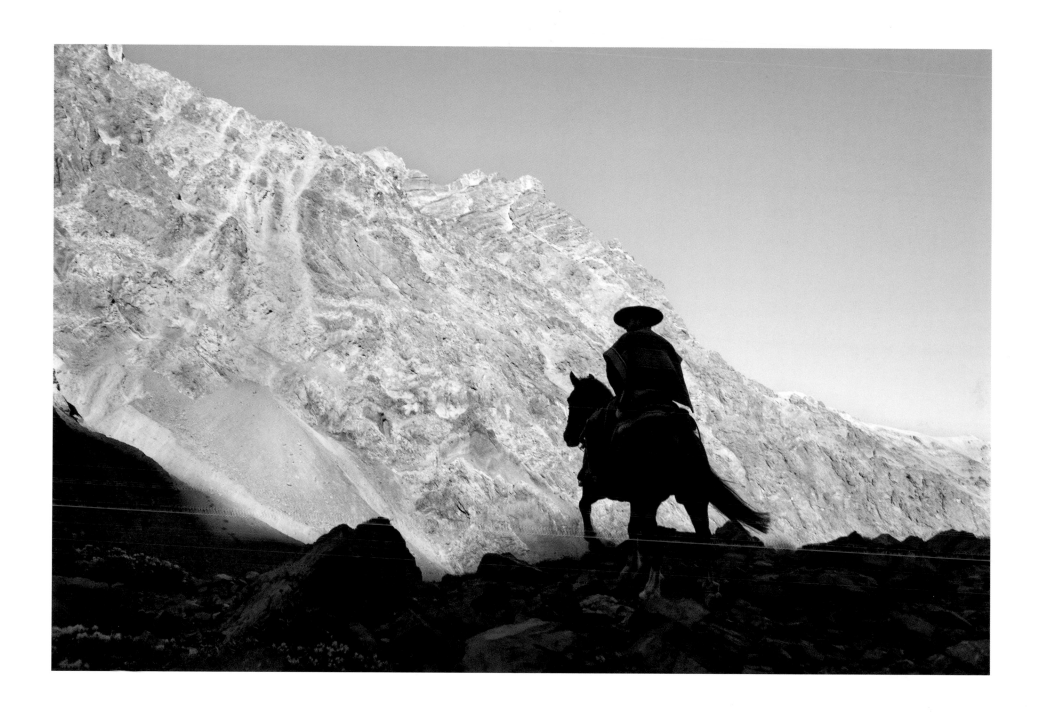

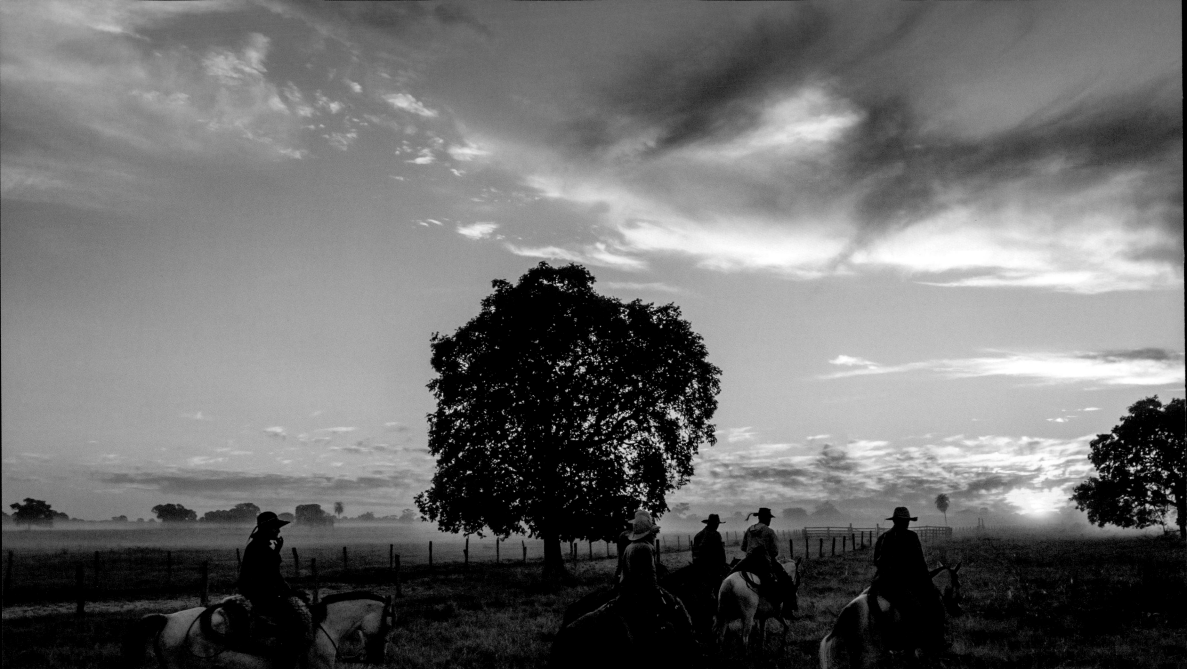

PANTANEIROS

Brazil

IN THE SOUTHERN reaches of Brazil, extending west into Bolivia and Paraguay, lies the Pantanal, the largest tropical wetland in the world. Bordered by dry forests to the west and southwest and the great Cerrado, or tropical savannah, to the north and east, it is essentially a landlocked river delta, a vast mosaic of raised islands and seasonally inundated marshes and swamps nearly five times the extent of Switzerland.

It is a world defined by water. The rains come in November, and as the Paraguay River and its tributaries overflow their banks, the water level in the great basin that is the geological foundation of the Pantanal rises as much as sixteen feet. By January everything is flooded save the *cordilheiras,* the winding gallery forests, and the round hummocks, or *capões,* islands of slightly elevated terrain also covered in forest.

Those animals adapted to aquatic conditions—giant river otters and caimans, tapirs, capybaras, anacondas, scores of wading birds, and no fewer than 325 species of fish—readily disperse across the flooded lands. Creatures that prefer to remain dry—howler and capuchin monkeys, jaguars and ocelots, foxes and marsh deer—crowd the exposed summits and ridges of what little land remains above water. The result is the greatest concentration of wildlife in South America—656 species of birds, 159 distinct mammals, and 151 species of reptiles and amphibians.

PREVIOUS SPREAD
Fazenda Baía das Pedras, Brazil

FACING
Santana, Brazil

Reaching these dry refugia is difficult, for the Pantanal remains without roads. There is little point in constructing infrastructure certain to be washed away by the seasonal floods. Thus, the few settlements and towns are isolated and widely dispersed. They too must cling to exposed patches of ground, certain to be surrounded for three months of the year by waist-deep floodwaters that reach to the horizon.

In May, with the onset of the dry season, the water recedes into ponds known as *baía*, where birds and foxes gather to gorge upon the stranded fish. In time these pools too dry up, and all life congregates along the narrow streams that emerge etched on the land as the water retreats. In three months the limitless marsh and flooded wetland are transformed into a dry, tawny savannah.

Given that cattle do not swim, the Pantanal would seem to be just about the last habitat capable of supporting a cowboy culture. In fact, the great wetland is home to over 2,500 *fazendas*, or ranches, and some eight million head of Nelore cattle.

The pantaneiro is a rare breed of cowboy. The scale of his landscape is vast and ever changing, and the conditions are difficult, with five feet of rain a year, clouds of mosquitos at all times, venomous snakes, thickets of thorn brush, and the constant threat of predators—jaguars, caimans, and anacondas.

The most challenging time is the annual roundup, which occurs over the last weeks of the dry season. Nelore cattle are fierce and dangerous, quick to stampede. It takes a team of drivers, or *boiadeiros*, together with a cook and wagon of provisions drawn by a team of six mules, the better part of a month to complete the task. Each morning at dawn the cattle boss plays the *berrante*, a three-horned wind instrument that emits a far-reaching, low-frequency sound that stirs the cattle into motion, one by one, until finally, as many as six thousand strong, they are ready to be herded toward a distant crossroads where they will be auctioned to the highest bidder.

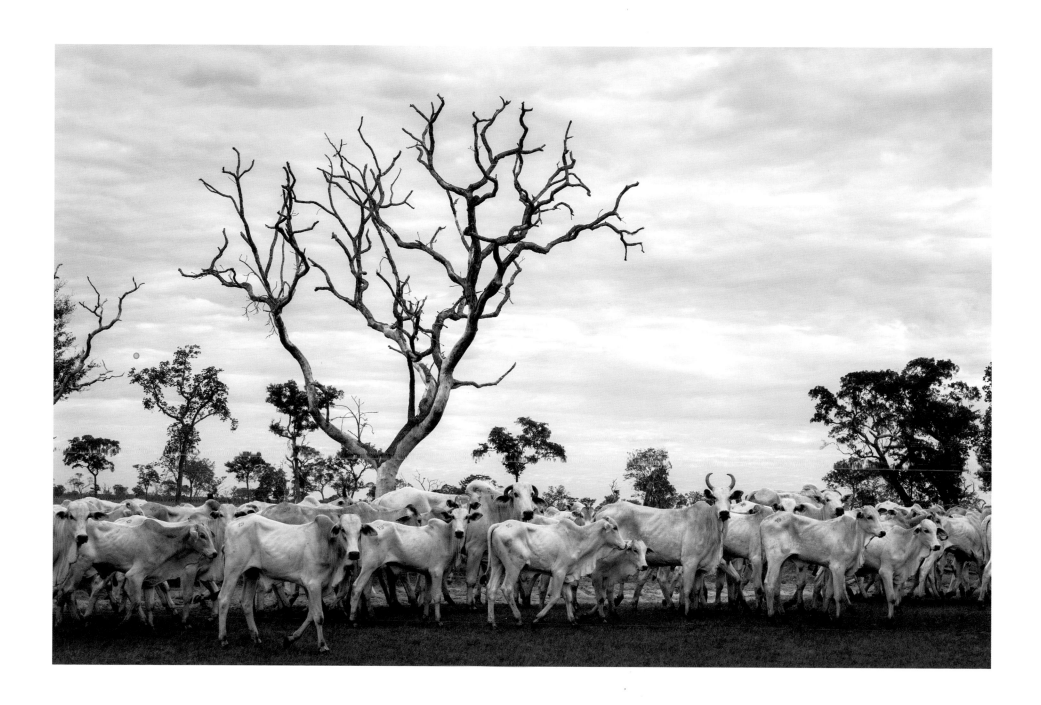

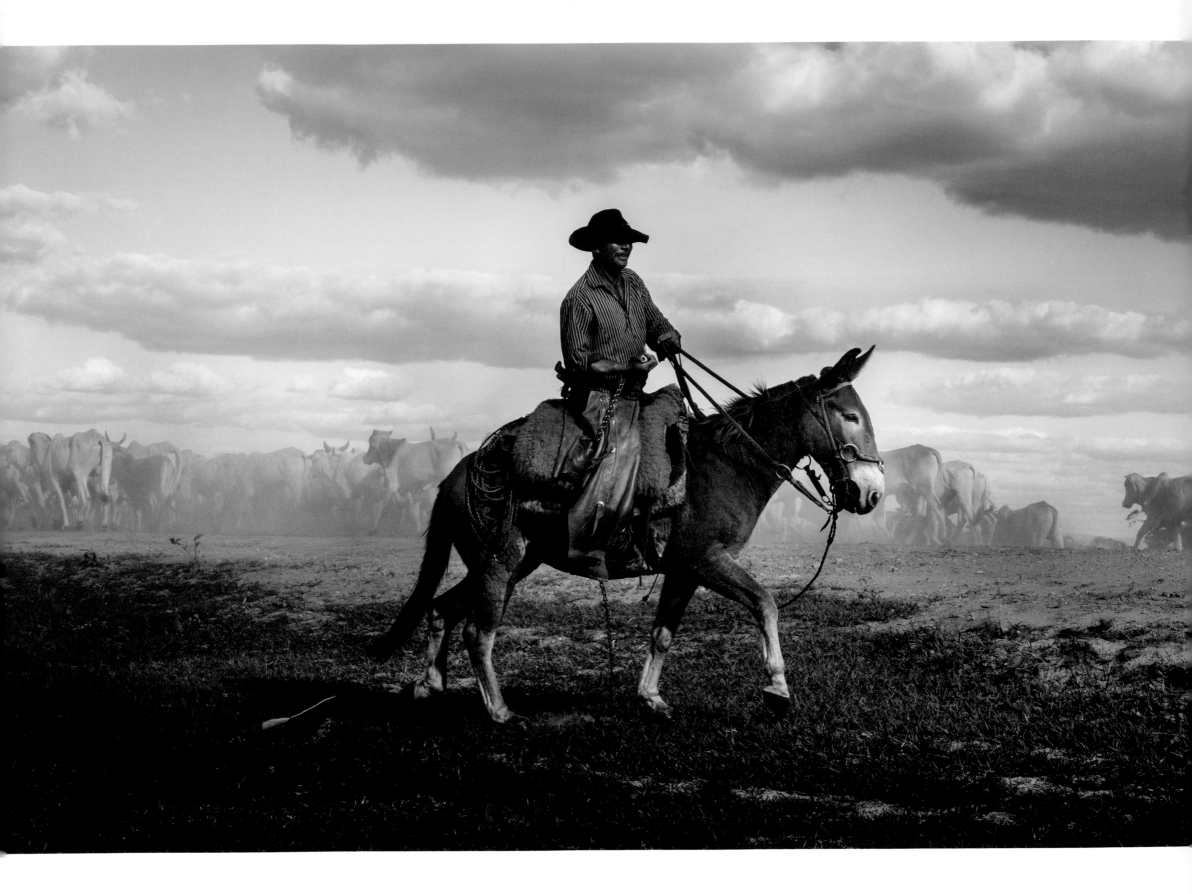

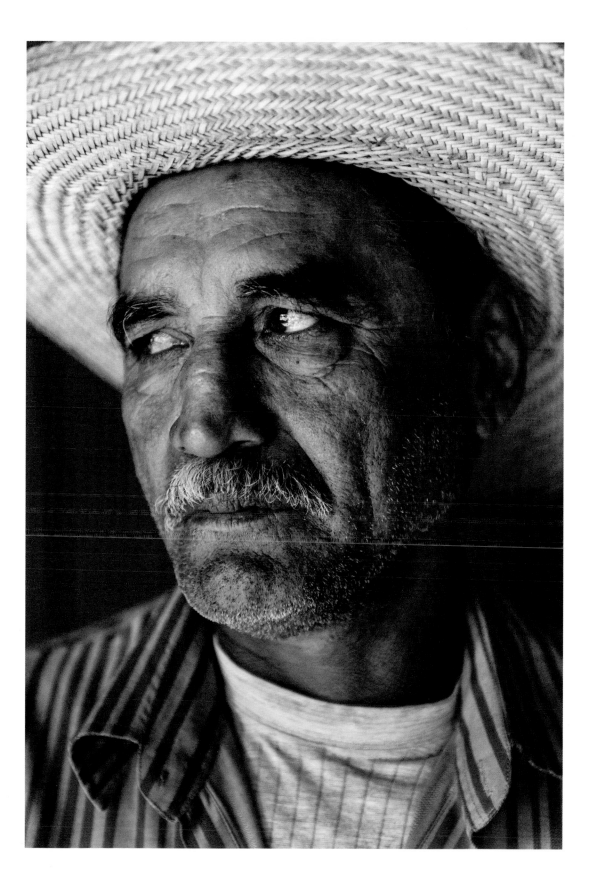

FACING
Corixão, Brazil
Valdemir Apolinario

LEFT
Fazenda Baía das Pedras, Brazil
Adelino

Fazenda Baía das Pedras, Brazil

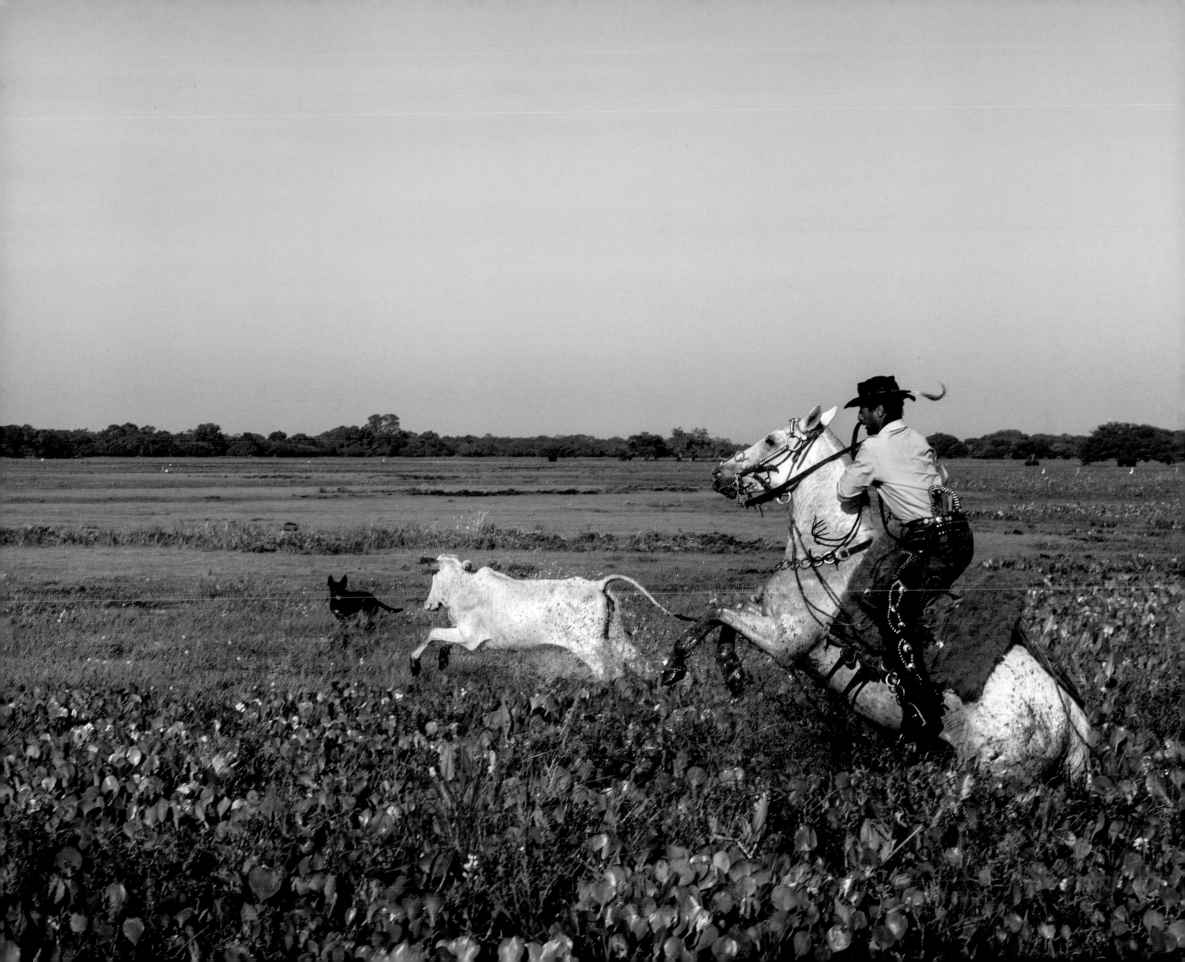

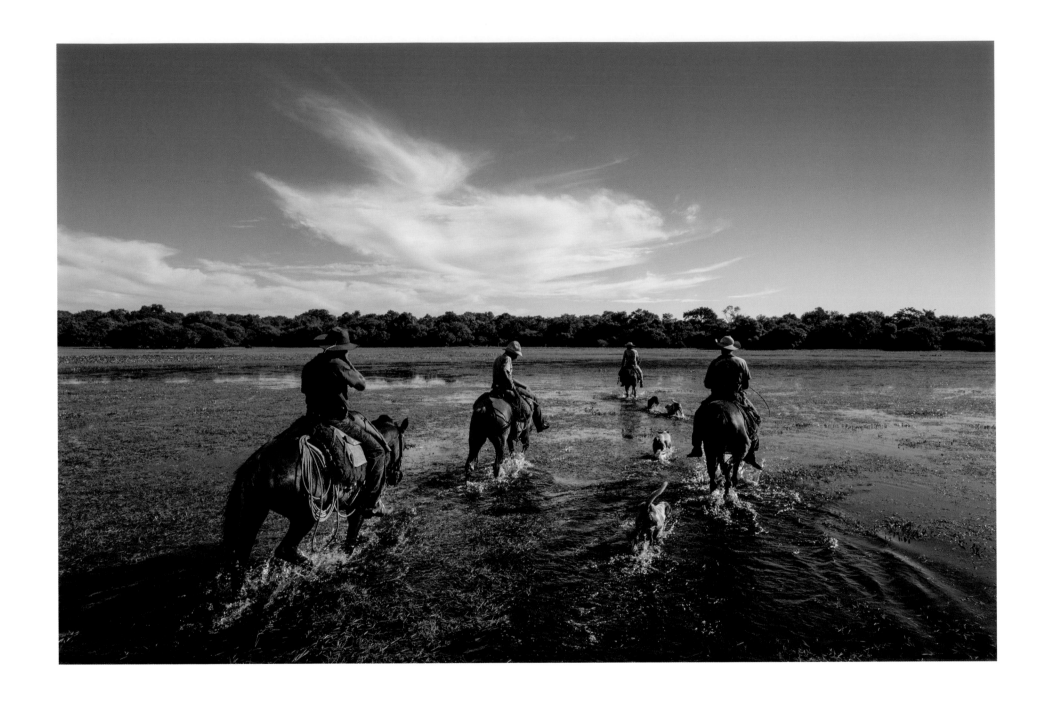

Fazenda Baía das Pedras, Brazil

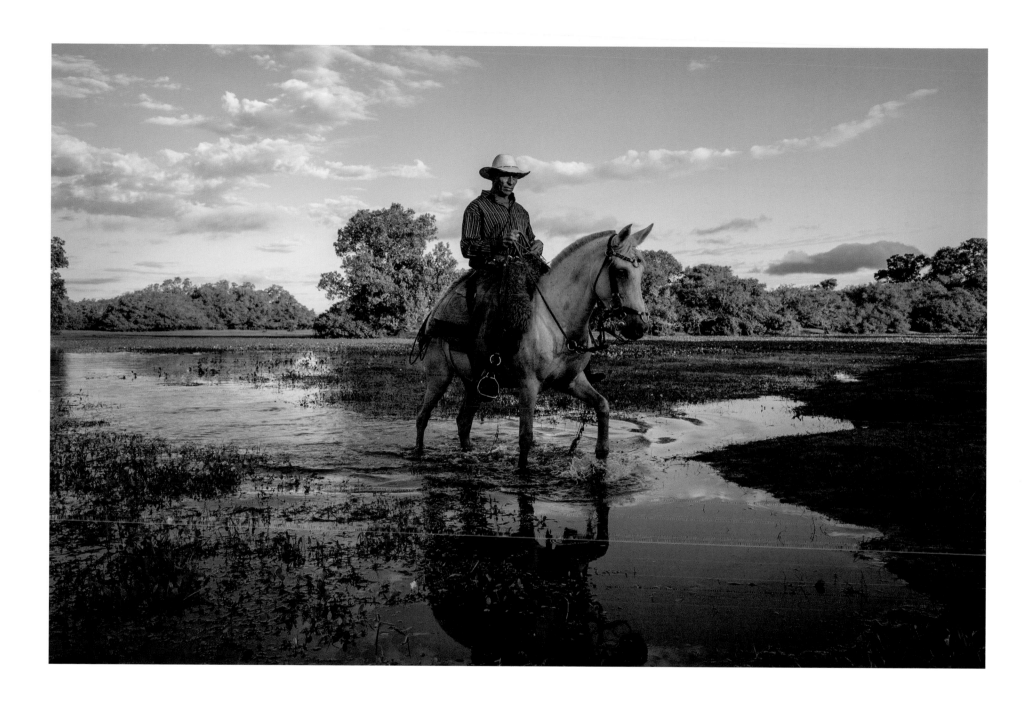

Fazenda Baía das Pedras, Brazil
Bosco

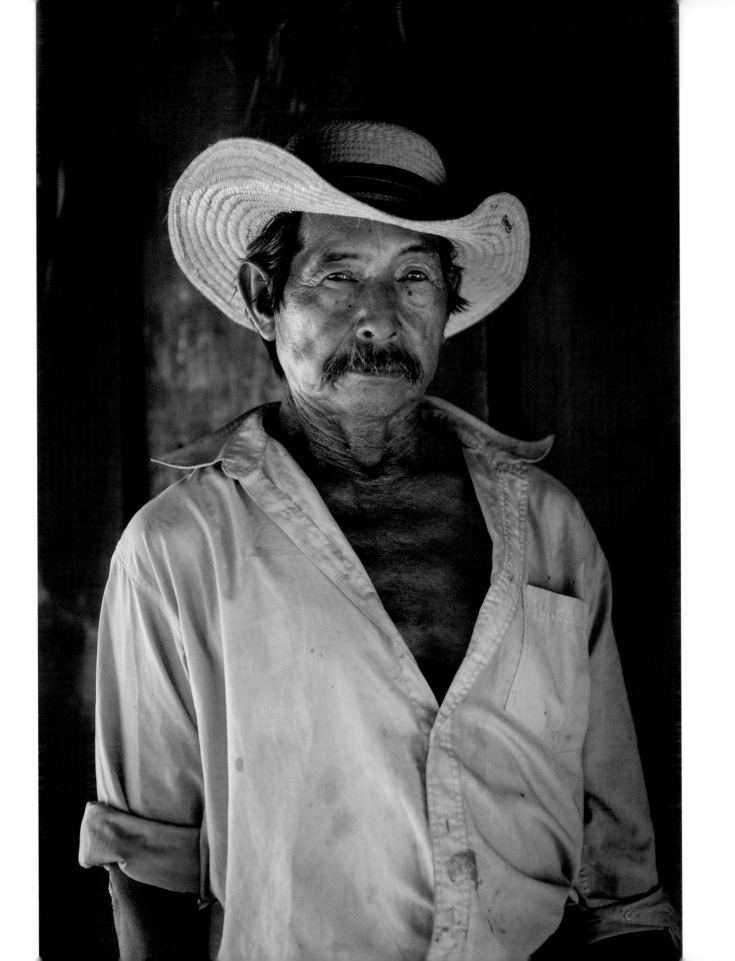

Fazenda Baía das Pedras, Brazil
Germano

São João, Brazil

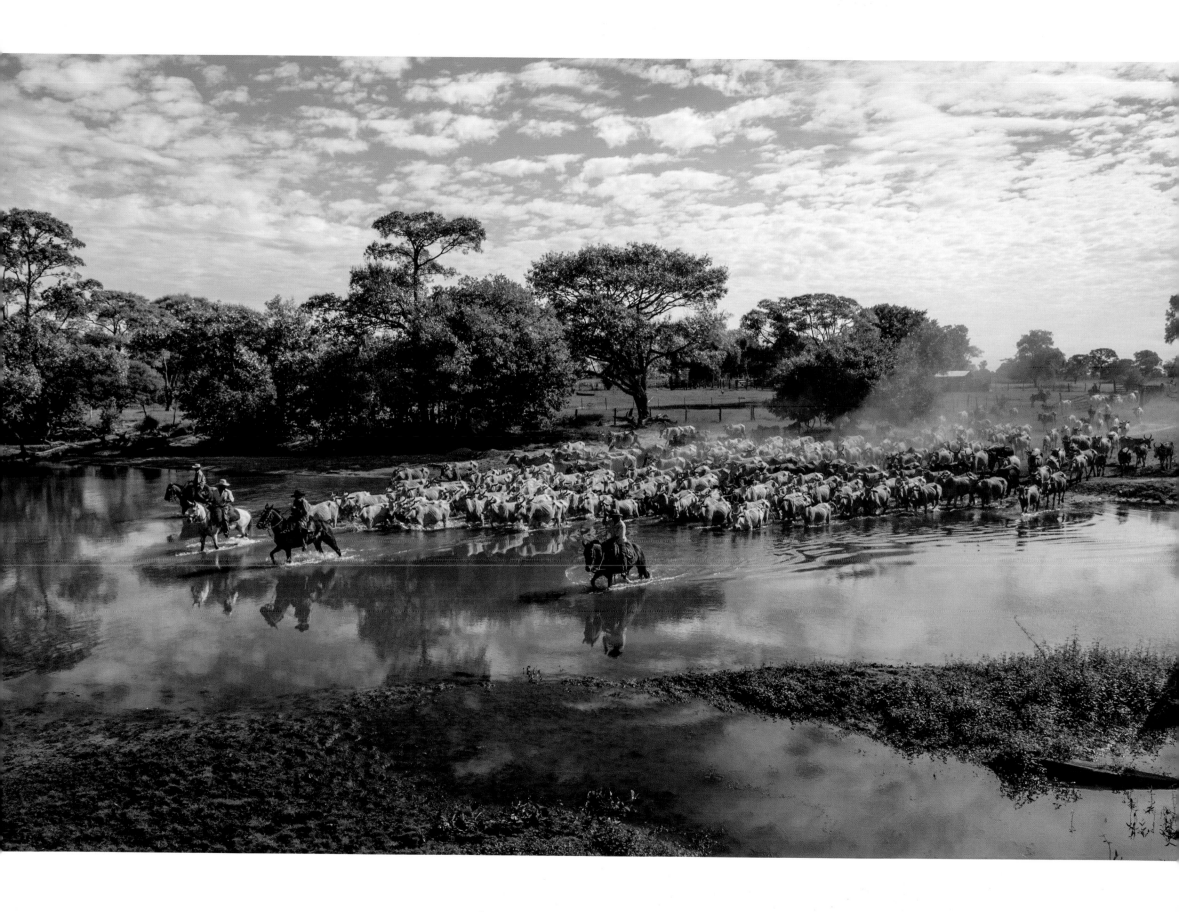

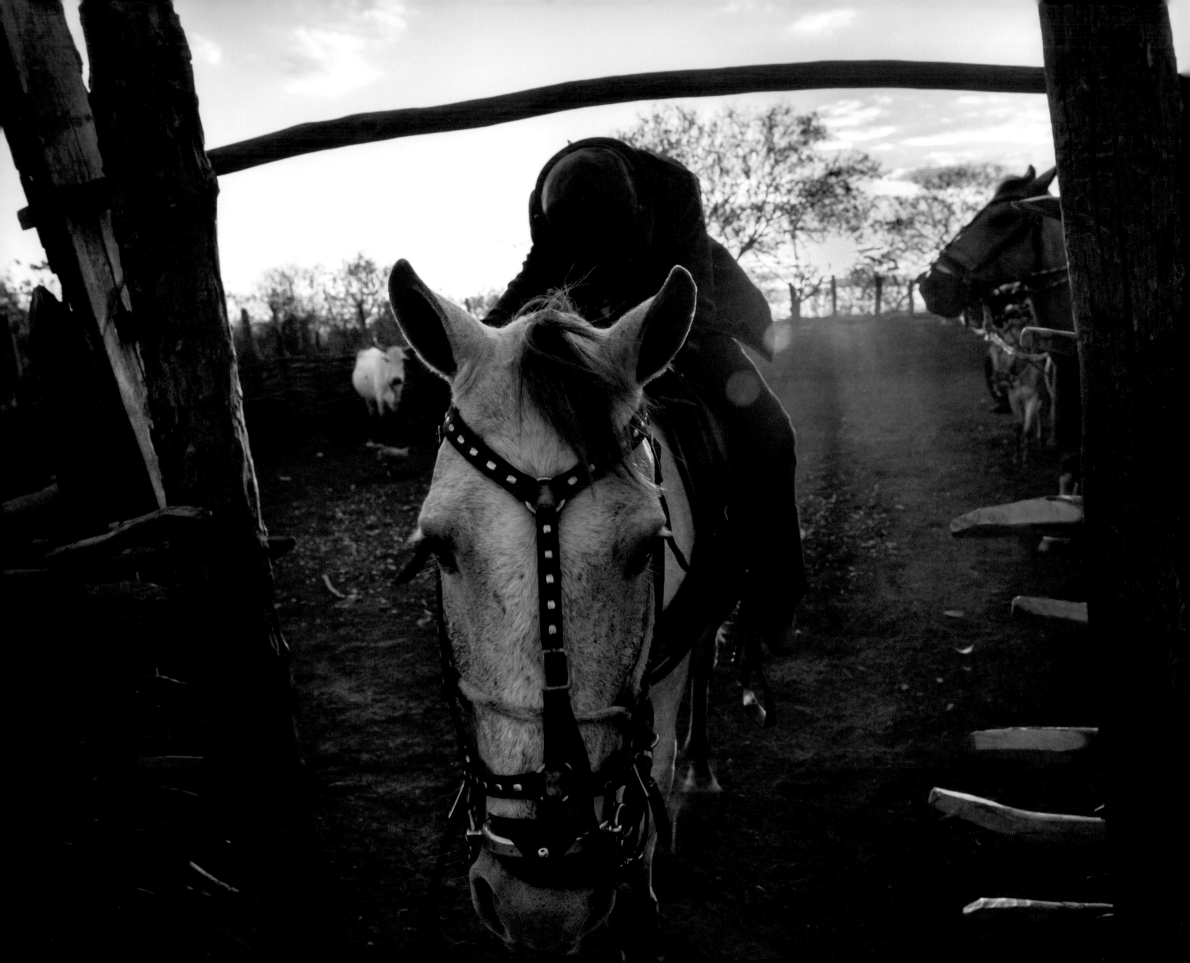

VAQUEIROS

Brazil

IF THERE IS a place in South America forgotten by God, it is surely the backlands of north-eastern Brazil, the Sertão, a vast expanse of dry, open scrubland where the relentless equatorial sun turns granite into sand, heating stones to temperatures that defy human touch. If rain falls—and it does, though rarely more than ten inches a year—it falls over a four-month span that shifts capriciously across the region. Eight months of the year there is no precipitation at all, and when the rains fail completely, as occurred in 1877, famine stalks the land, killing, as it did in that terrible year, fully half of the region's inhabitants.

The natural vegetation, known as *caatinga*, the white forest, consists of low thorny brush, cacti and agave, frail acacias, and scandent shrubs with thick leaves the texture of sandpaper, all adapted to the extreme climate and dearth of water.

Three centuries of cattle ranching has degraded what was already a sparse ecology, leaving a ravaged landscape of barren rock and sand, scabrous half-hearted trees, and dense thickets of thorn scrub. Dried cow dung covers much of the ground, and when the wind blows it stirs up an unhealthy mix of sand, dust, and bovine excrement.

Cow dung is a major source of fuel for the vaqueiros. Theirs is a Spartan existence, as tough and raw as the seasoned leather that in the absence of wood and steel, linen and wool, provides the foundation of their material existence. Their diet is meat and milk in

the rainy season, wild fruits, maize, beans, and meat the rest of the year. Fences are built of stone and wood. Furniture and doors, ropes, knife sheaths, sleeping platforms, slings and saddlebags, horse hobbles and lunch baskets are all made of leather. So too is the vaqueiro's traditional garb, which consists of leggings and a breastplate, as well as a doublet, or jacket, a hat of folded leather brimmed in the middle along the length of the skull, a pectoral apron, thick gloves, and boots of crude leather.

In the searing sun the traditional garb is brutally hot, and by the end of day even raw leather is moist and soft with sweat. But the leather garments provide protection from the sun and the brush, allowing the vaqueiros to thunder with abandon through the thickest of scrub, even as sharp branches and green thorns rip at their flesh.

A breastplate of leather protects the horse's chest, and leather blinders shelter the animal from fear. These coverings are elegant in design, exquisite in their beauty, and eminently practical in their purpose. The vaqueiro's leggings extend from the foot to the groin and are fastened at the waist so that the body is free to ride. Hat and chestplate are adorned with stitching and closed with leather laces. Gloves cover the back of the vaqueiro's hands, freeing his fingers to control the reins or grasp a weapon.

All is not harsh and austere in the life of the vaqueiro. In the rainy season the *caatinga* blooms, pastures become thick with grass, water can be found, and cows laden with milk yield to the intentions of good men. But when the rains cease cattle can lose more water in a day to the relentless sun than they can take in at the scattered watering holes. Animals drop in weight by three pounds a day. Thin and exhausted, they are driven to the modest respite of higher ground in the low-lying hills or herded into stone paddocks to be fed a diet of coral tree branches and mimosa, cactus and native succulents—*xique, mandacarú, acheiro,* and *macambira*—cut up and burned to eliminate the spines.

The vaqueiros are tough and proud, and they expect as much from their horses, which they treat with a harsh discipline that borders on brutality. Because of the thick underbrush, they alone among all cowboys rarely use lariats; they capture steers and bulls by running them down through the thickets and seizing the animals by the tail. All of this for earnings of a dollar a day, hours on horseback in the yellow dust of the *caatinga*, drinking brackish water foul to the taste, and, for food, a simple stew, sometimes eaten by hand from a common pot.

And yet there is among the vaqueiros a bond that comes from a fraternity of stoic men who live simple and authentic lives. Humble and poor, they are immensely gracious and welcoming to strangers. Their words are few, but they are men of their word. "My name is Francisco de Assis," explains an old vaqueiro, his own skin the texture of burnt leather, "and I am a son of this land. I like good horses, a soft saddle, and a caring woman to love me every day."

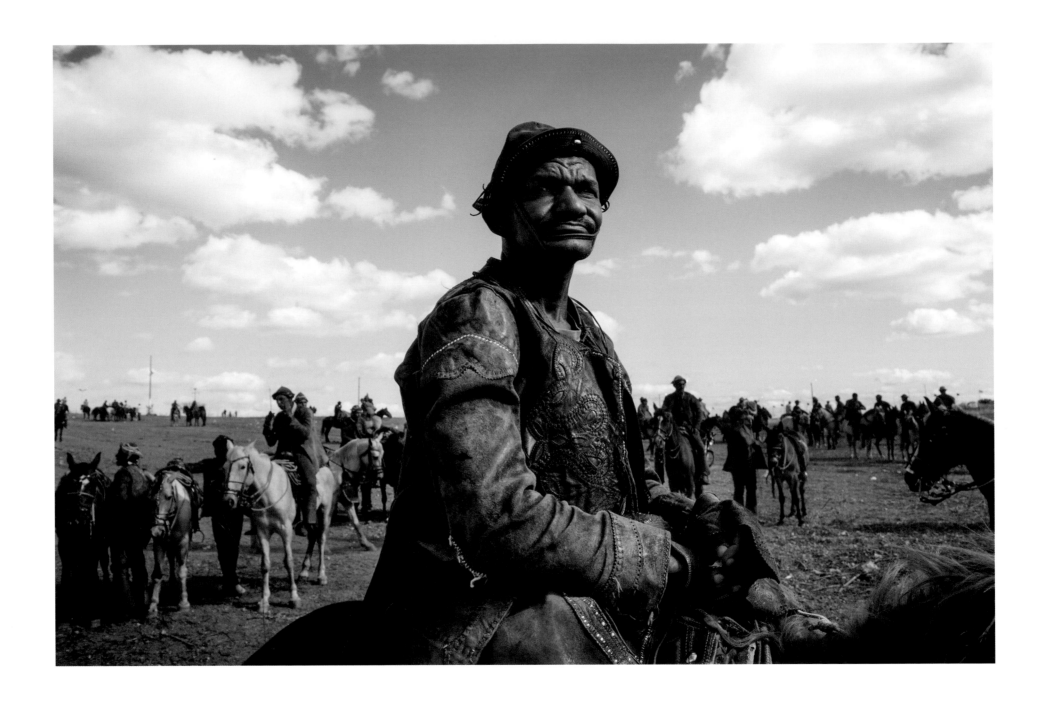

Pintadinha, Brazil

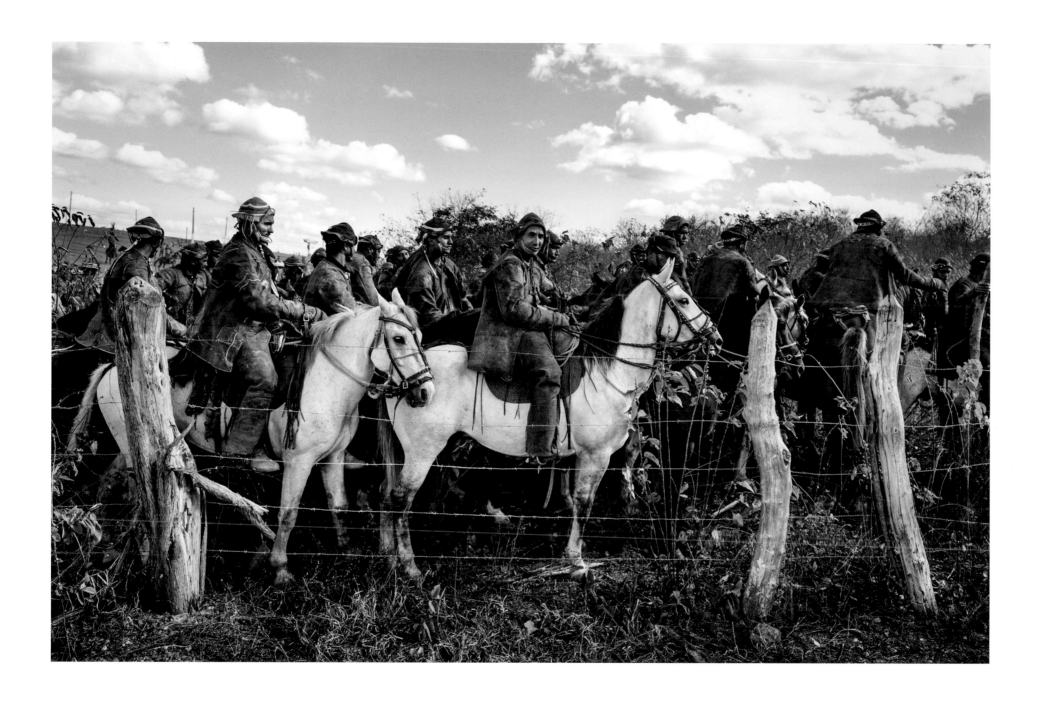

Pintadinha, Brazil

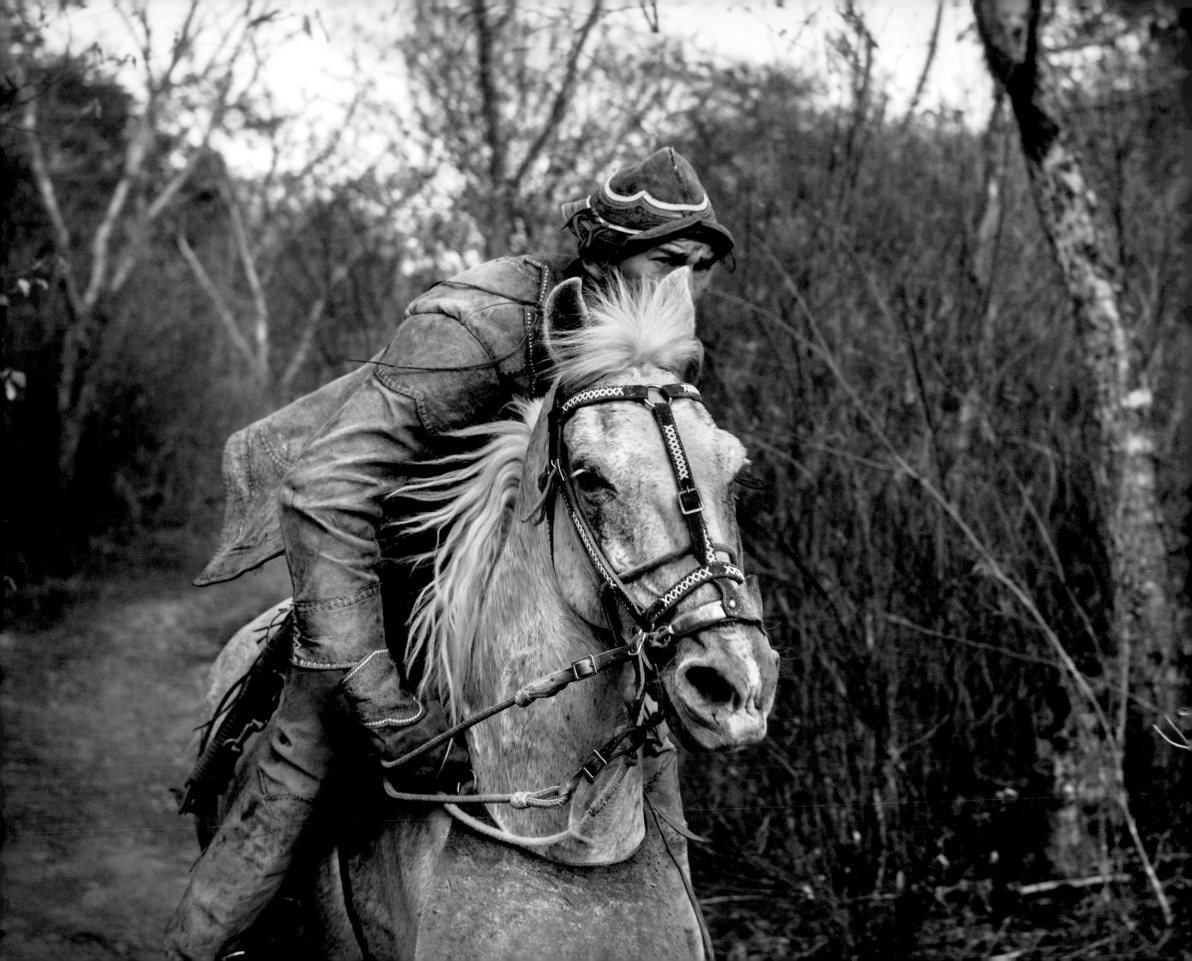

Serrita, Brazil

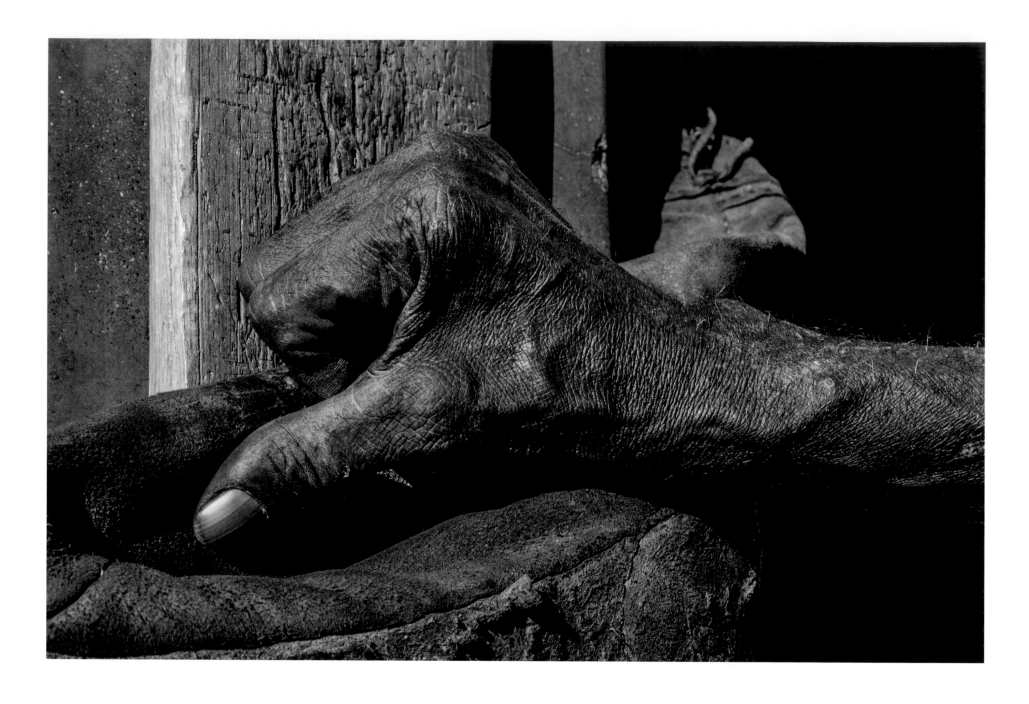

ABOVE
Serrita, Brazil

FACING
Ingá, Brazil
Pedro Arthur

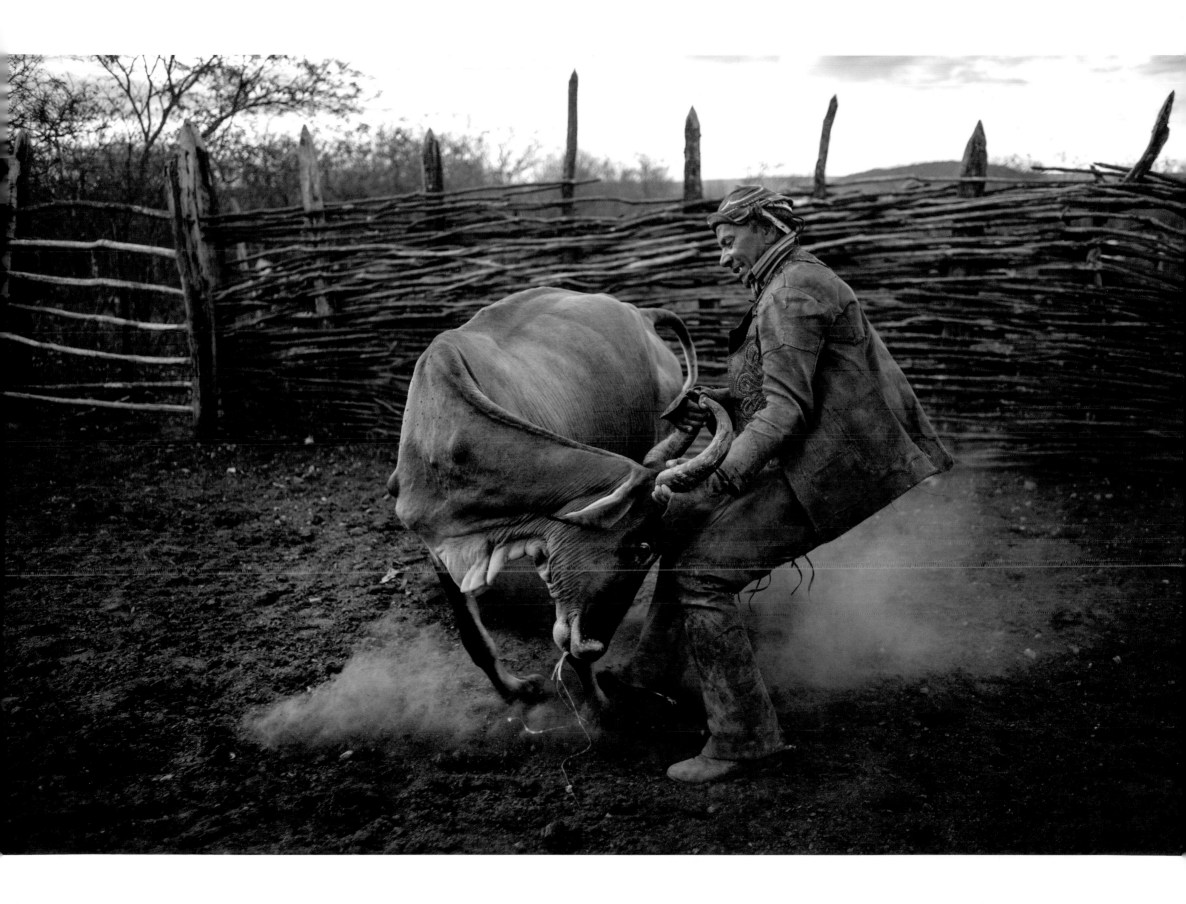

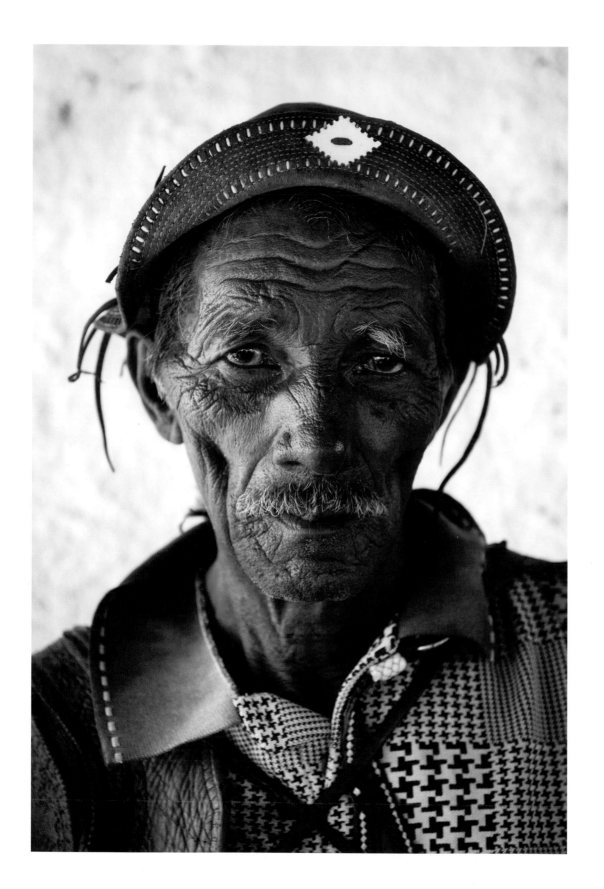

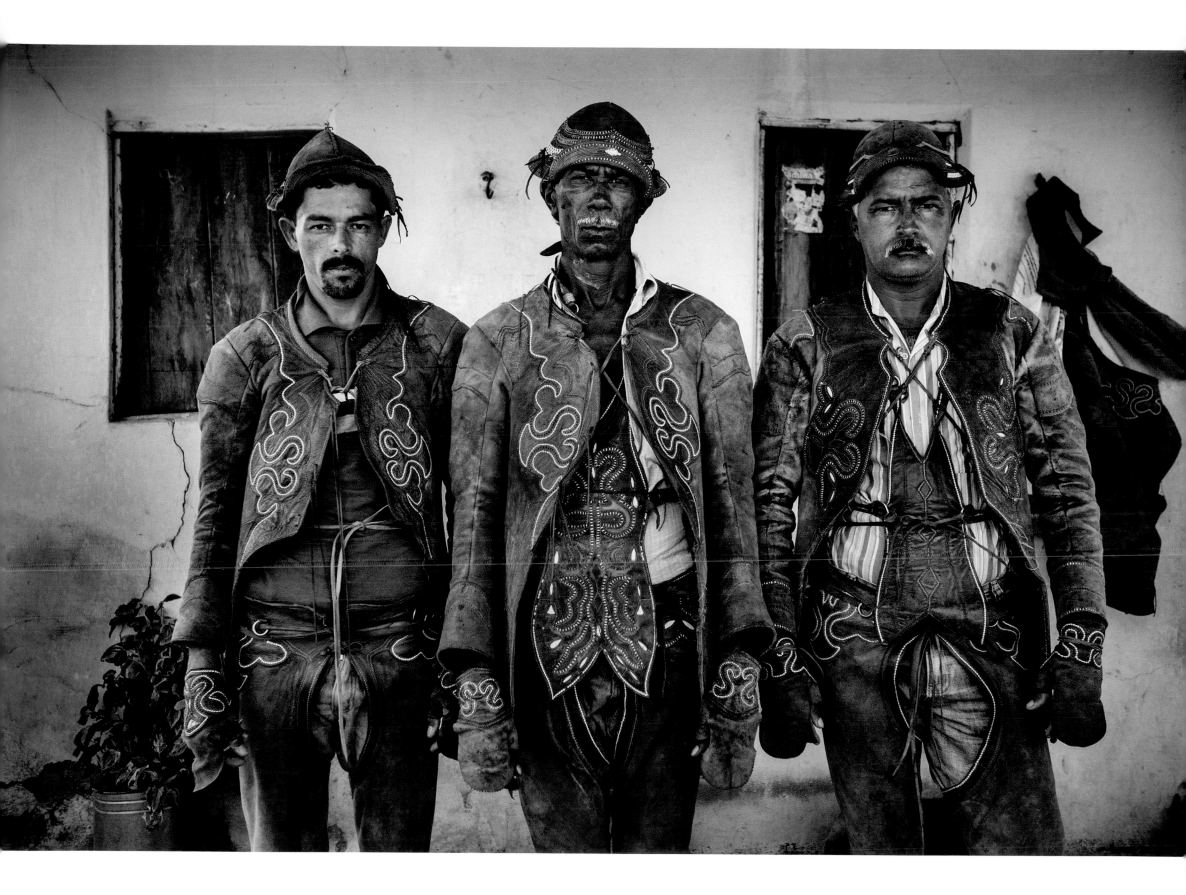

Serrita, Brazil
Zé do Mestre

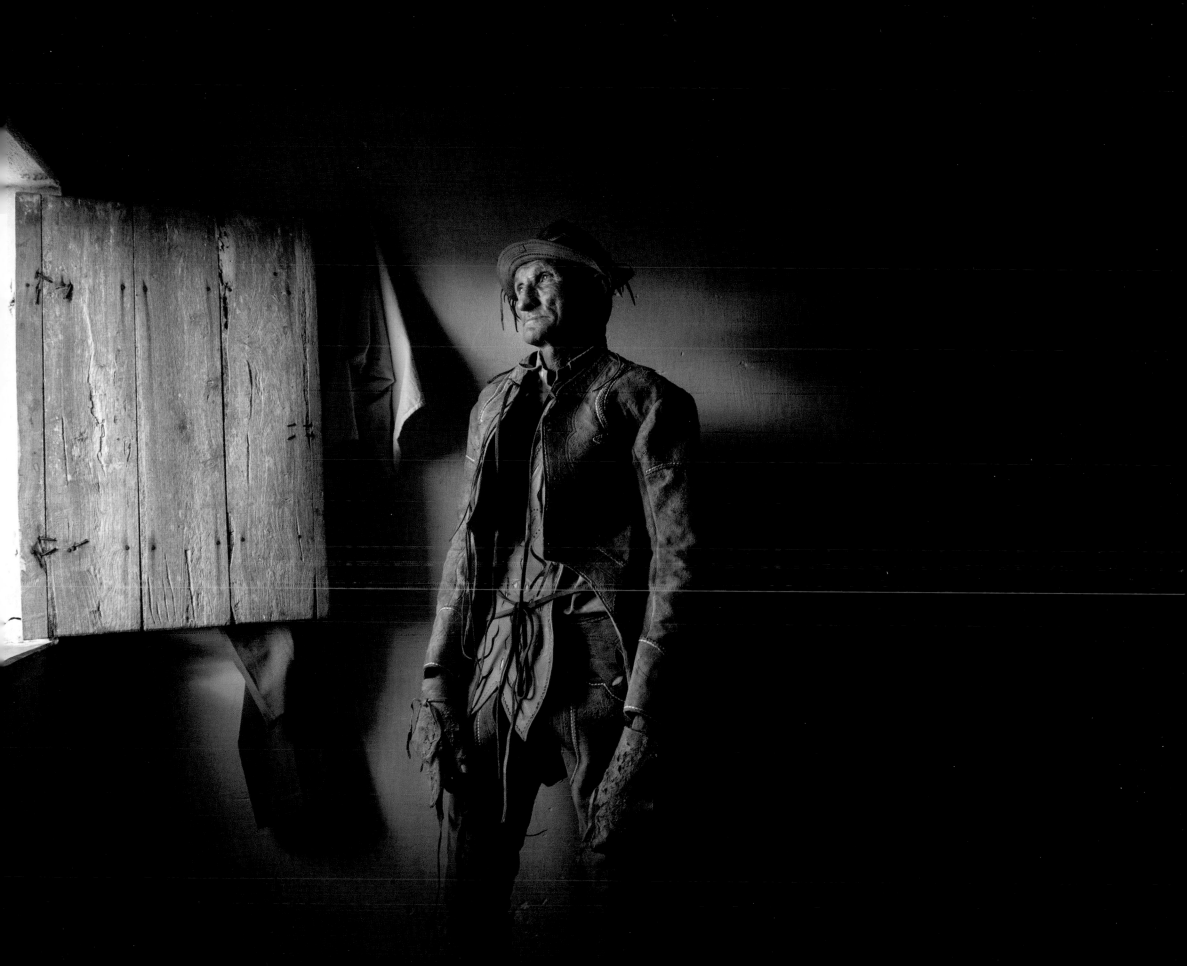

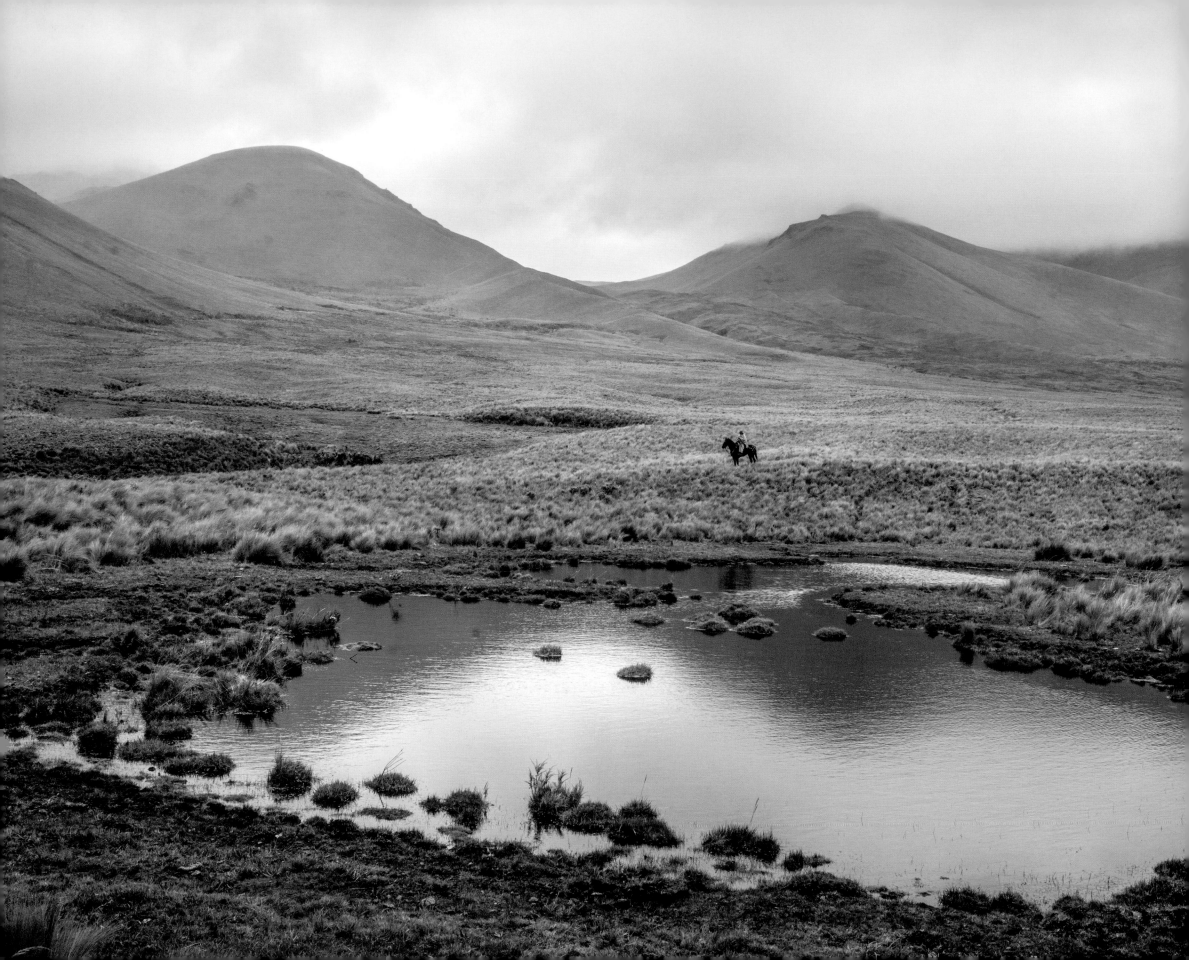

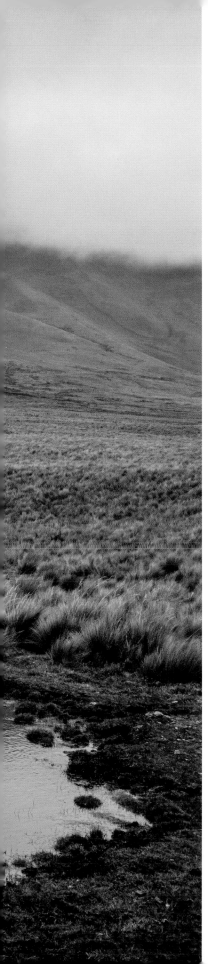

CHAGRAS

Ecuador

AT ELEVEN THOUSAND feet the equatorial air is clear, the sky a refined blue, thin and transparent. Homesteads are scattered at great distances, simple mud houses, nestled low to the ground, their thatch roofs blackened by smoke. There is a great silence, a stillness broken only by herds of wild horses and cattle and the winds that fall away from the glaciers at the summits of Ecuador's immense volcanoes: Cayambe, Cotopaxi, Chimborazo. There is no place on earth where the sun comes closer to the surface of the planet.

Climb higher, and even these few signs of human presence fade and the land opens onto the *páramo*, a vast, treeless expanse of vegetation, an exotic and mysterious ecological formation unique to the northern Andes. Farther south, in Peru and Bolivia, the land lying above eleven thousand feet is arid and barren, windswept and cold, a highland desert, or *puna*, useful only for the grazing of alpacas and vicuña. Near the equator the same elevation is equally forbidding, but it is constantly wet. The result is an otherworldly landscape that seems on first impression eerily like an English moor grafted onto the spine of the Andes. In the mist and blowing rain, there are only the espeletias, tall and whimsical relatives of the sunflower, spreading in waves to remind you that you are in South America. With bright yellow flowers that burst from a rosette crown of long, furry leaves, espeletias look as if they belong in a children's book. In Spanish the plant is known

as *frailejón*, the friar, because seen from a distance it can be mistaken for the silhouette of a man, a wandering monk lost in the swirling clouds and fog.

The *páramo* is the terrain of the chagras, mountain farmers who abandon their fields for a few weeks several times a year to ride as cowboys high into the mist in search of cattle and feral bulls. Their horses, known as Parameros, are all descendants of the Berber mounts of North Africa, small but extremely tough animals capable of negotiating the mire of the *páramo*. When attacked by a wild bull, they instinctively gallop up the steepest slope, leaving the beast far below.

The roundup is unlike any other. It begins at dawn as the chagras form a *medialuna*, or half moon, a crescent of a dozen of more riders that arches across the vast expanse of the páramo. The foreman of the crew lifts a horn of *trago*, raw liquor, and toasts the men. The horn passes from one to another as each takes a draught, deliberately dribbling a few drops on the earth as gifts to the goddess Pachamama. Then, at the foreman's command, the alignment of men and horses spreads out like a scythe, encircling the heights and slowly raking the mountainsides, driving before them cattle by the score, pushing them ever lower into the narrow draws that run away from the heights and lead to massive holding pens, corrals built of eucalyptus and *queñoa de altura*, the highest-growing tree in the Andes.

Like all cowboys, chagras have a strong sense of identity, never spoken about but never forgotten. They are independent, hardworking, and fearless. If they sleep—which they rarely do, preferring to spend their nights singing and drinking—they lie in the open, still wearing their chaps and thick woolen ponchos, covered only by the crude rubber capes that by day protect them from the wind and rain. Their prized possession is not a gun but a lariat known as *la veta*, a lasso strong enough to restrain a wild bull. It is made from a single hide, cut concentrically an inch wide from the center outwards.

On the *páramo* the mist invariably rolls over the summits' ridges at noon, condensing into a dense fog that by late afternoon softens every sound and obscures every landmark. Even the chagras can become lost and find themselves following animal paths that go everywhere and nowhere, disappearing into caves and rocky outcrops, stunted groves and dense thickets of gleichenia ferns and ephedra. At such moments the chagras wait, wet and stoic, calling out to each other, sometimes sending men to light small fires in the north, south, east, and west. Perhaps someone will slip away to hunt rabbits. A rubber poncho goes up as shelter. The men huddle closely, drinking, eating, singing, knowing that always there is another morning and a new sun to wash over the mountain.

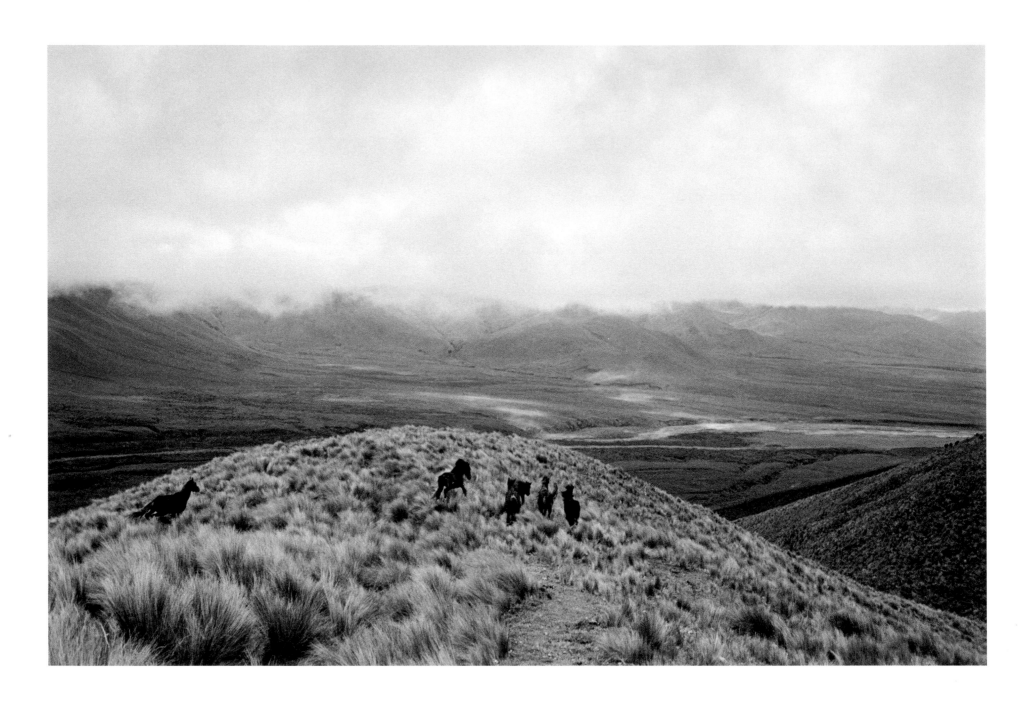

Hacienda El Tambo, Ecuador

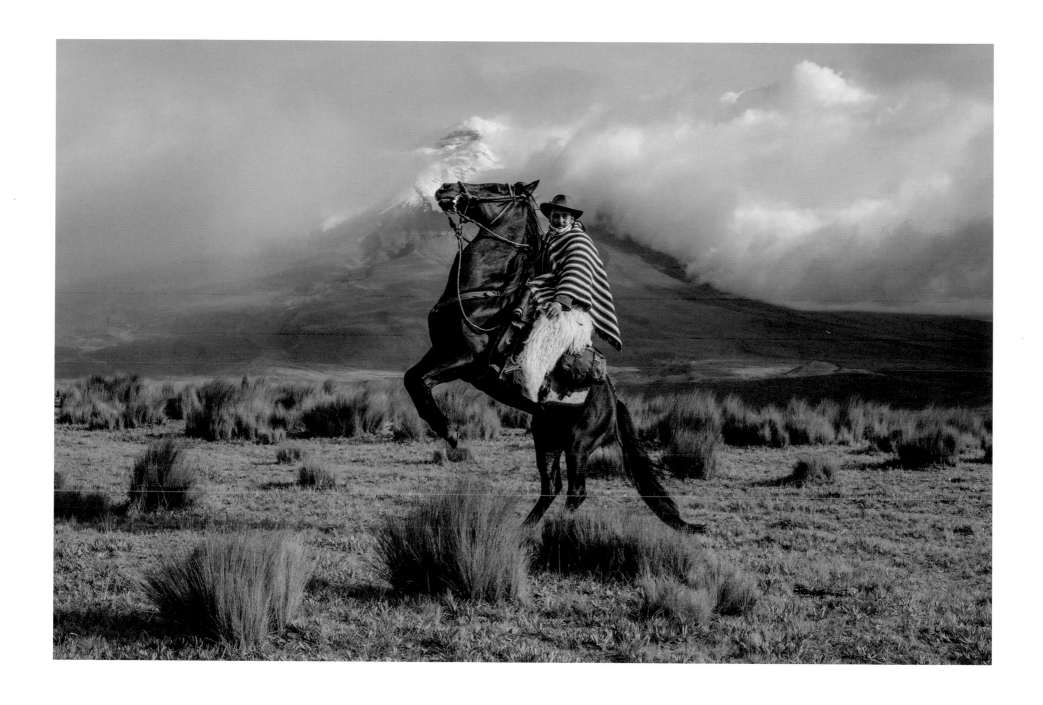

Cotopaxi, Ecuador

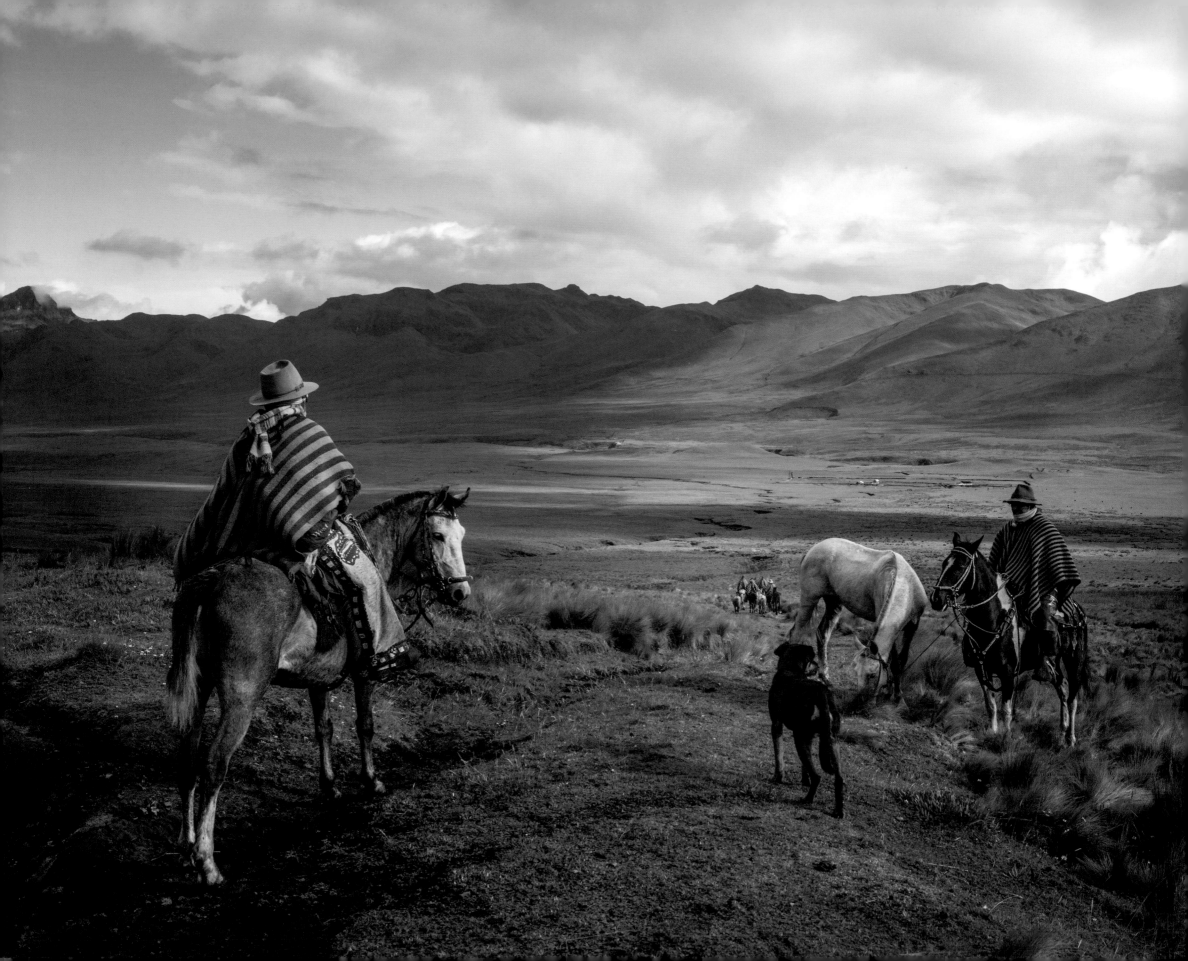

Hacienda Chalupas, Ecuador

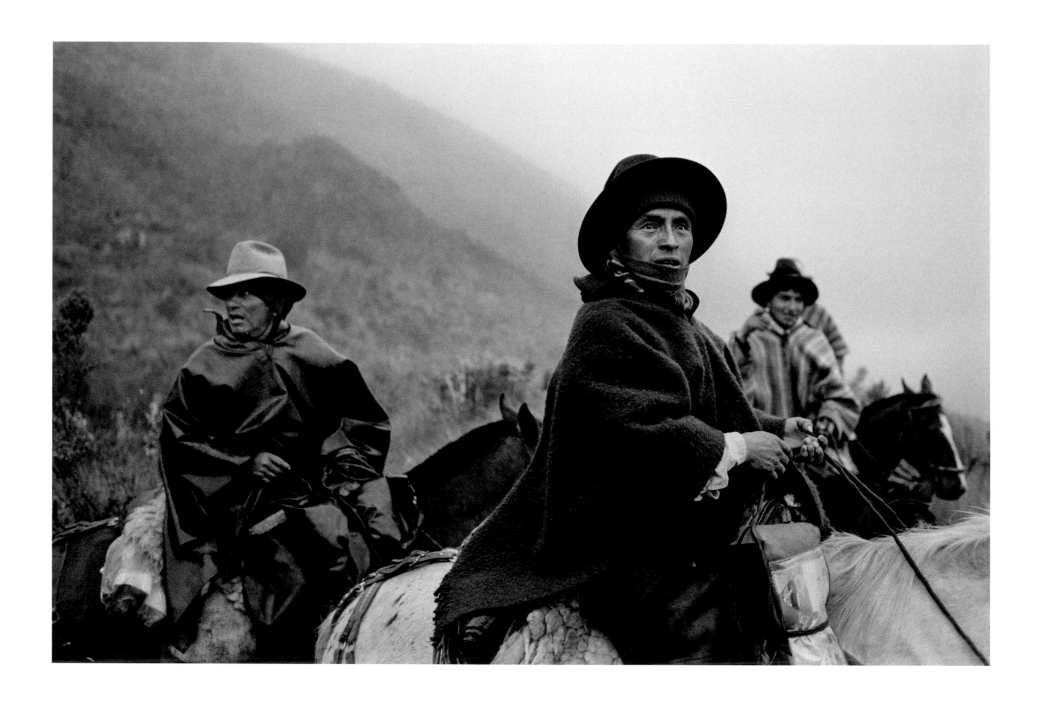

Hacienda Yanahurco, Ecuador

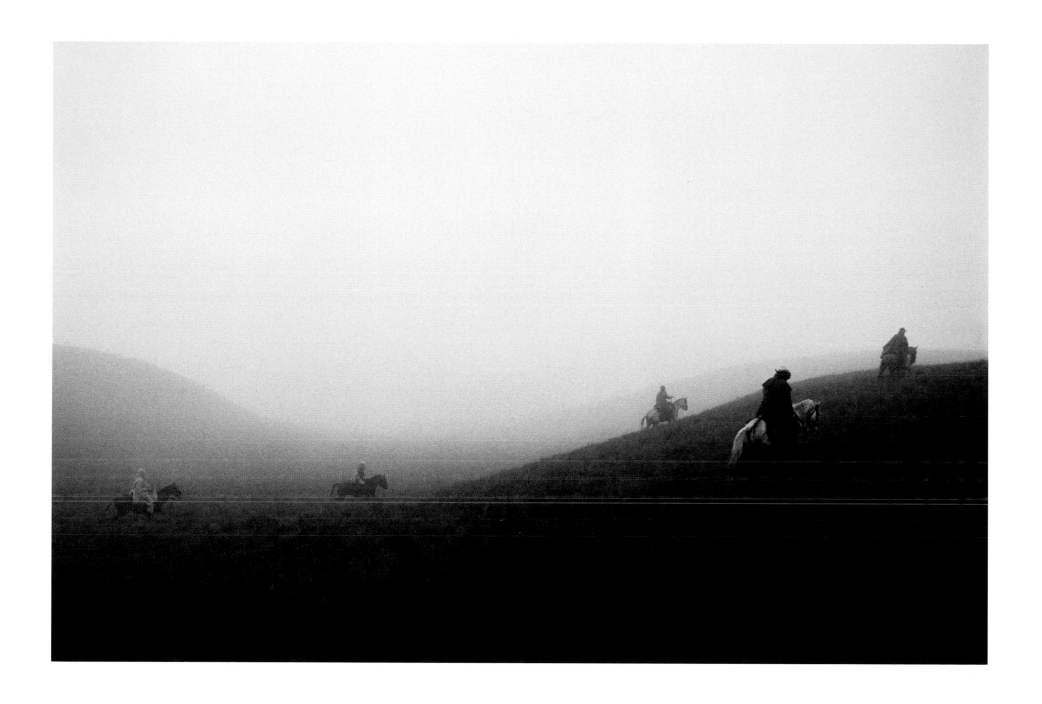

Hacienda Yanahurco, Ecuador

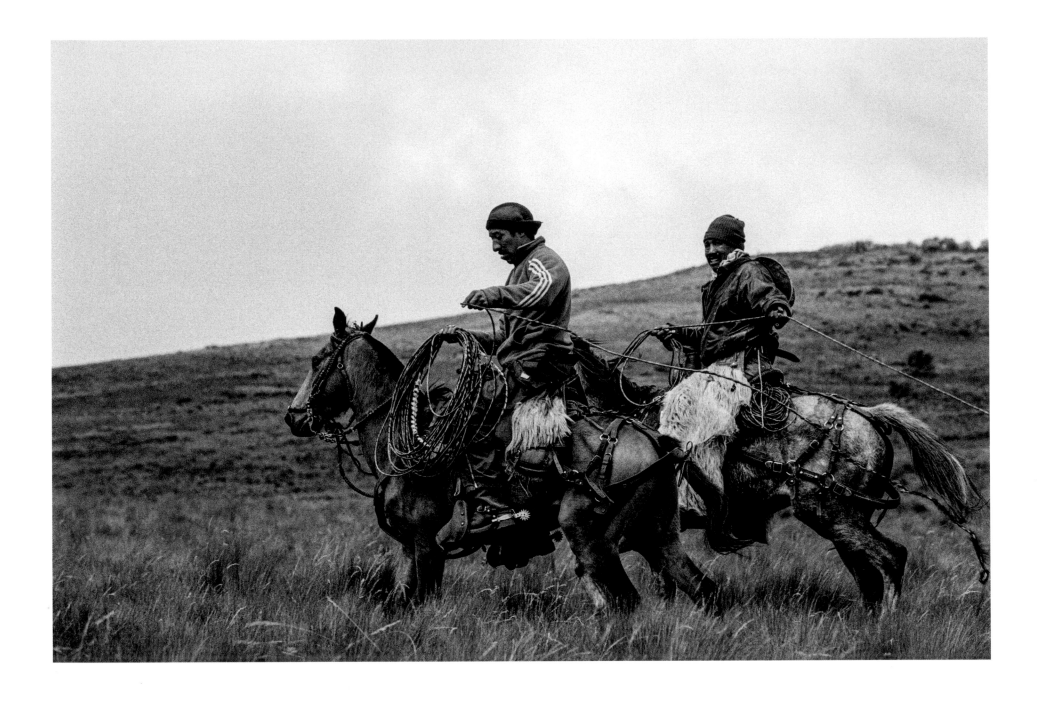

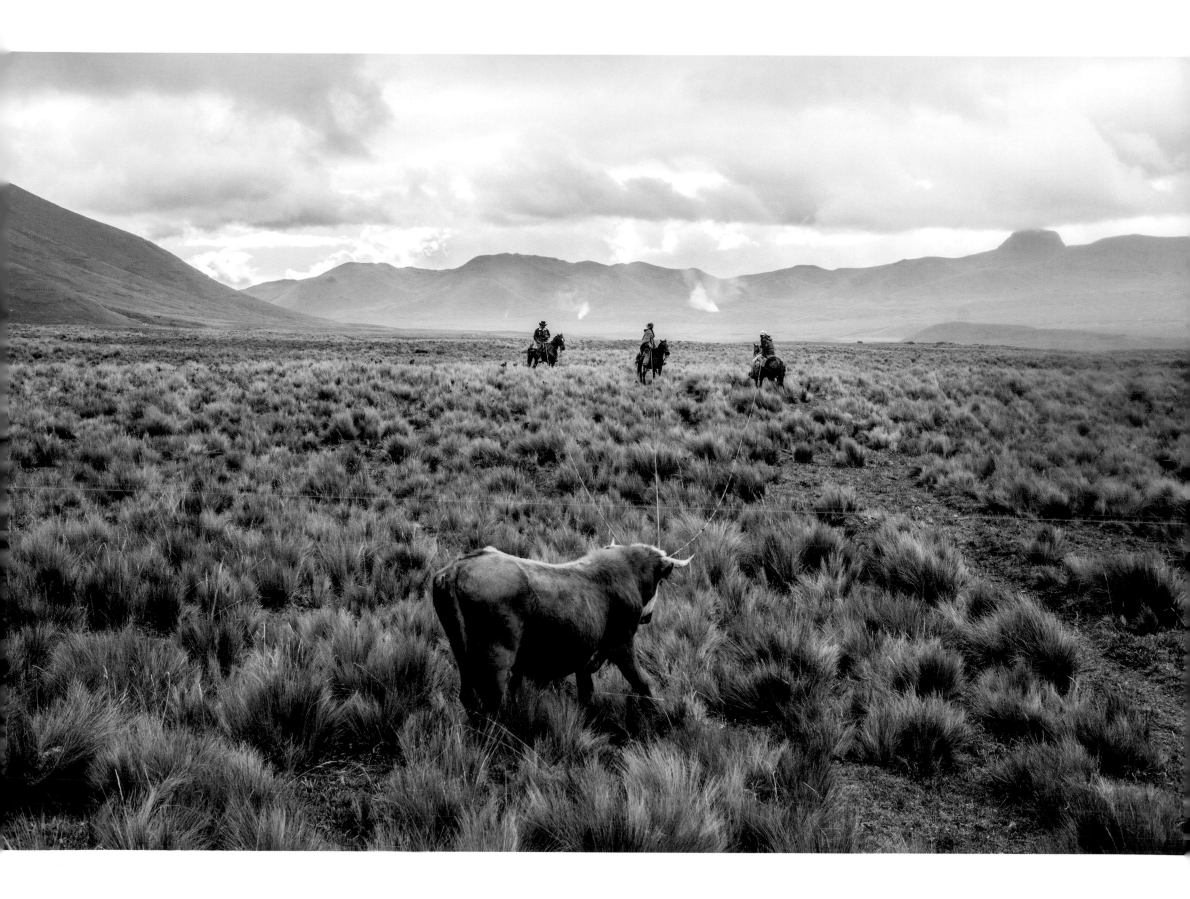

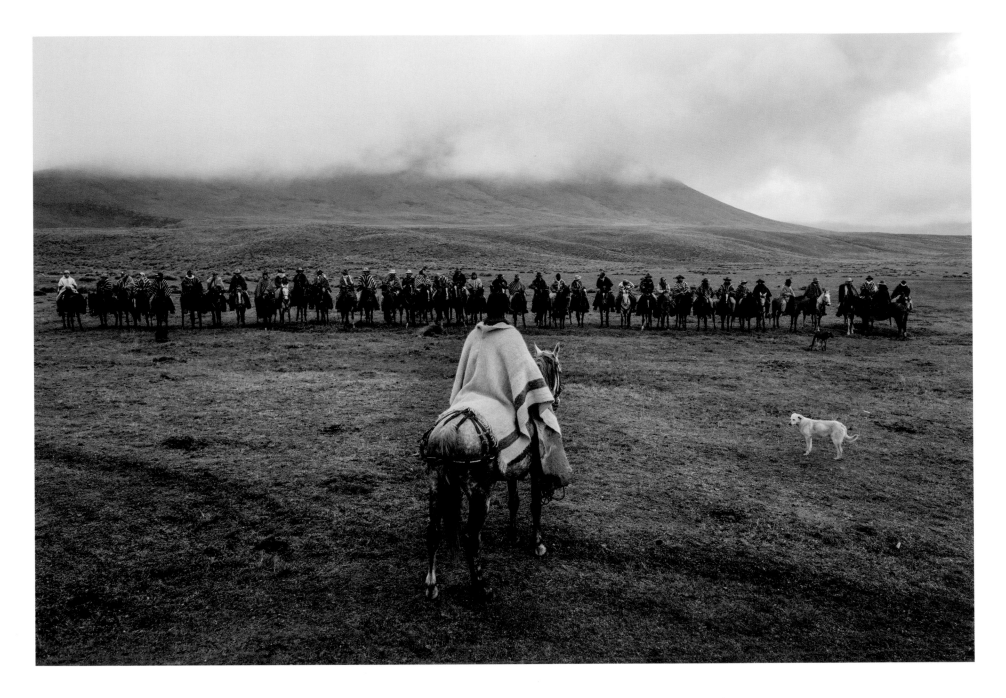

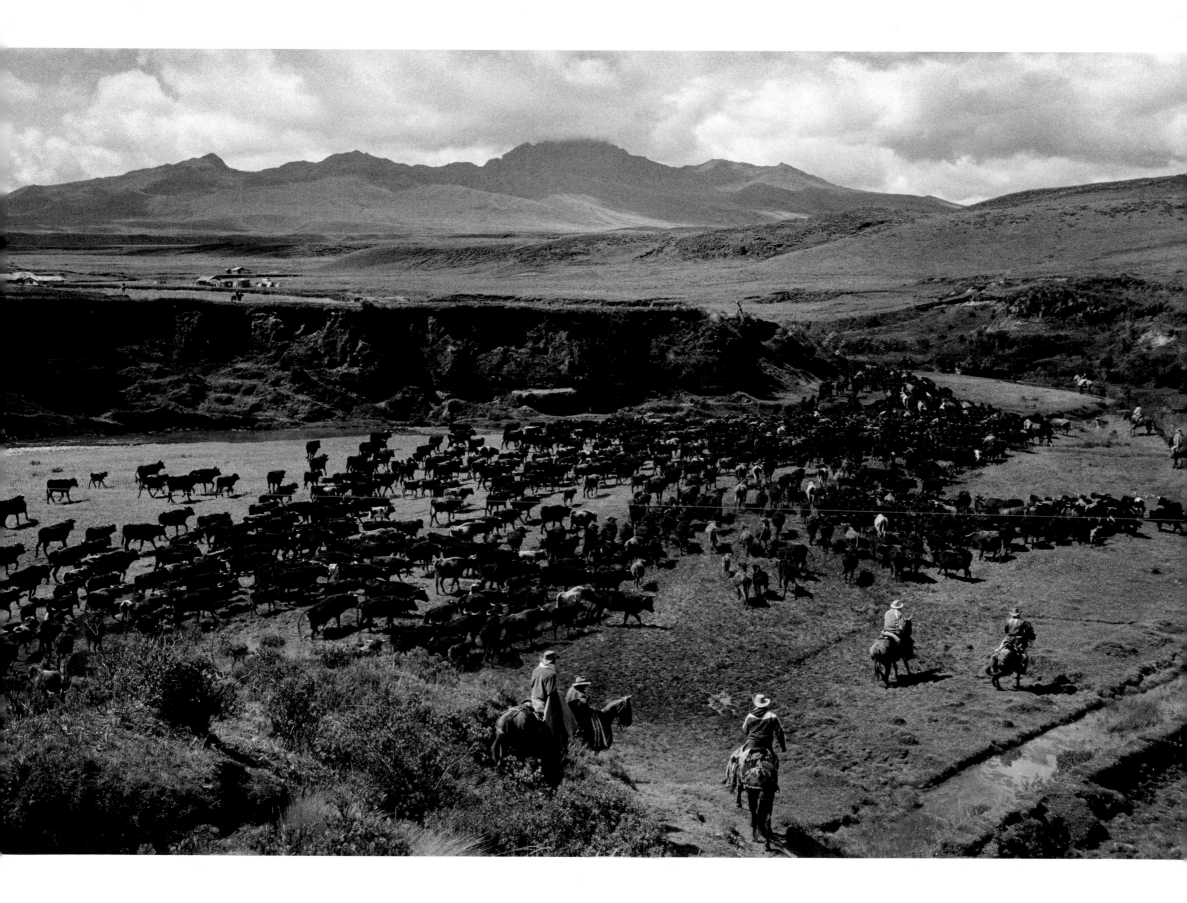

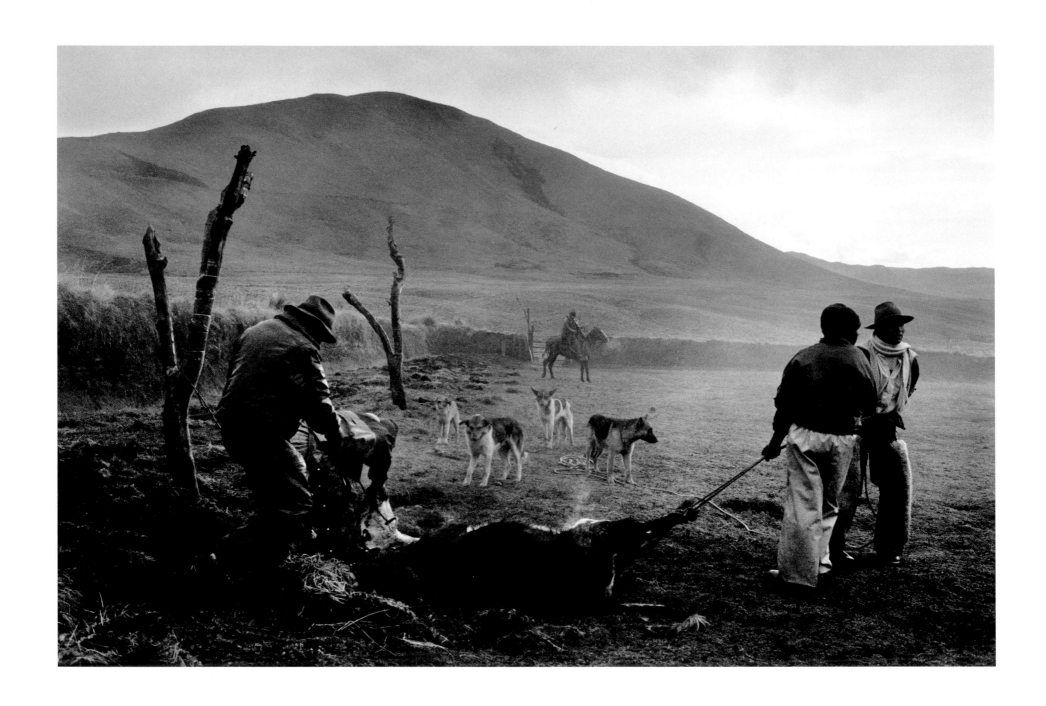

Hacienda Chalupas, Ecuador
Foreman Manuel Alvarez branding
bulls with his sons

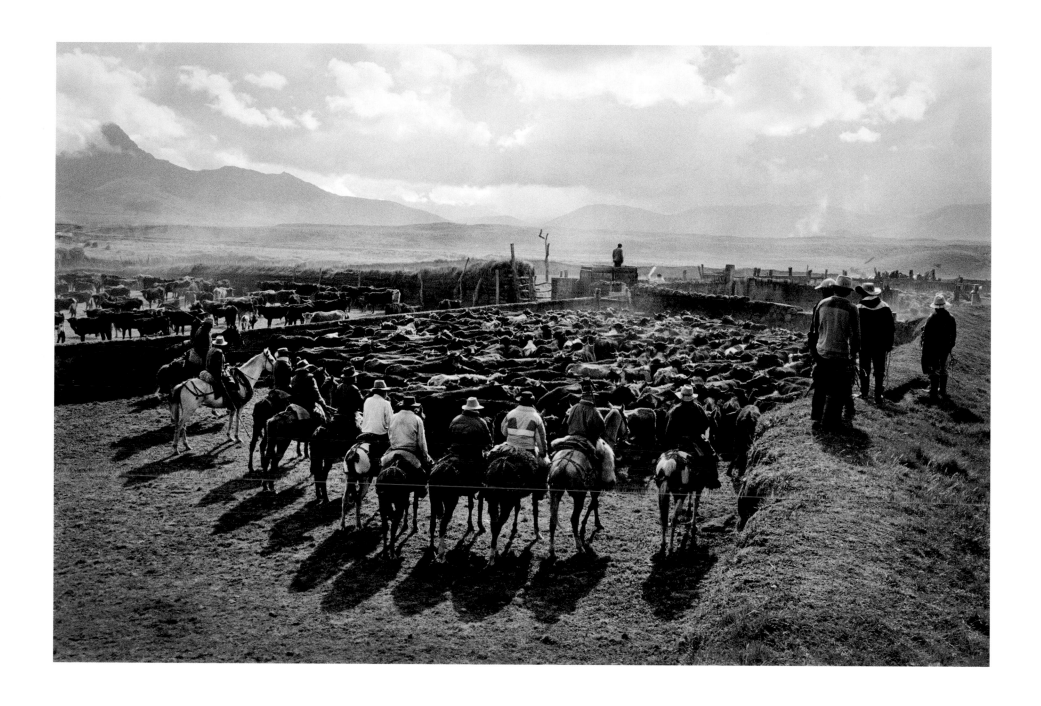

Hacienda Yanahurco, Ecuador

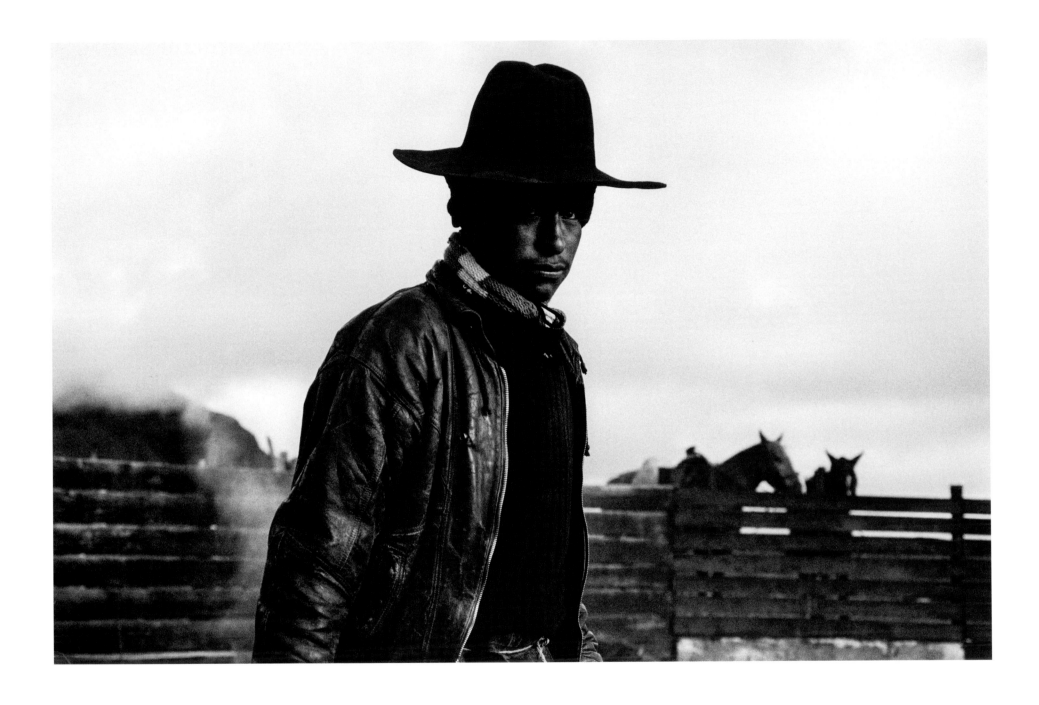

Hacienda Yanahurco, Ecuador

Avenida de los Volcanes, Ecuador

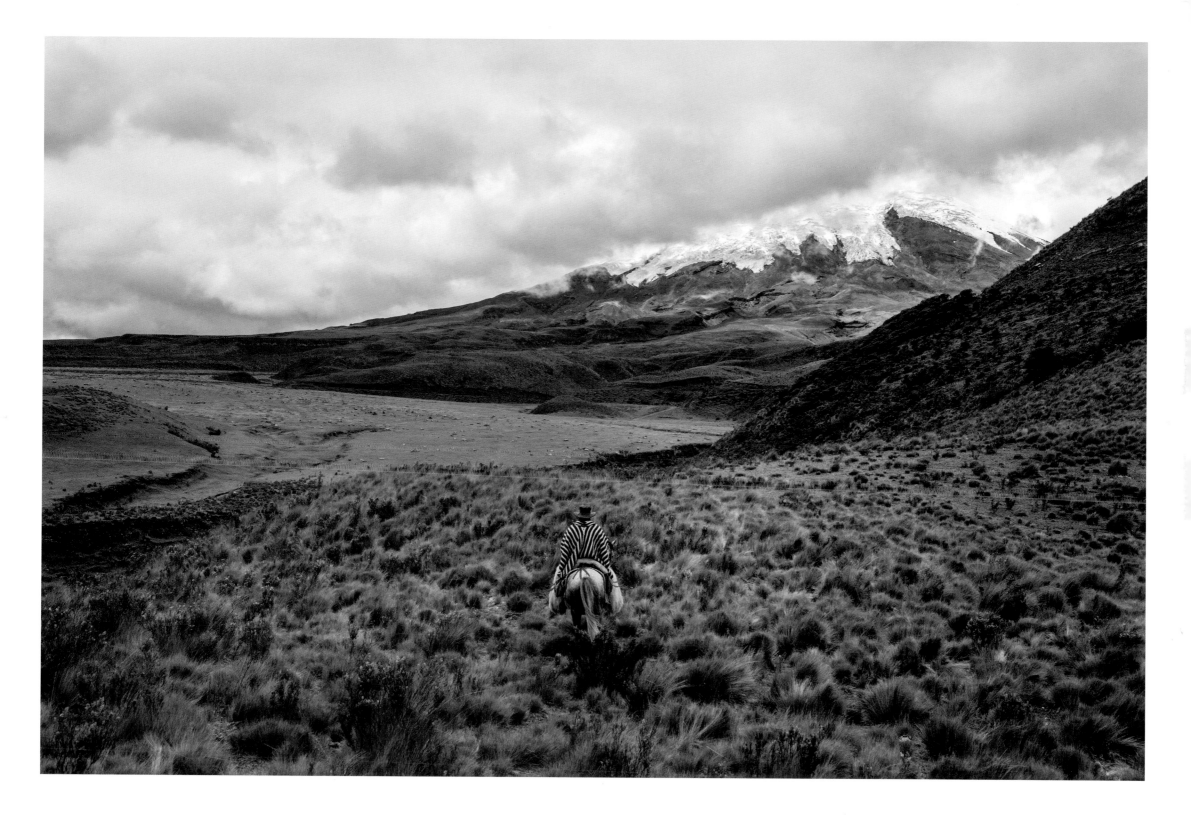

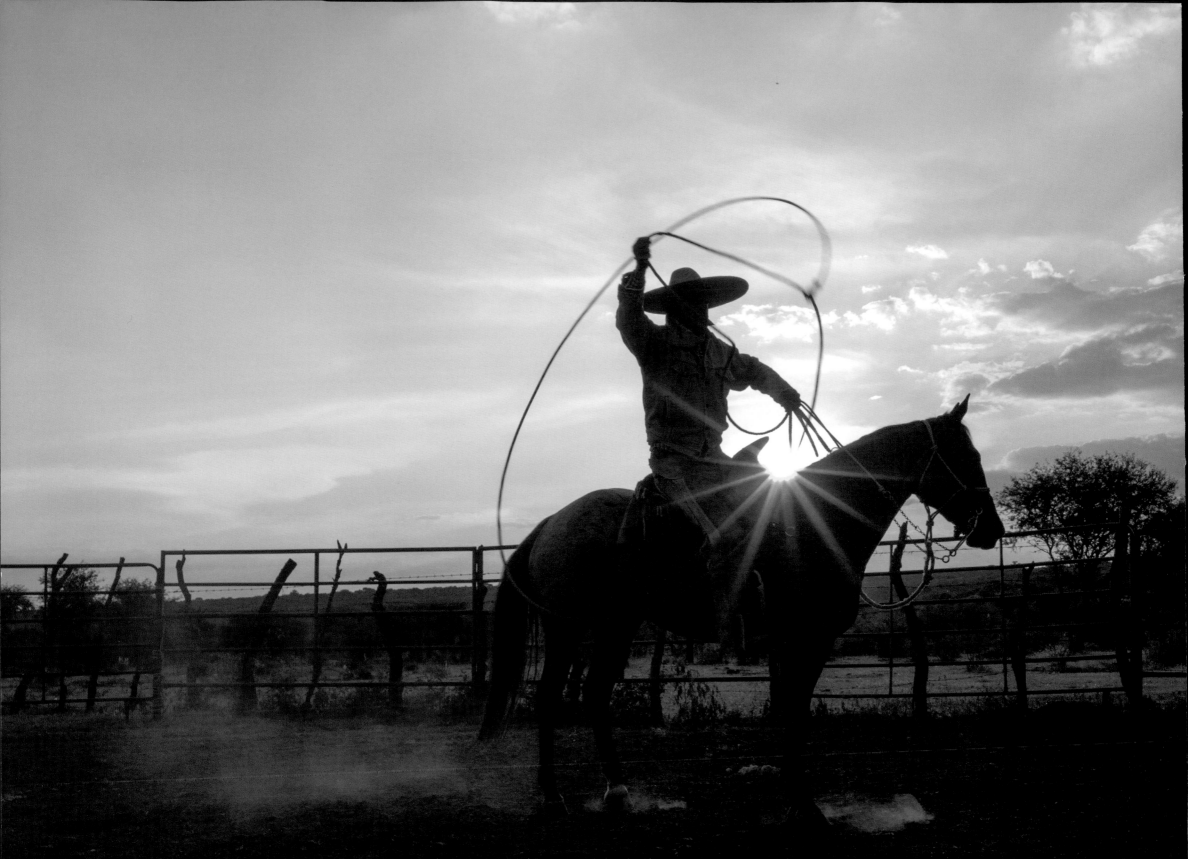

CHARROS

Mexico

THE MEXICAN CHARRO was born of fire, steel, and blood, the crucible of conquest that gave birth to the modern nation of Mexico. The charro's iconic costume—the elegant suit of wool and leather, dark blue, brown, or gray, the flamboyant white shirt, the silver buttons and thread, boots the color of the earth—was less a fashion statement than a bold expression of class and political power.

In the early days of the Viceroyalty of New Spain, ownership of horses, and indeed the freedom to ride, was a privilege of the elite, denied to both native people and lowly peasants. Yet men were needed to work cattle, and special dispensation was granted to those mestizos employed on the haciendas. These cowboys, or *cuerudos*, were adorned in a specific outfit identifying their status.

To distinguish themselves from the *cuerudos*, wealthy landowners adopted the finery of the charro, with rich ornamentation in silver embroidery and great broad hats of felt or palm fiber, sombreros tied in leather at the chin that offered anonymity in love and protection not only from the elements but also from the thrust of a dagger or a sword or the sweep of a rabid bull's horns.

Throughout the 19th century, the condition of the poor in Mexico worsened by the decade. A handful of wealthy families owned most of the arable land, with individual

PREVIOUS SPREAD
Lagos de Moreno, Mexico
Alejandro Pedrero

haciendas comprising as much as a million acres. Fully half of the rural population lived on these vast estates as indentured servants, caught in a trap of debt peonage. Beginning in the 1880s, a flood of investment from abroad displaced the *campesinos* from what little land they still controlled. By 1894, 20 percent of Mexico's land was owned by foreign companies, and great armies of peasant farmers worked for a pittance on plantations of cotton and sugar, sisal, coffee, and cacao.

It was more than anything the fury of the landless poor that fueled the Mexican Revolution of 1910, a storm of rage that left more than two million dead. In the spirit of Zapata, with the rolling violence of Pancho Villa, the legitimacy and power of the landlord class was destroyed. The economic foundation of the old order was eliminated for good during the great agrarian reforms that followed in the wake of the upheaval. The impact on the traditional haciendas was immediate and transformative. A way of life simply ended. The *hacendados* lost everything, even their horses. The traditional Mexican Criollo mounts—strong, noble, quick tempered—suffered such slaughter in the war that the entire stock of the country had to be replaced with American Quarter Horses.

By the 1930s, even as the *traje* of the charros became democratized as the national dress, a symbol of the nation celebrated in films and books, the actual cowboy tradition shifted to the towns and cities. *Charrería*, a uniquely Mexican kind of rodeo, emerged as a popular sport. Crowds filled urban arenas to witness the remarkable horsemanship of these iconic cowboys, born of a way of life long gone and celebrated at the *charrería* at least in part as an act of nostalgia.

Nevertheless, throughout Mexico, families once endowed with lands the size of small nations still cling to memories, though selective memories to be sure. "To be a charro is to

be Mexican," declares Don Manuel Vega Díaz Infante, who lives on the remnants of the hacienda where he was born, land first settled by his great-great-grandfather in Ojuelos, central Mexico. "The agrarian reform took the best, most productive part of the lands belonging to my family, leaving the least fertile for us to live off."

In a proud gesture of defiance, Don Manuel long ago swore never to abandon his family's land. Today, he lives for the past and dresses every day in charro finery, with a pistol strapped to his belt. On what remains of the vast estate of his ancestors, he raises fighting bulls, and by reputation they are as mean, irritable, and brave as any the country has ever produced.

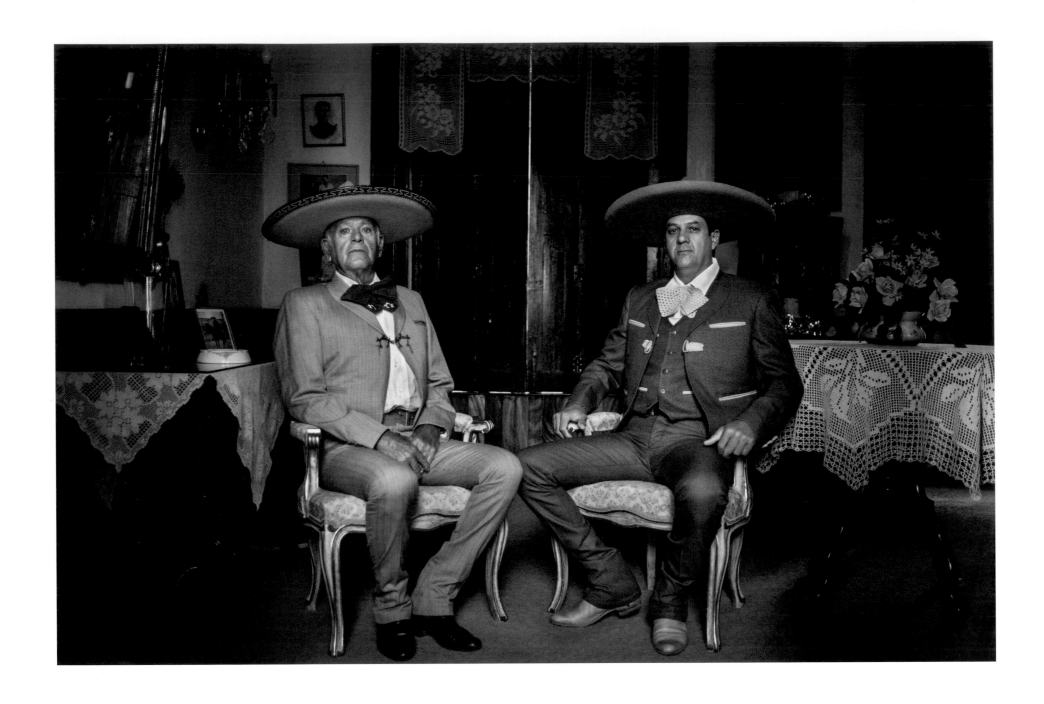

Lagos de Moreno, Mexico

The Pedreros, father and son

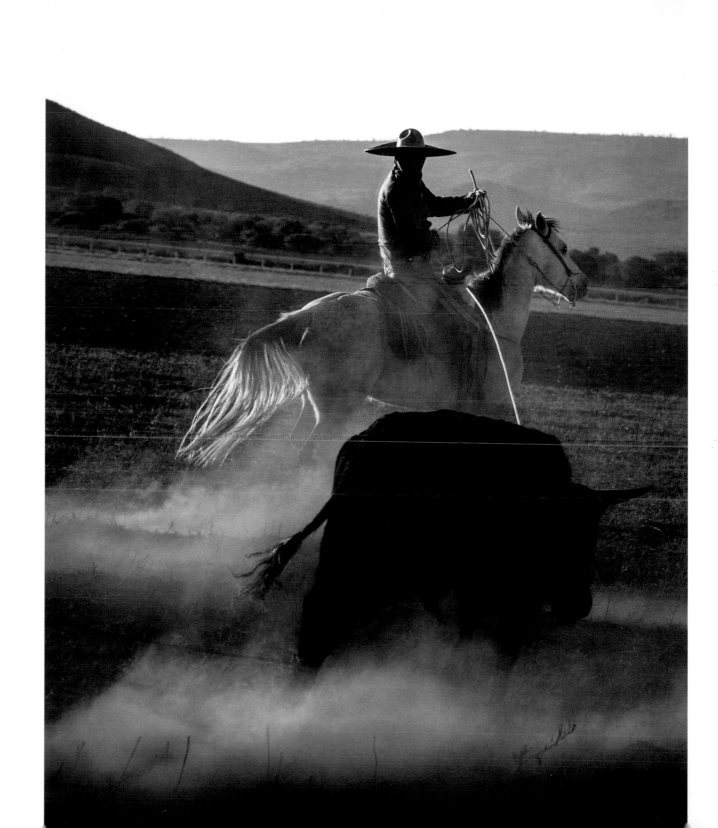

Lagos de Moreno, Mexico

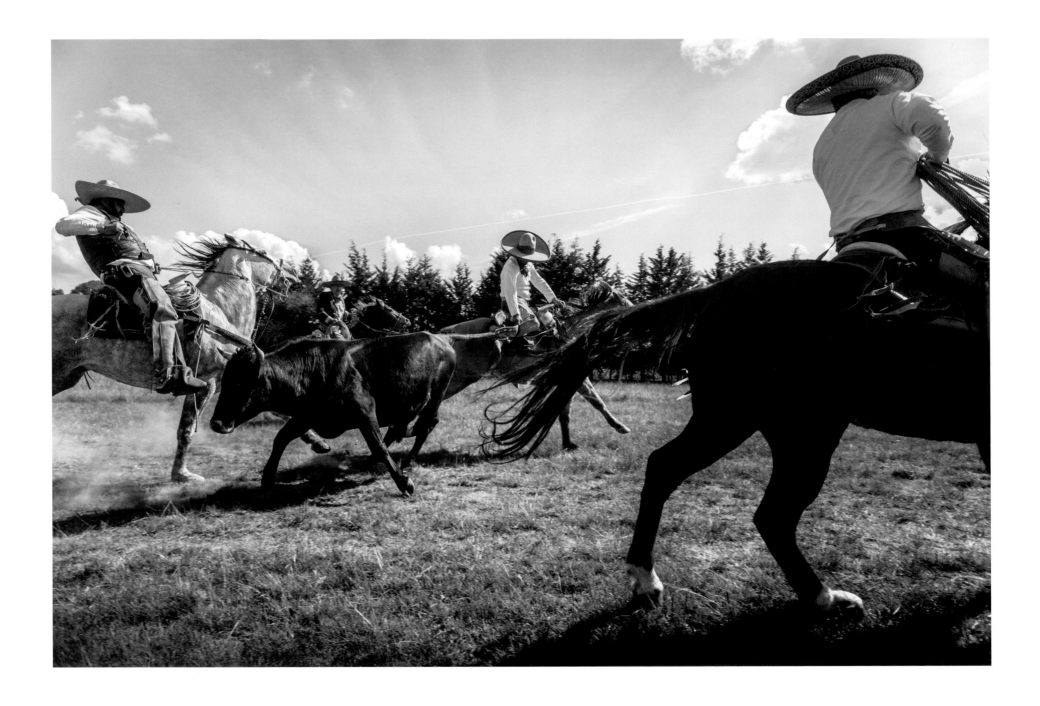

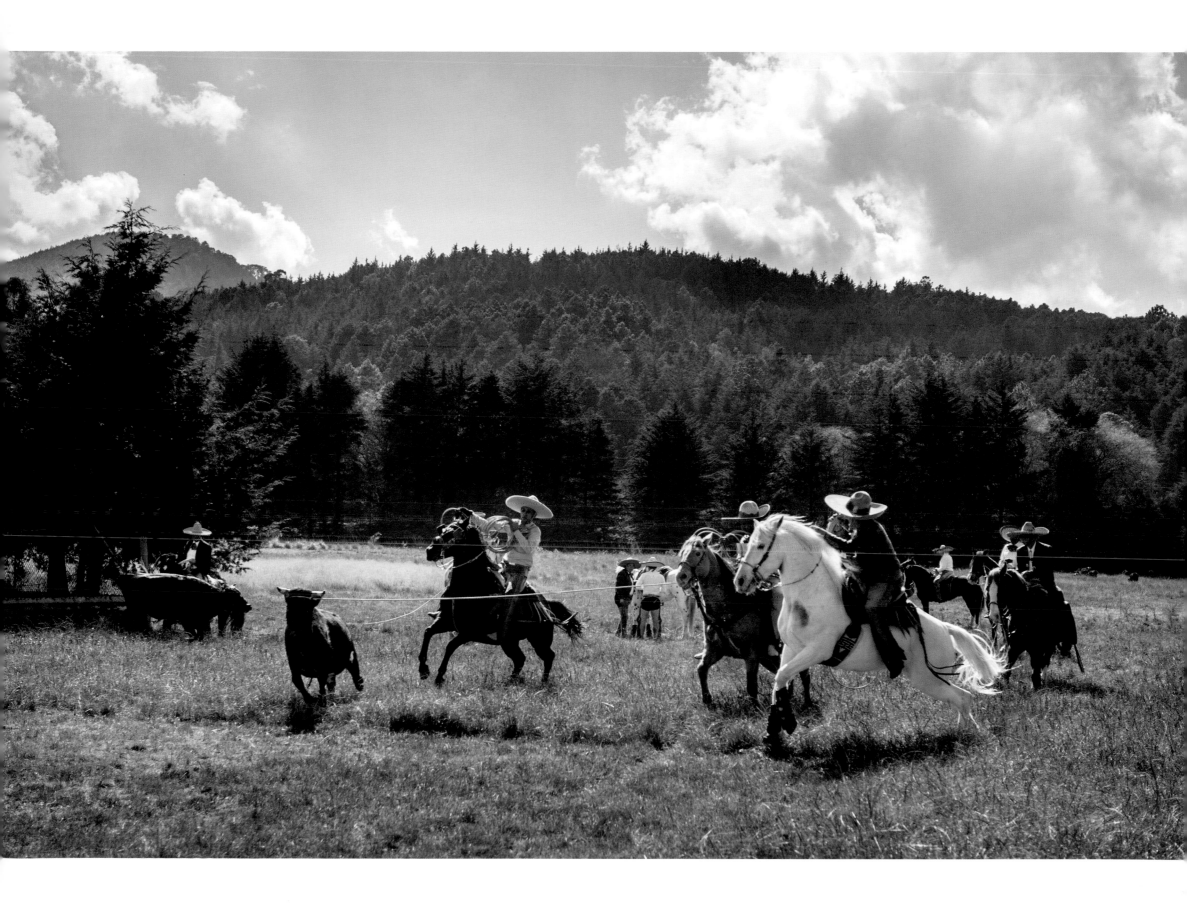

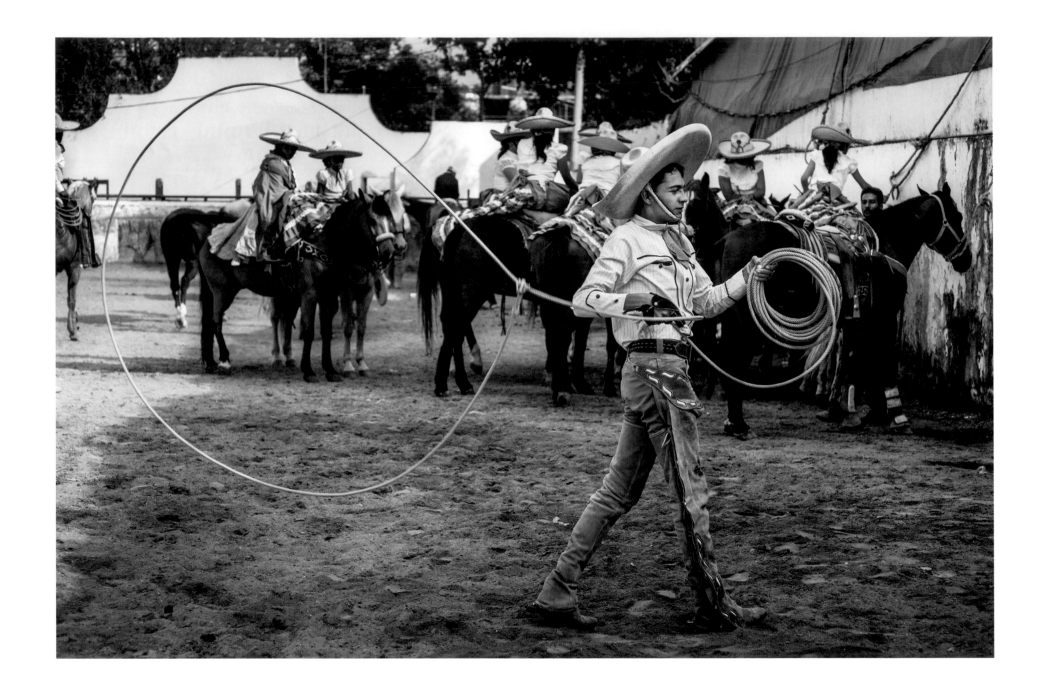

Puebla, Mexico

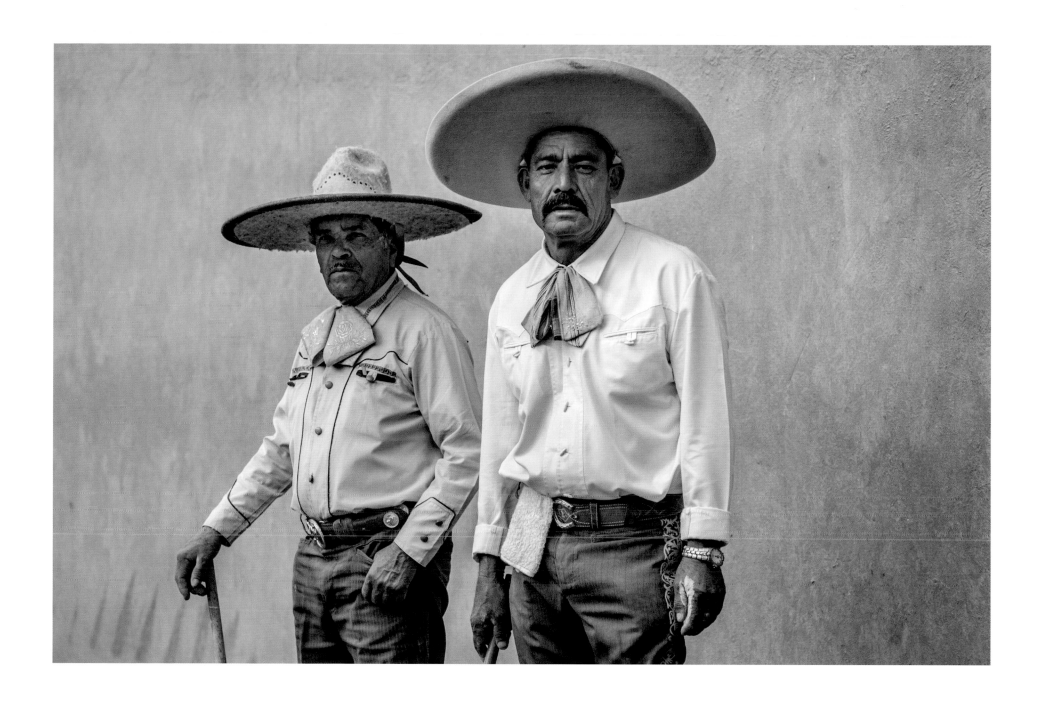

Jalisco, Mexico

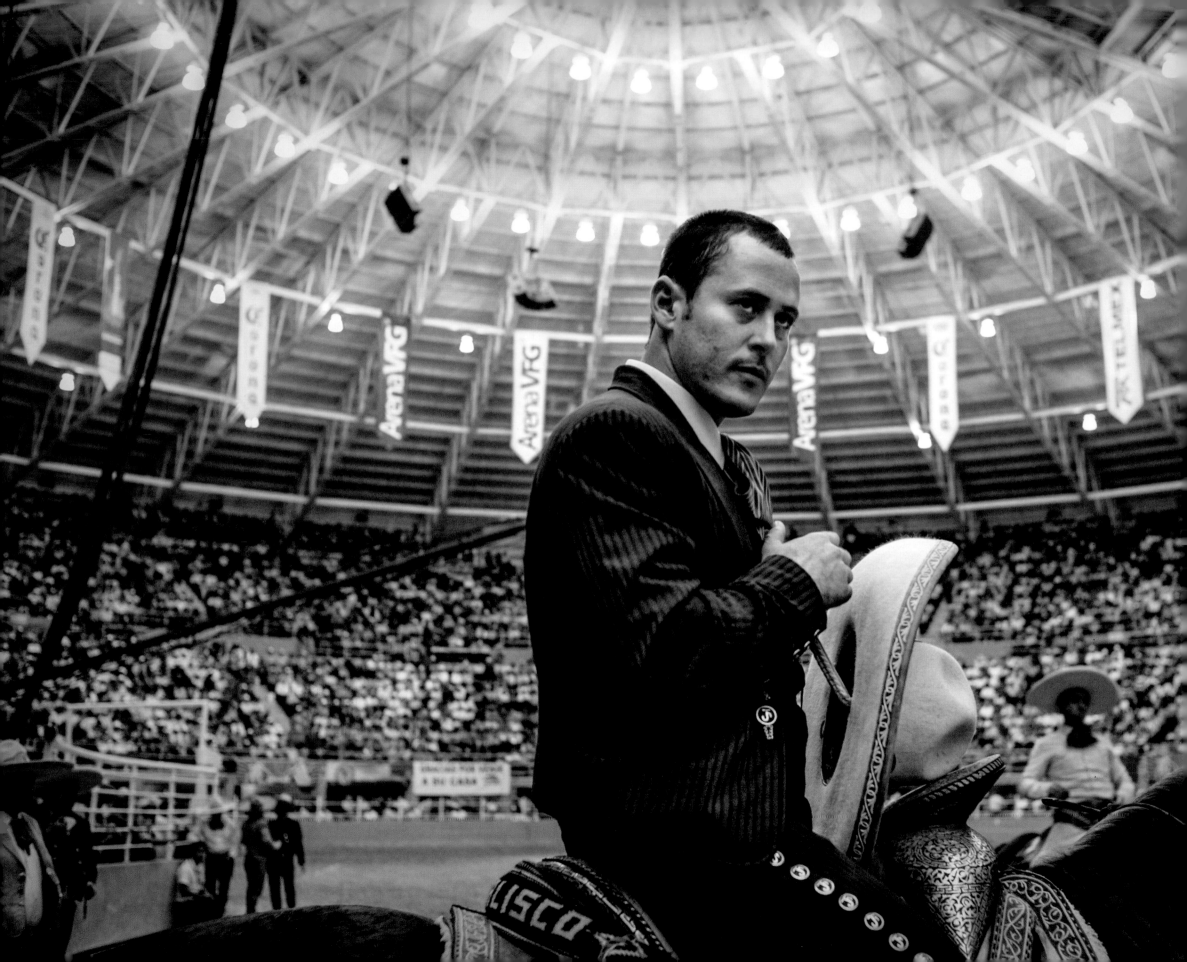

Guadalajara, Mexico
Arturo Ibarra at the finals of the
National Charro Championship

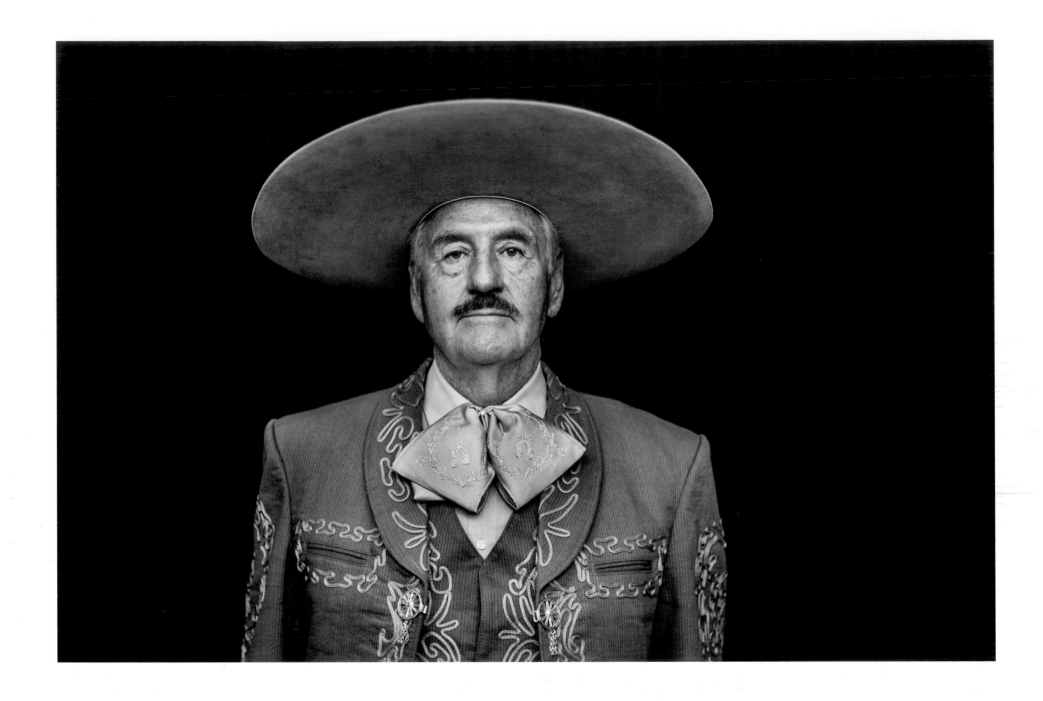

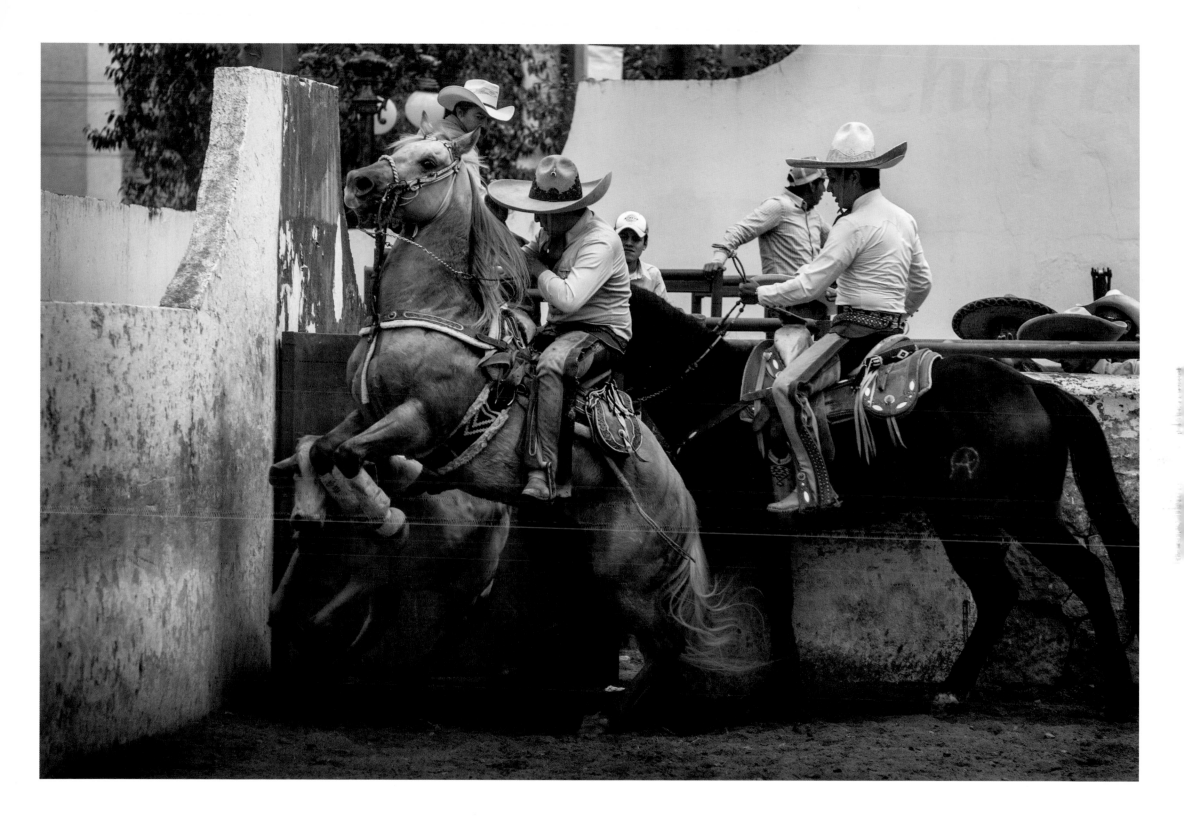

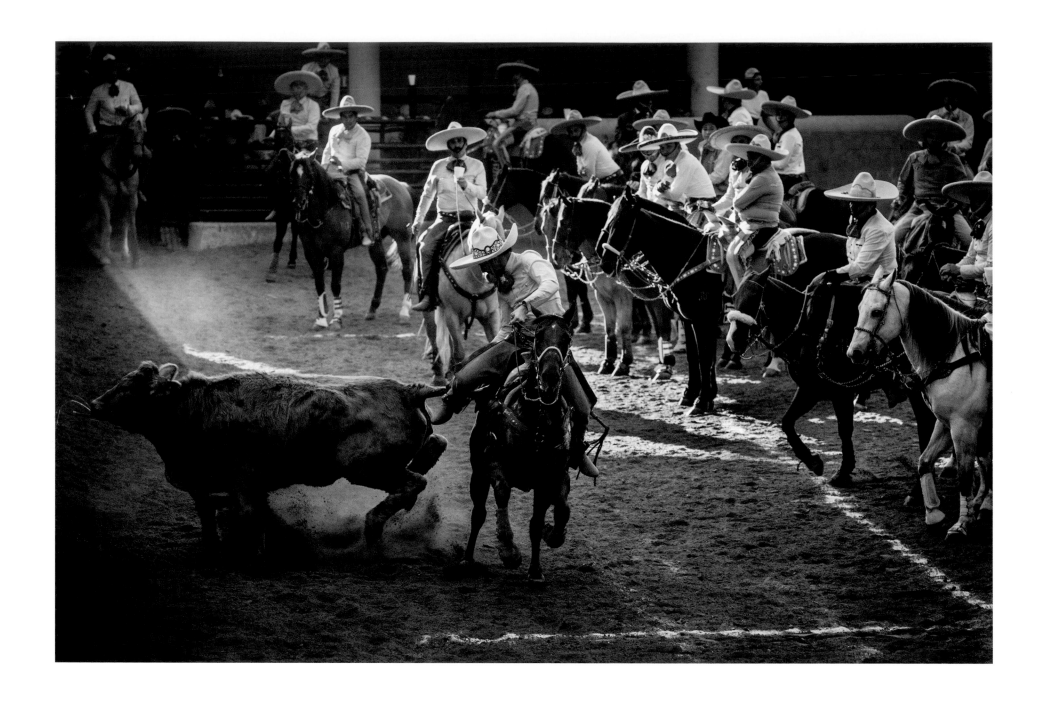

Puebla, Mexico

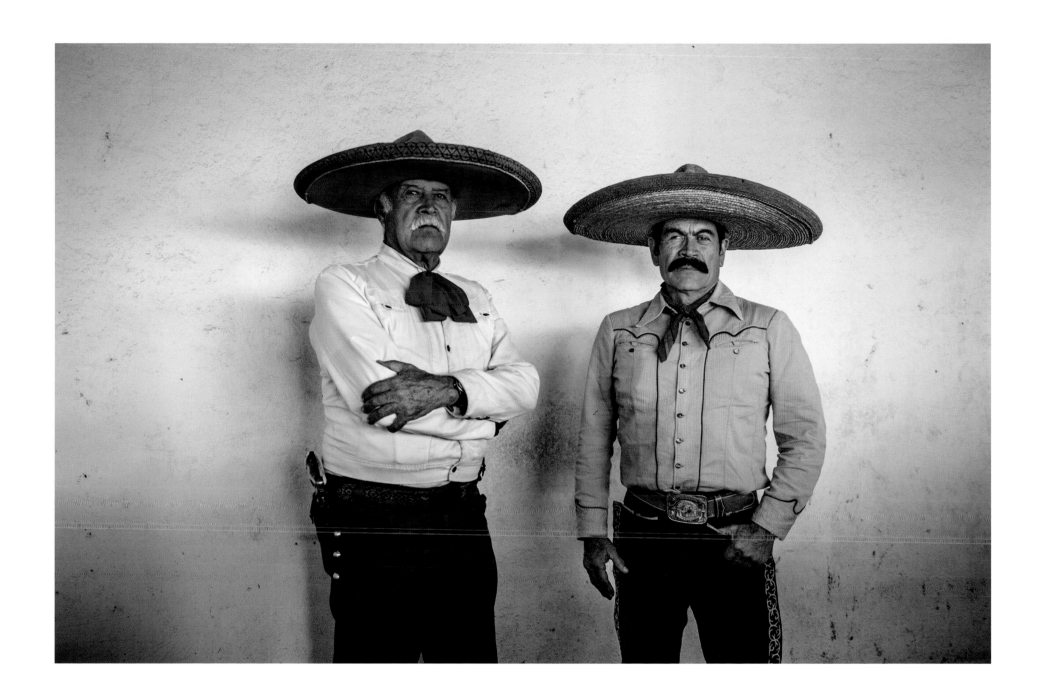

Ojuelos, Mexico
Don Manuel Vega Díaz Infante and
Don Enrique Morín Guerrero

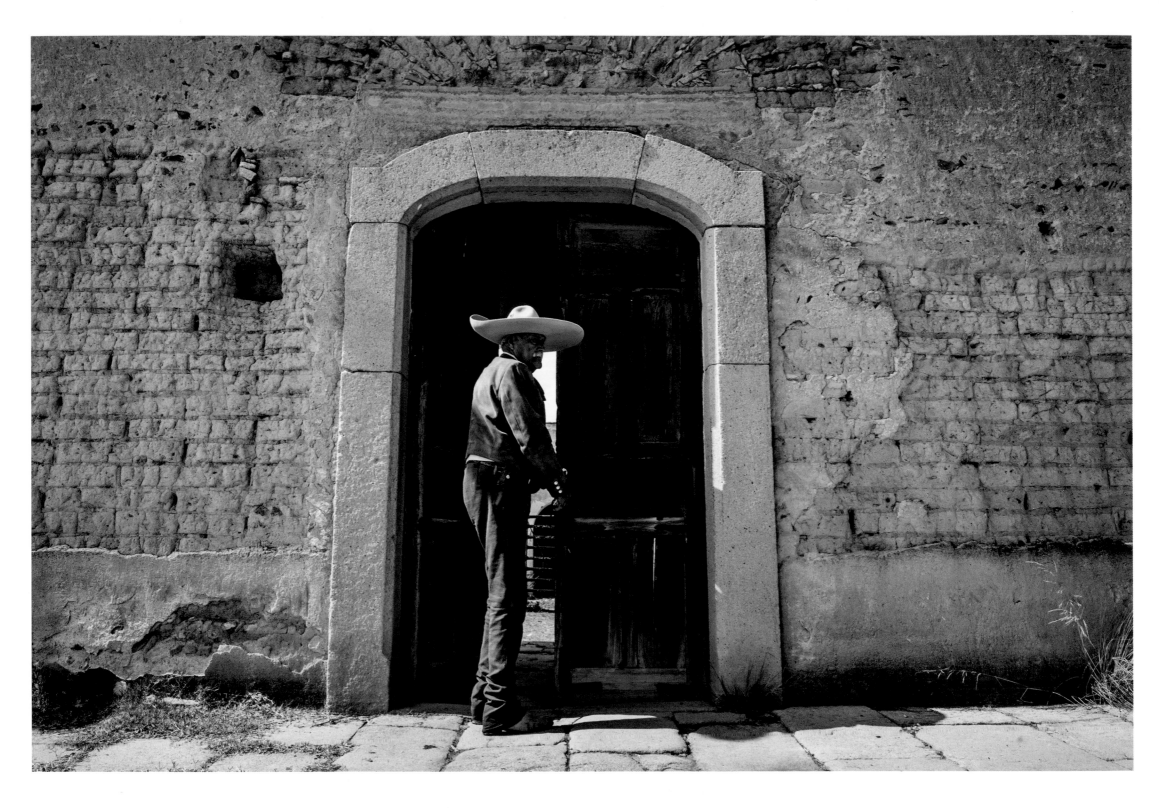

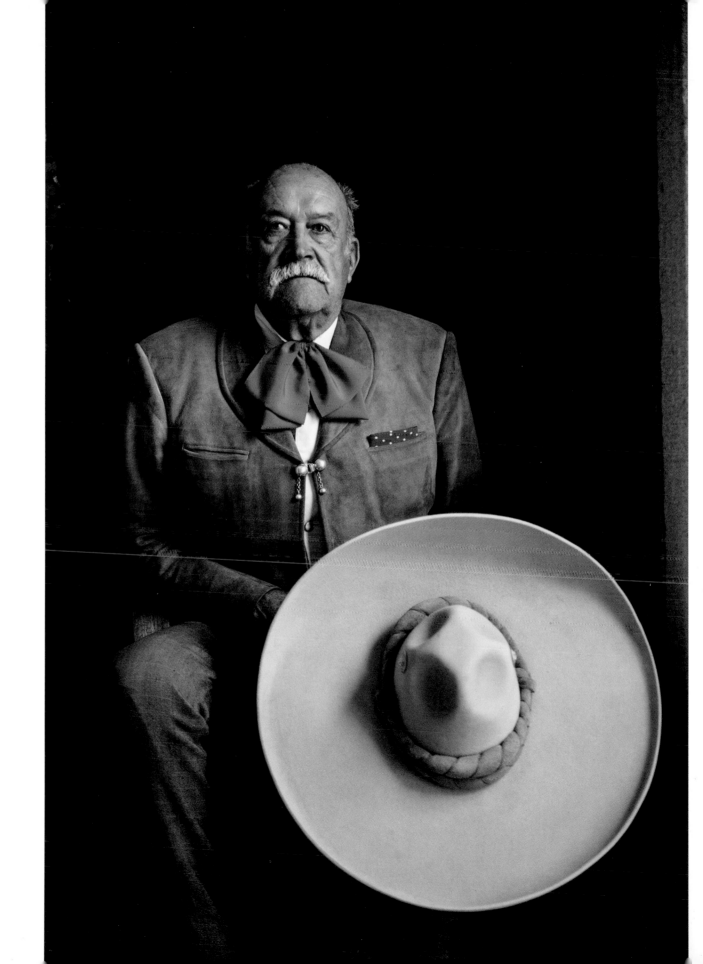

FACING
Ojuelos, Mexico
Don Manuel Vega Díaz Infante

LEFT
Ojuelos, Mexico
Don Infante

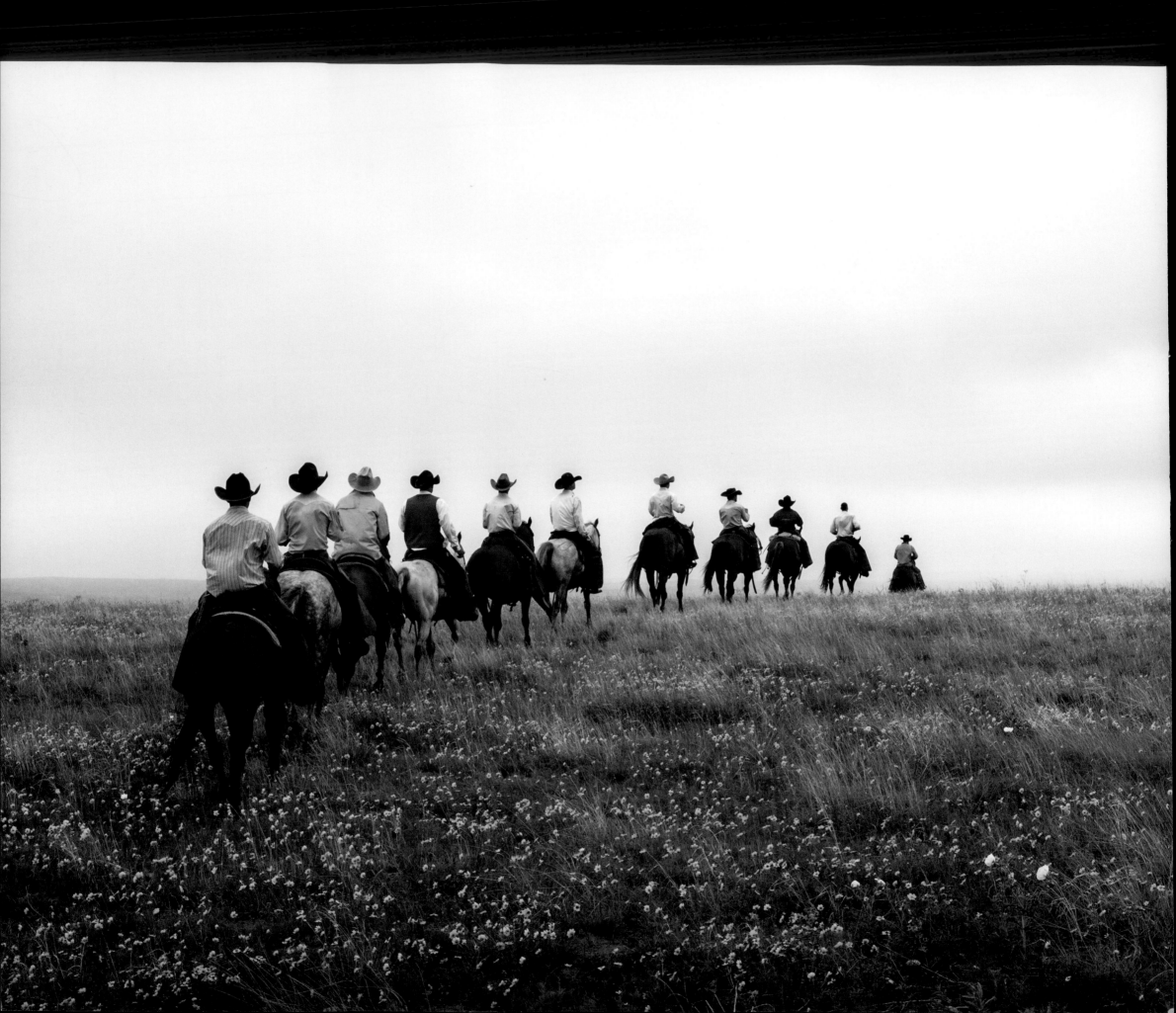

COWBOYS

United States

A SINGLE FACT of geography defines the American West. Beyond the 100th meridian, a line of longitude that bisects the Dakotas and Nebraska and runs through Kansas, Oklahoma, and Texas, there is no place in a thousand miles, from the Mexican frontier to the Canadian border, that receives more than twenty inches of rain a year. The entire region was once known as the Great American Desert. But deserts are places of scarcity, minimalist landscapes that, however beautiful, are perceived as being innately hostile, austere, and infertile. Austerity is a notion foreign to the American ethos.

Thus, as the frontier moved west, the nomenclature of place shifted and the desert was transformed in language if not in fact, becoming the Great Basin, the Colorado and Columbia Plateaus, the Snake River Plain, the Blue Mountains, and the Bitterroot Range. But the stark reality remained. The Great Salt Lake, the Black Rock and the Painted, the Mojave and the Sonora are all deserts, as dry as many parts of the Sahara. The great cities and scattered towns, the ranches and grim farmsteads, the roadside strip malls, motels, and filling stations, the broken-down drive-ins and every blue highway pawnshop and souvenir trading post between Taos and Denver could not exist without the massive manipulation of water.

PREVIOUS SPREAD
Pitchfork Ranch, Texas

The Bureau of Land Management administers 245 million acres in the American West and has set aside 155 million acres for cattle, as much land as is to be found in fourteen states east of the Mississippi. Yet altogether these federally permitted grazing rights support only five million head, less than 10 percent of the national beef production. To maintain the cattle industry, the four states of the Upper Colorado Basin—Wyoming, New Mexico, Utah, and Colorado—devote fully 90 percent of the water they draw from the river to the growing of crops, with nearly 90 percent of this production as forage for cattle. In California, Arizona, and Nevada, roughly 85 percent of the water allotment goes to agriculture, and roughly half of this land is again devoted to the raising of meat. The production of a single pound of beef requires on average 1,800 gallons of water. The cultivation of alfalfa alone consumes 7.5 million acre-feet of water, close to half of the entire flow of the Colorado.

Contrary to popular belief, the water crisis in the Southwest is not caused by swimming pools in San Diego, fountains in Las Vegas, or golf courses in Palm Springs. All municipal and industrial uses combined take from the Colorado River but 630,000 acre-feet each year. Nearly all diverted water goes to a single purpose, growing feed and cattle in a landscape where neither belongs.

Thus, the American cowboy embodies a fundamental contradiction. Families such as the Haythorns, good and decent men and women who have worked the rolling sandhills of Nebraska for five generations, or the crew of the Pitchfork Ranch in the plains of Texas, a spread of some 180,000 acres founded over a century ago, remain fiercely proud of their independence and self-reliance. Yet the ranching way of life is made possible only by the most massive of public subsidies—not just price supports for cattle, but also the tens

of billions of dollars that have been spent to reconfigure and divert all the rivers of the American West.

The once verdant delta of the Colorado River could be reborn with the water that now goes to support but a third of one percent of the nation's cattle production. As severe drought becomes a regular feature of climate in California and many of the western states, it is not clear how long the American people will continue to support a way of life that is rich in nostalgia but highly inefficient, both in water consumption and in its impact on the natural landscape.

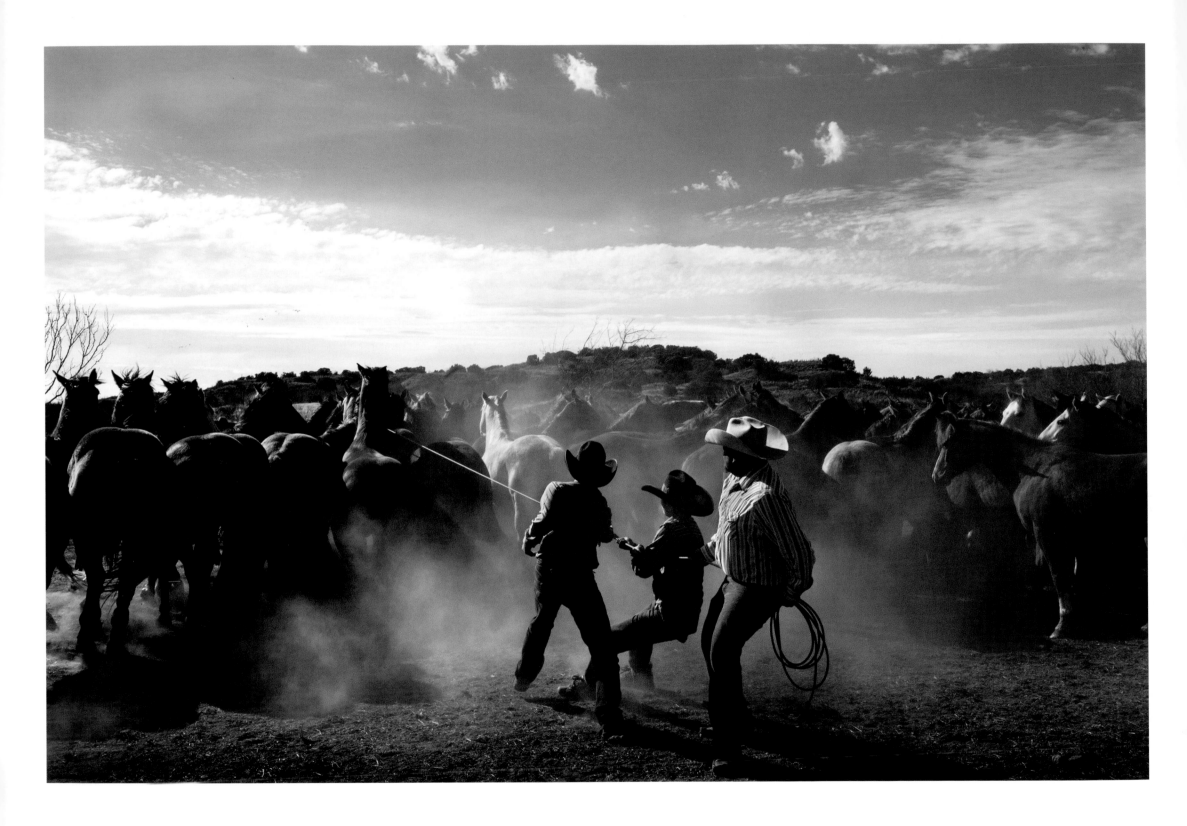

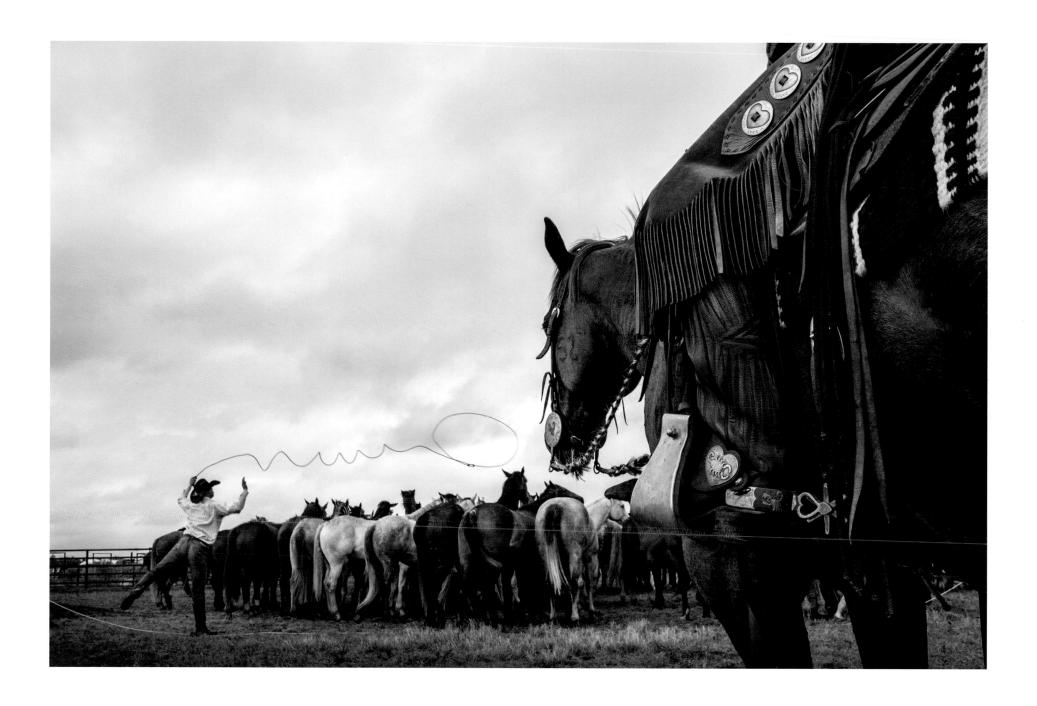

Pitchfork Ranch, Texas

Pitchfork Ranch, Texas

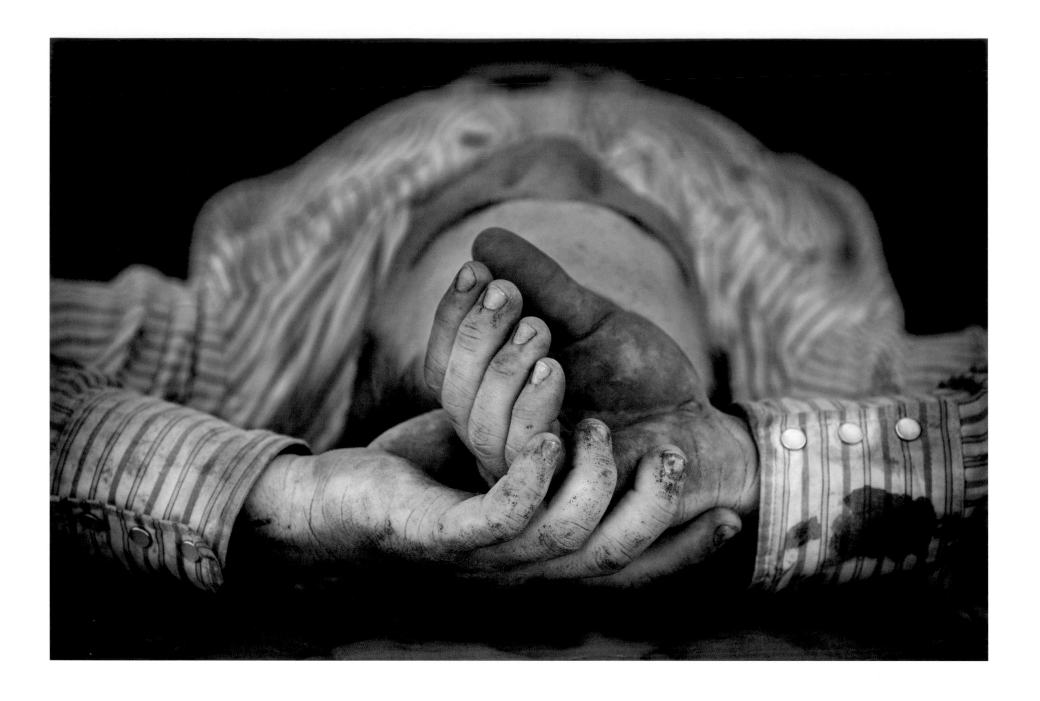

Pitchfork Ranch, Texas

Pitchfork Ranch, Texas
Wagon boss Cody Taylor and his
roundup crew

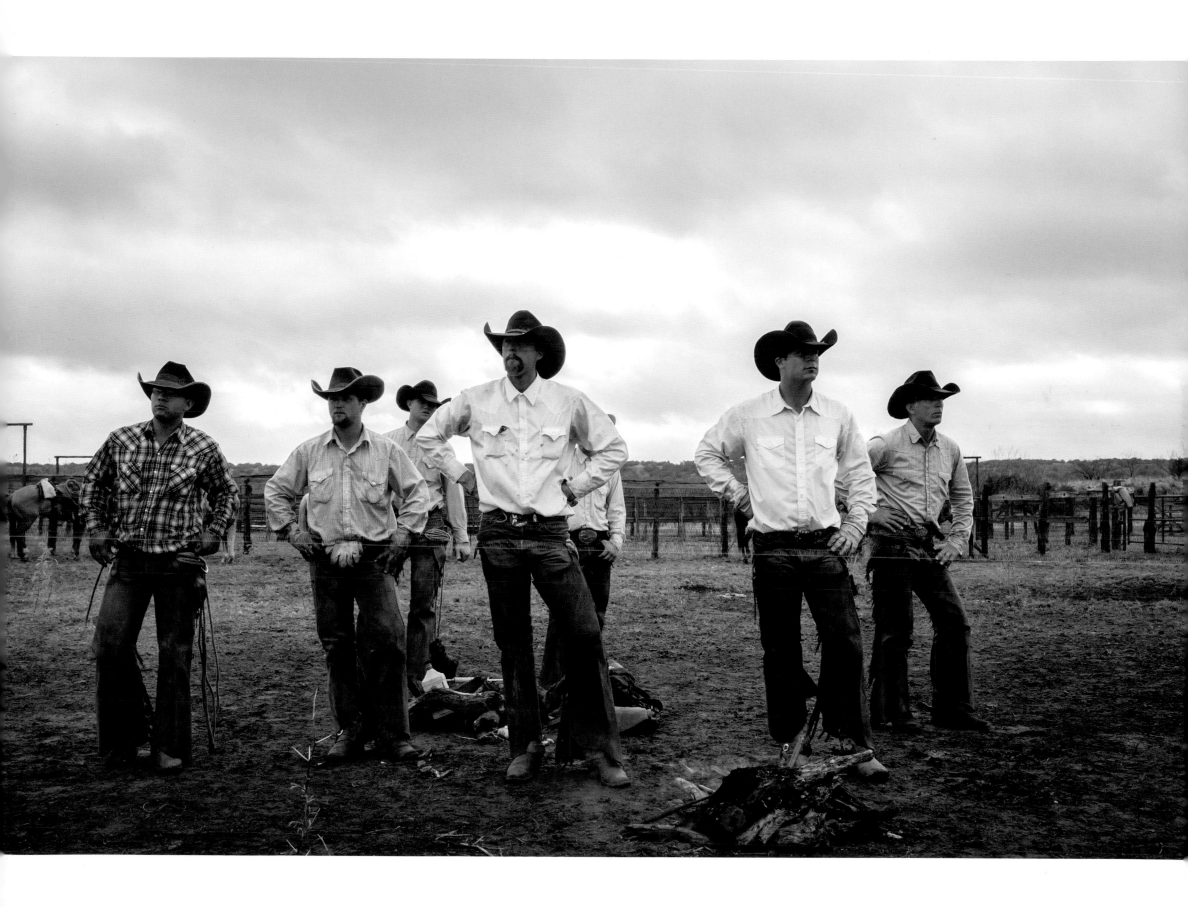

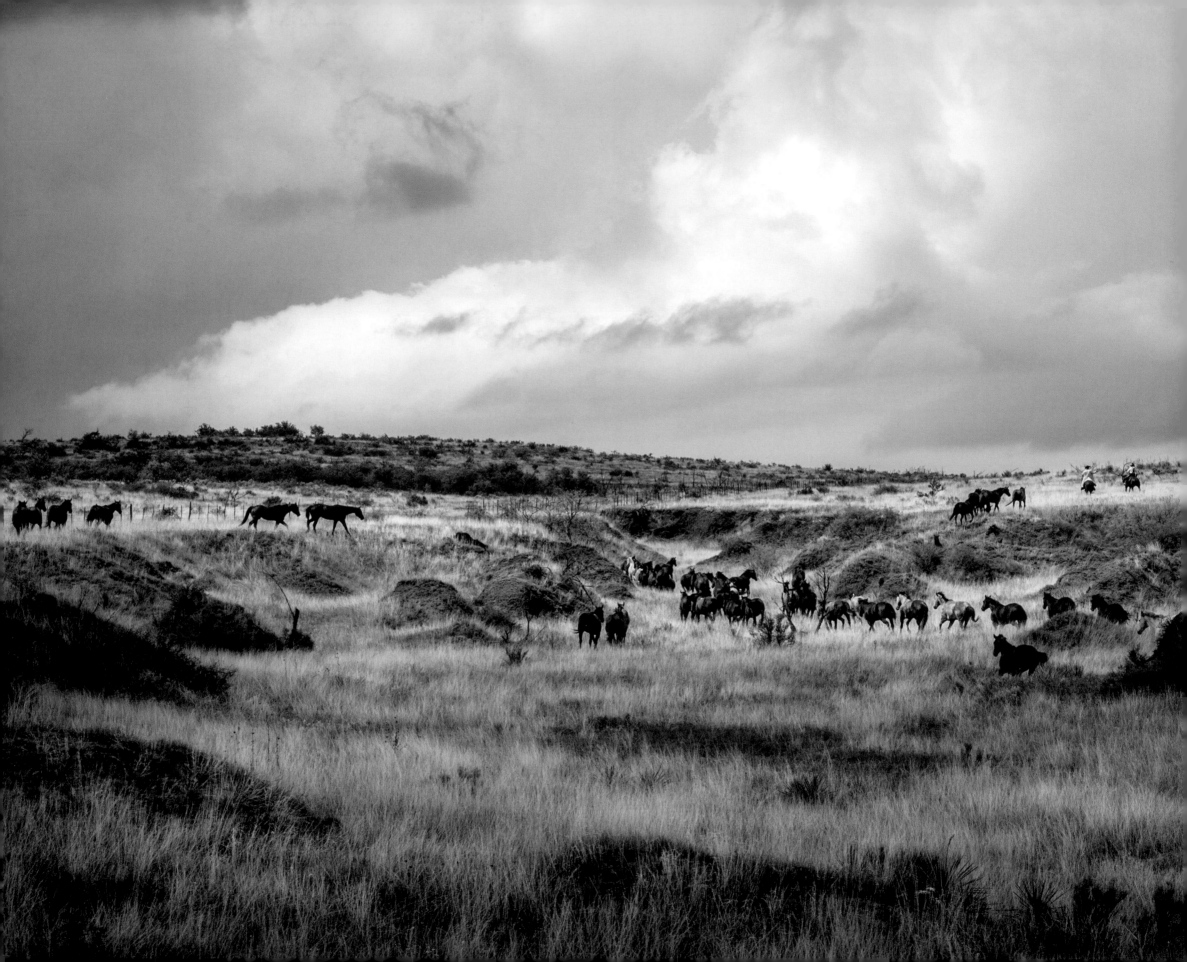

Pitchfork Ranch, Texas

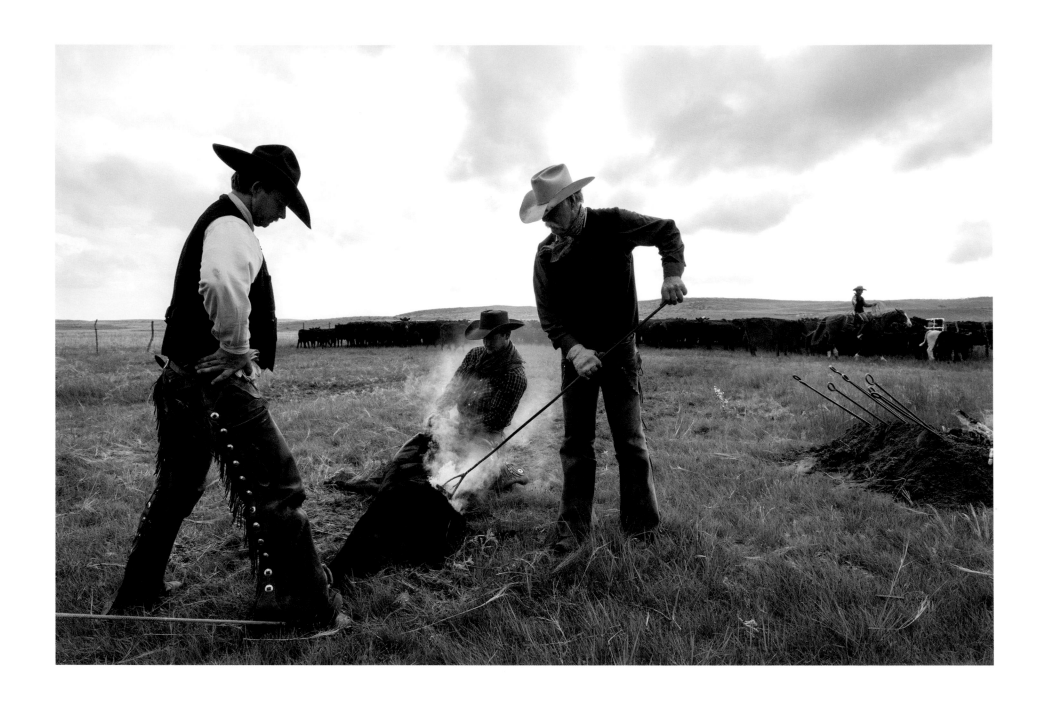

Haythorn Ranch, Nebraska
Greg Haythorn, branding

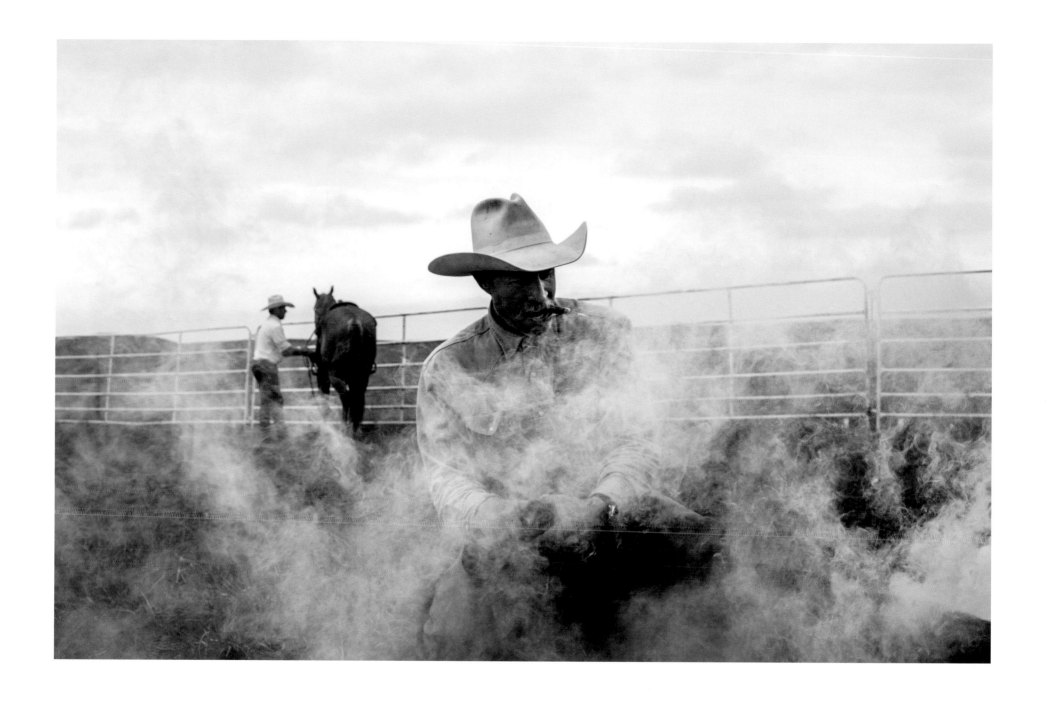

Haythorn Ranch, Nebraska
Denley Norman, calving

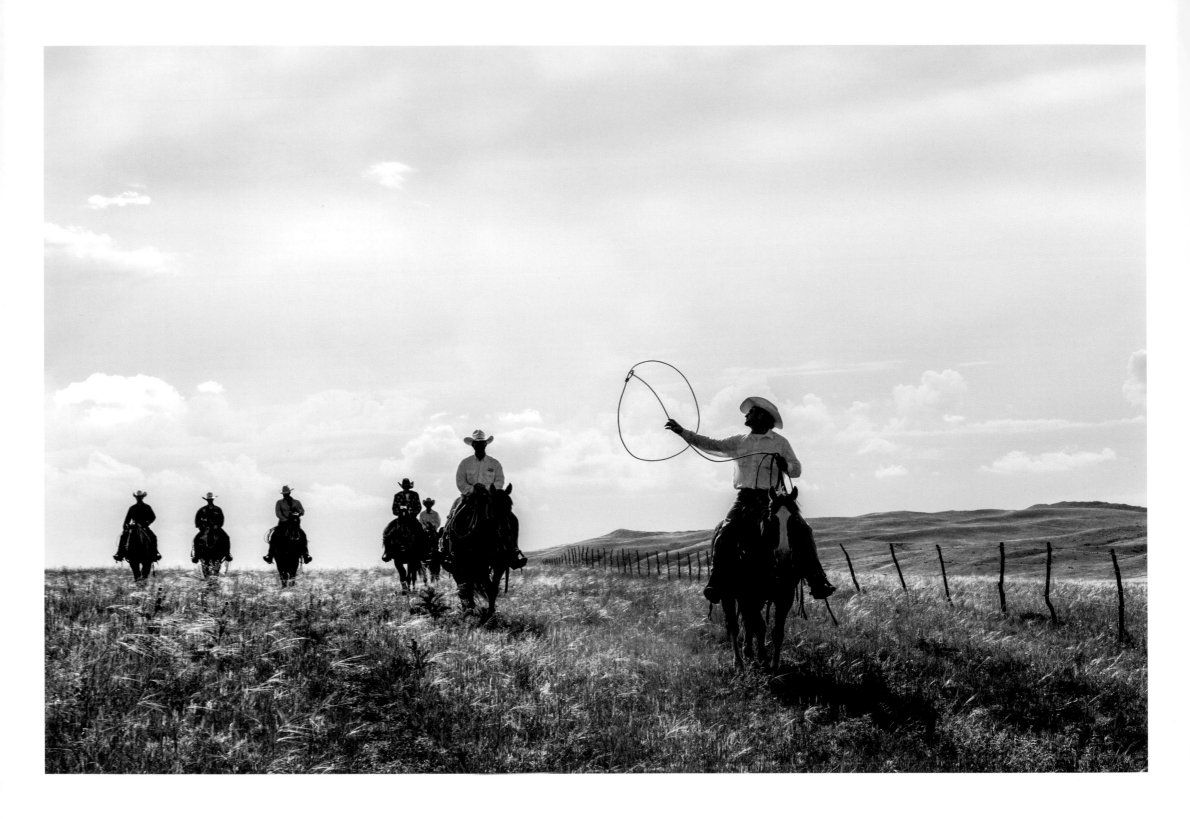

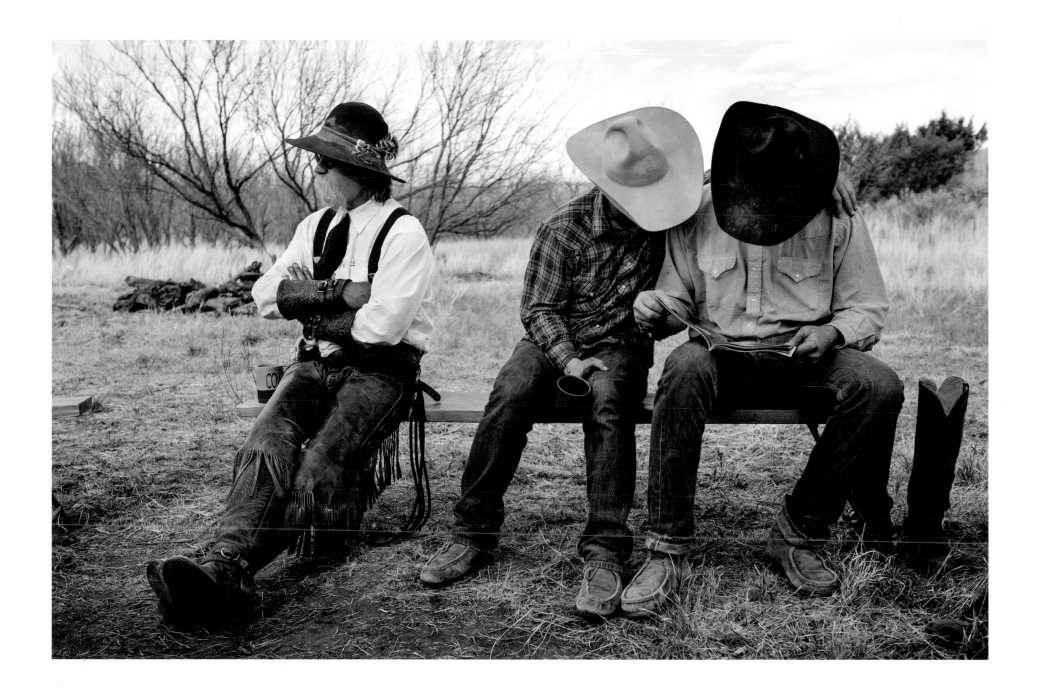

FACING
Haythorn Ranch, Nebraska
Cord Haythorn

ABOVE
Pitchfork Ranch, Texas
Wrangler David Ross

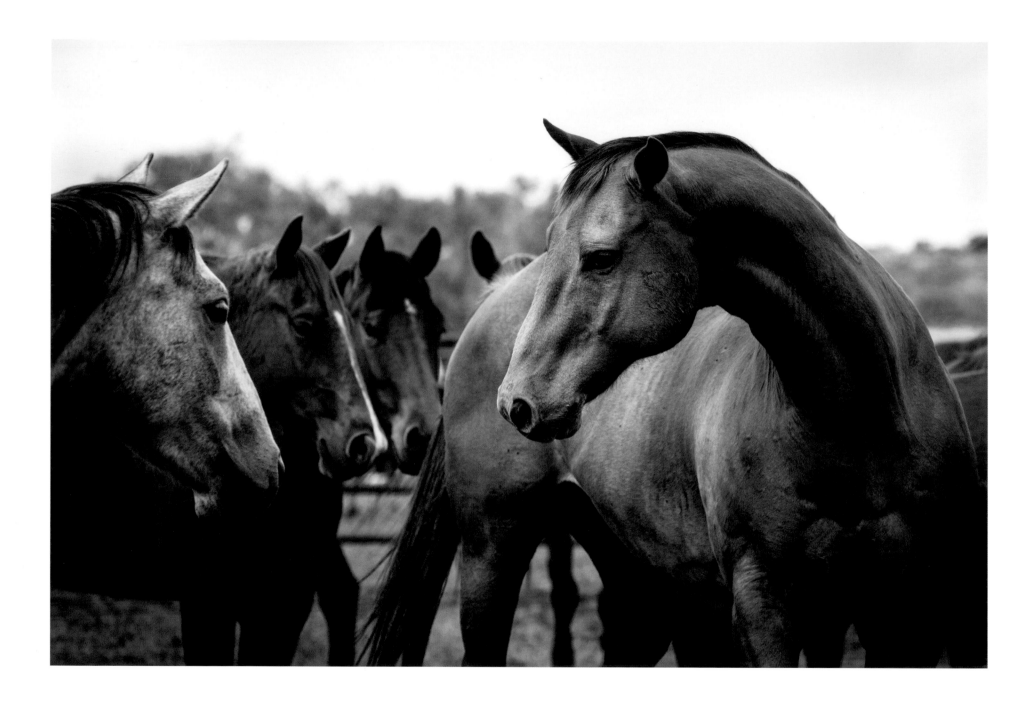

ABOVE

Pitchfork Ranch, Texas

Quarter Horses

FACING

Pitchfork Ranch, Texas

Peter Robbins

140 | Cowboys of the Americas

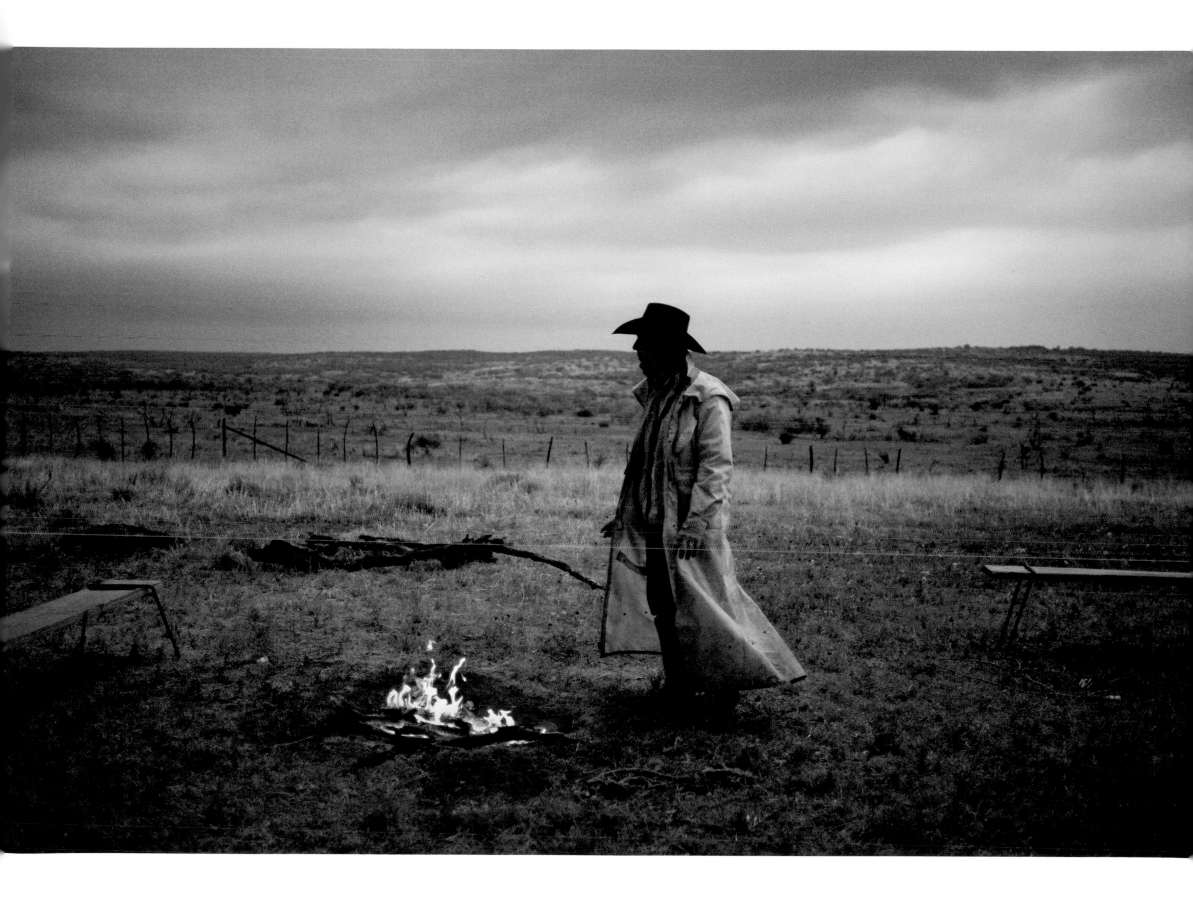

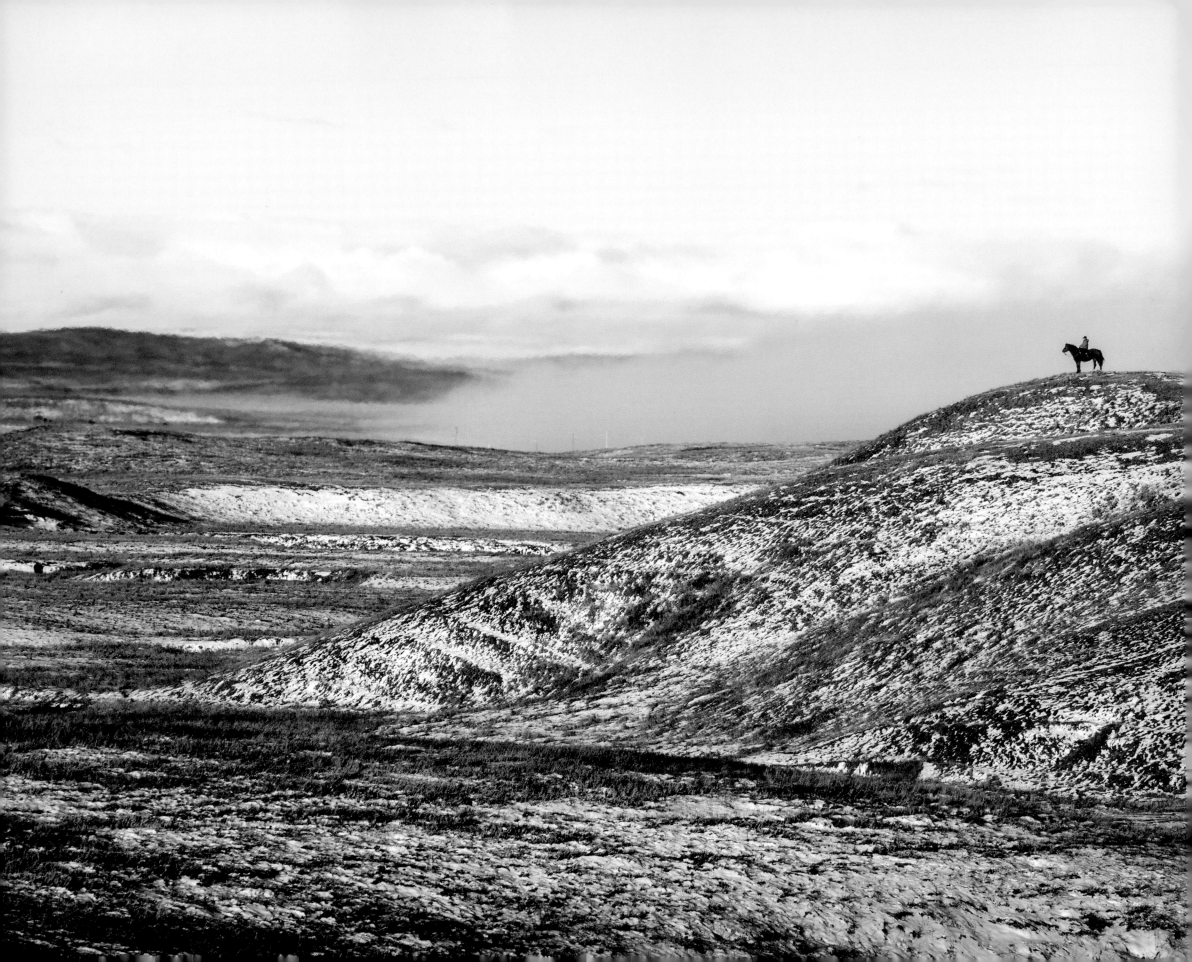

COWBOYS

Canada

FOR EVERY DOUGLAS LAKE, Waldron, or McIntyre Ranch—vast holdings the size of small nations—there are dozens of family ranches in the Canadian West struggling to make it. Their challenge is oil and gas, an industry that is, ironically, both the key to their survival and the cause of their demise.

The eastern foothills of the Canadian Rockies and the prairies, running away a thousand miles to the east, remained virtually roadless in 1905, when the provinces of Alberta and Saskatchewan came into being. A single ribbon of steel, the Canadian Pacific Railway, bound the new nation together. With its vast land grants, the railroad sold the dream of the west to tens of thousands of immigrants, settlers without whom the tracks would have nothing to carry. The great ranches of the west were staked by horse and wagon or on foot, and the pioneers lived through winters so cold that elk grazed on willow branches thick as a man's thumb. All that was to be heard were the whispered messages of the wild.

Today there is virtually no field or meadow in all of Alberta outside of the national parks that has not been crossed and crossed again by pipelines, seismic lines, and roads servicing the tens of thousands of oil and gas wells that now litter the landscape.

Ranchers have little choice but to welcome such activity on their lands. Theirs is a marginal existence. Most ranches are heavily mortgaged. Equipment costs are high, with

PREVIOUS SPREAD
McIntyre Ranch, Alberta

a combine alone running close to half a million dollars. Factor in drought, devastating winters, the volatility of prices for cattle and grain, and you have all the makings of a financially precarious way of life, despite its rugged appeal.

It is no wonder that many ranch families look forward to a visit from the land agent representing the oil and gas industry. The initial compensation can be in the tens of thousands of dollars, and the ongoing payments are enough to at least cover the costs of land taxes. The ranchers' lives are disrupted during construction, but once the line or installation is in operation, the impact is minimal. Cattle and horses happily graze on land crisscrossed by shallow pipelines. Land with a well on it or a pipeline running through it invariably increases in value.

But if these cash infusions make for short-term benefits, the long-term social and ecological consequences of oil and gas development may ultimately mean the end of Canadian cowboy culture. Access roads bring a host of challenges—range fires caused by exhaust sparks or the careless disposal of cigarettes; disruption to the habitat of wolves and bears, driving these predators toward domestic herds; and most serious of all, the introduction of invasive species of weeds and soil contaminants that threaten the ecological integrity of the grasslands upon which the entire ranching economy depends. Biosecurity is not an exotic term but rather a constant topic of conversation on the ranches and farms of the Canadian West.

Perhaps the most corrosive impact of oil and gas is the lure of big money. It is impossible for ranch families to pay wages that can compete with what young men and women, including their own children, can earn in the oil patch. In good times, almost anyone can land work as a derrickhand or equipment operator and pull down a six-figure salary. When

the inevitable downturn comes, such workers find themselves mortgaged to the hilt, deep in debt, and unable to return to a cowboy's wage even if they wanted to do so. The only ones turning to the ranching life today are urban cowboys, successful professionals who want a place in the country and whose presence in the ranching economy only serves to drive up the costs of everything from saddles to feed.

To be sure, there are still some real cowboys out there in the foothills of Alberta, men who knew the Blackfoot and witnessed the Sun Dance and who to this day can recall terrible winters when cattle and horses died and only buffalo remained immune to the cold. It is in the spirit of these elders that at least some young men and women today, despite all the distractions and temptations of urban life, still ride the western range.

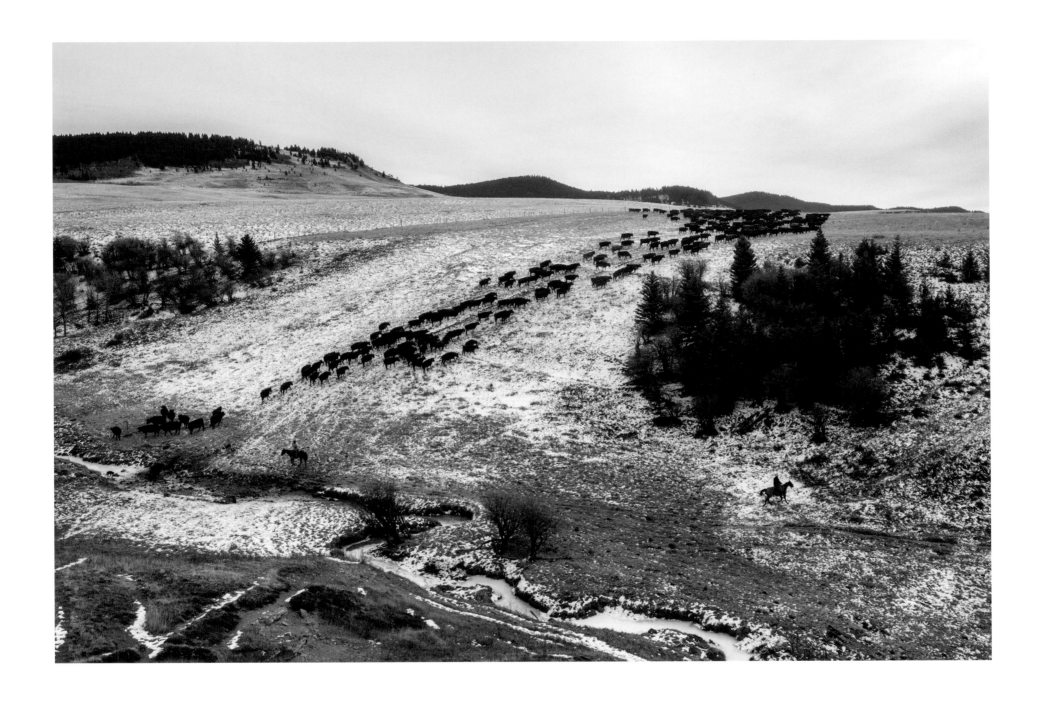

Waldron Ranch, Alberta

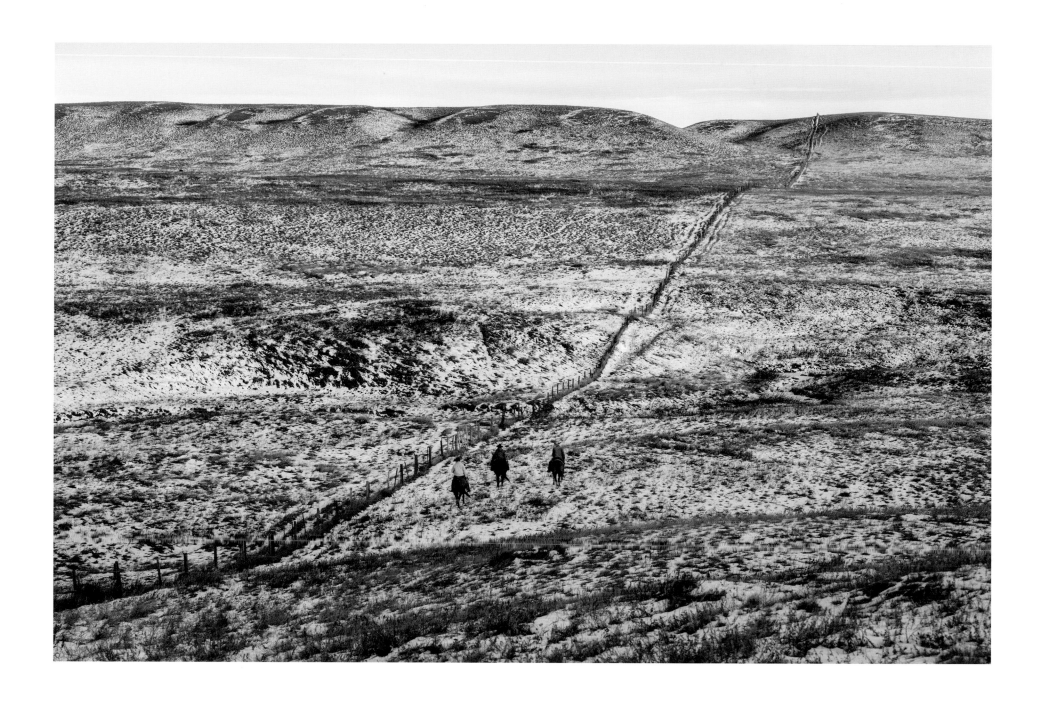

McIntyre Ranch, Alberta

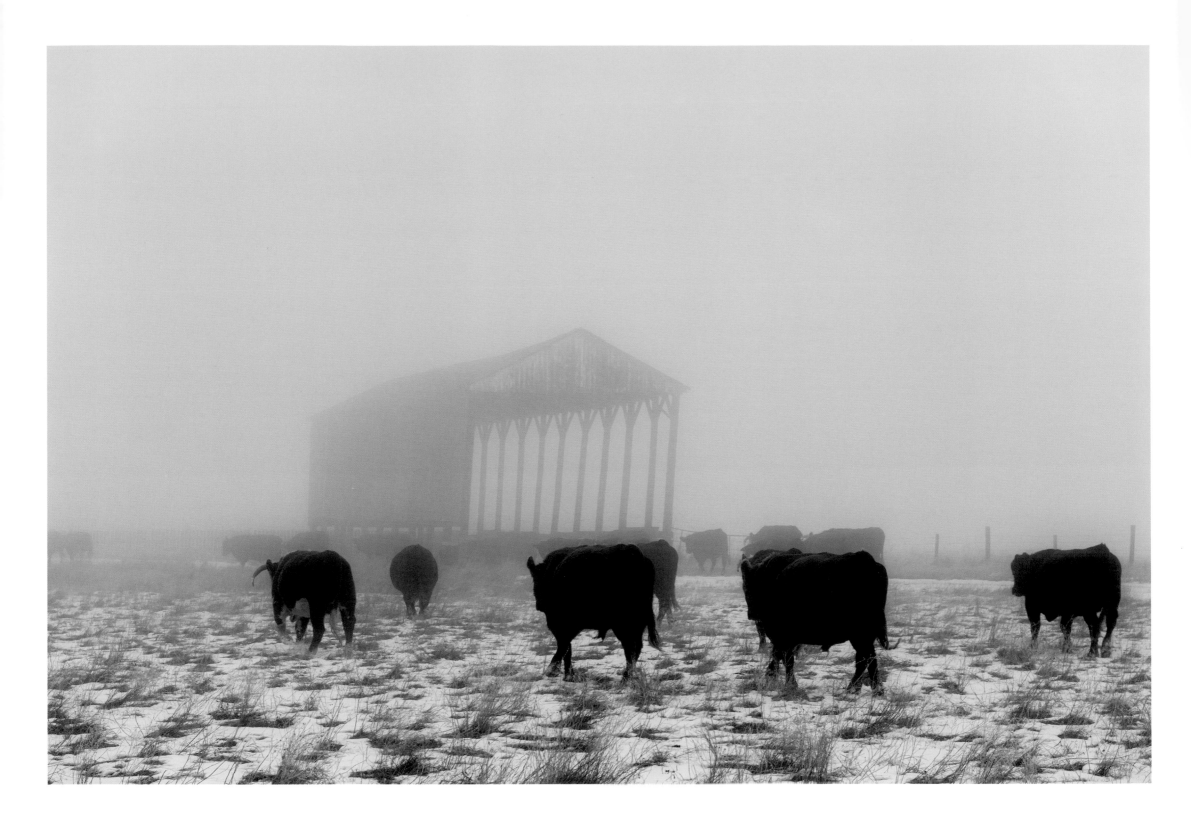

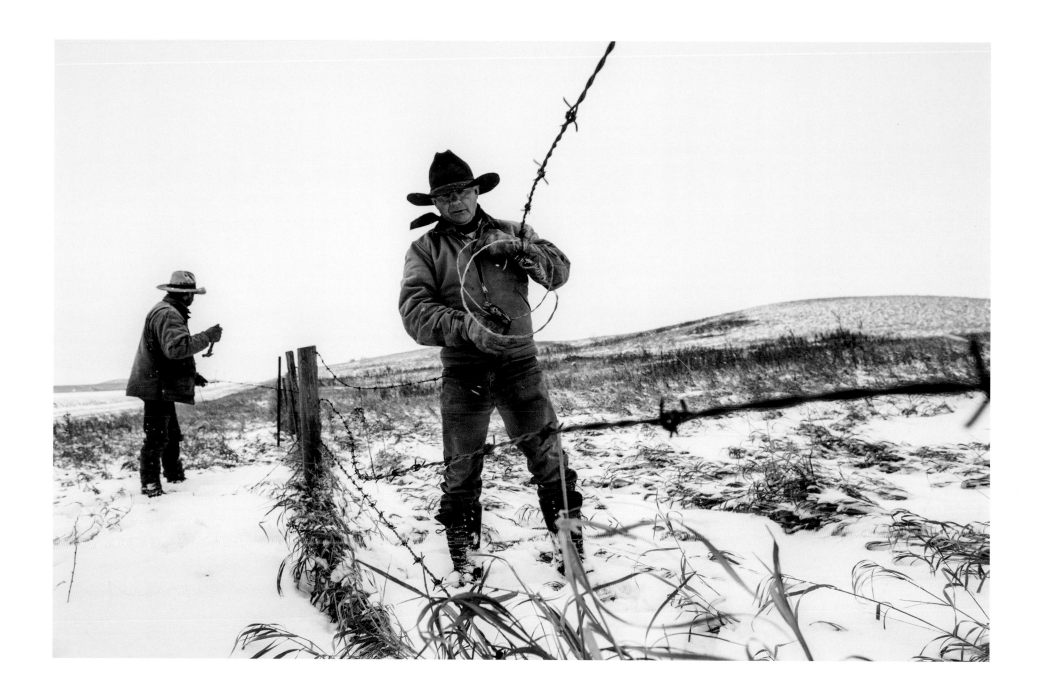

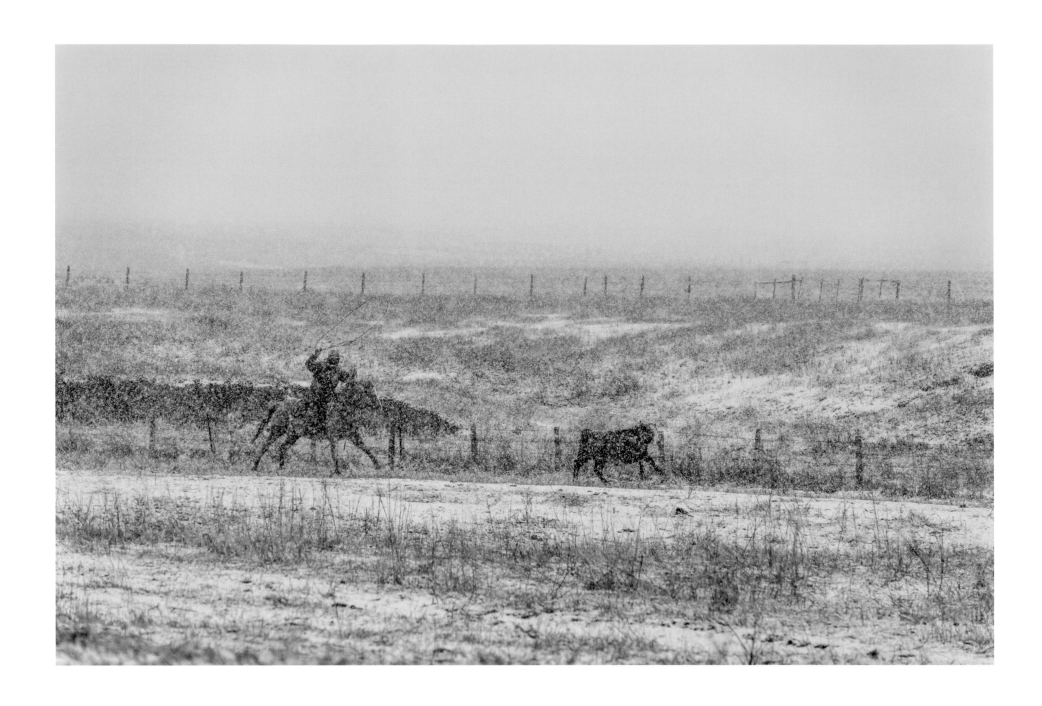

McIntyre Ranch, Alberta

McIntyre Ranch, Alberta
Keston Prince

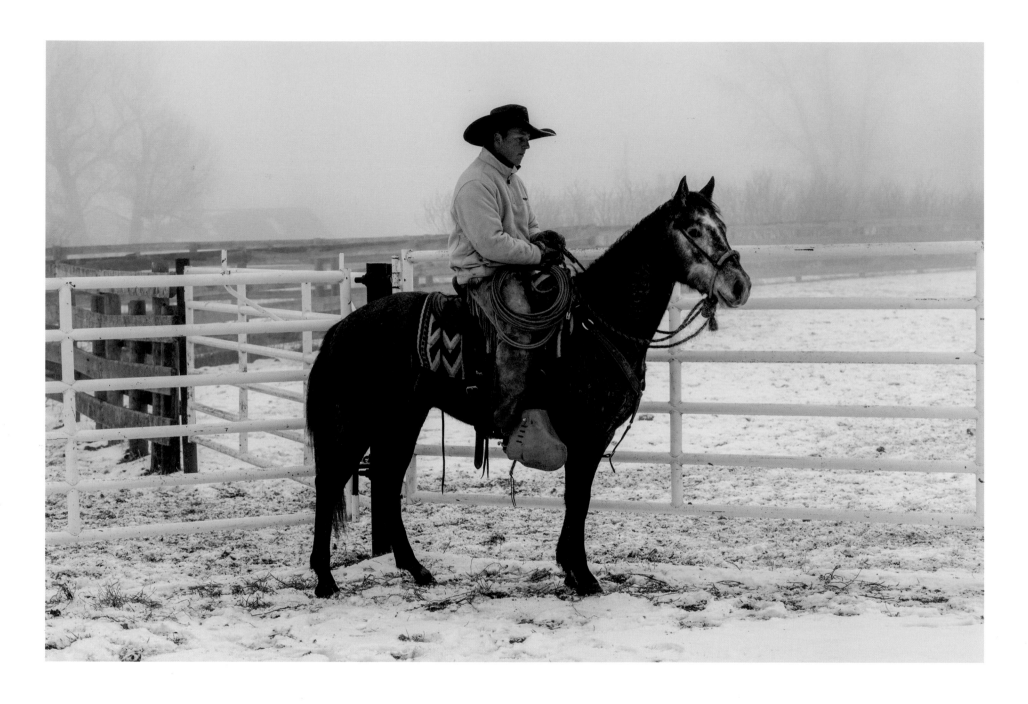

ABOVE

McIntyre Ranch, Alberta

Colt Duce

FACING

Douglas Lake Ranch, British Columbia

Gregg Speller

152 | Cowboys of the Americas

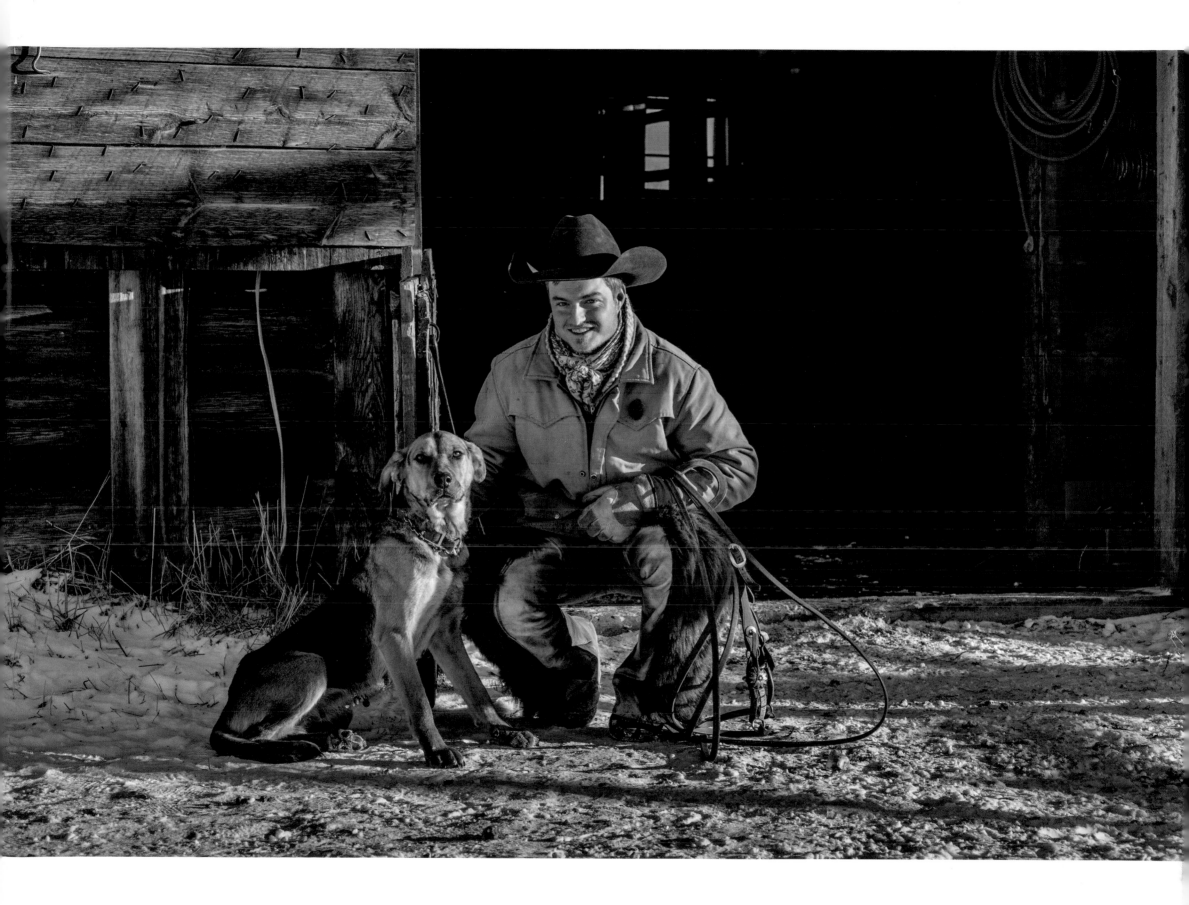

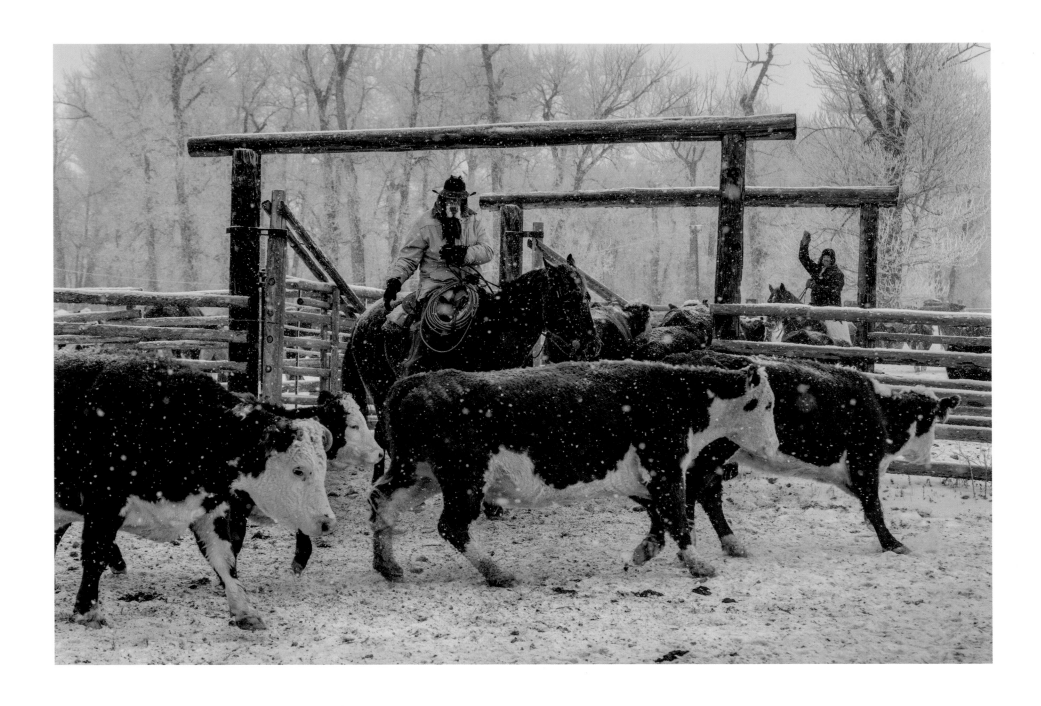

Douglas Lake Ranch, British Columbia
Stan Jacobs and his son

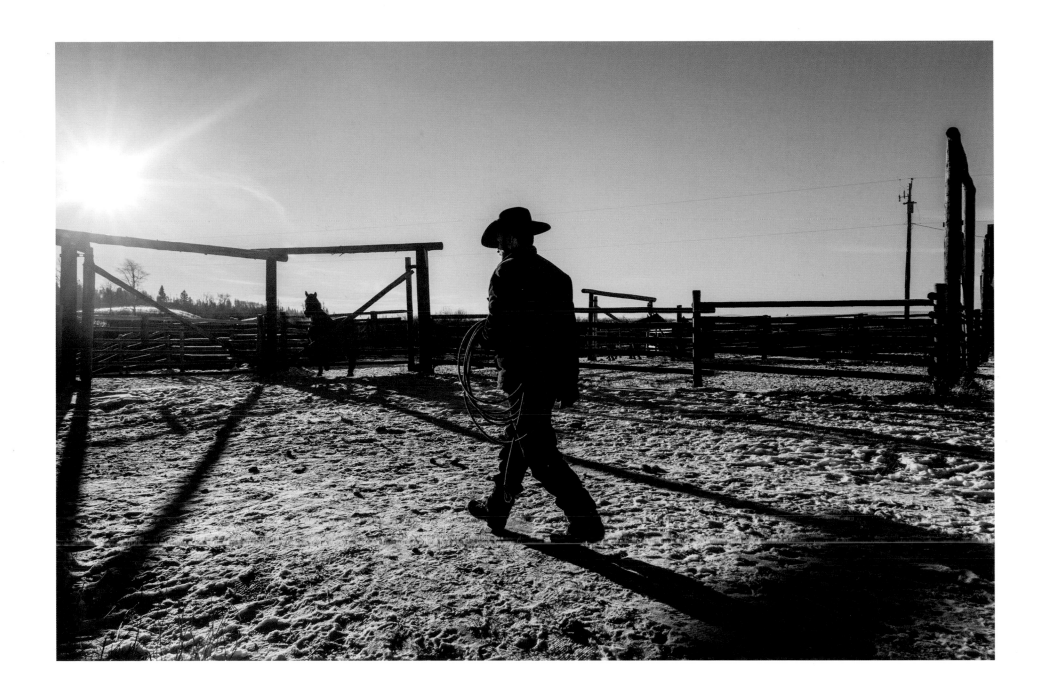

Douglas Lake Ranch, British
Columbia
Steve Brewer

ACKNOWLEDGMENTS

THE VISION and trust of people very dear to me made this project possible. Thank you to Wade Davis, Quina Fonseca, Ignacio Flores, Diego Landa, Beatriz Castro, Daniel Vidart, Gonzalo Vial Concha, Alejandro Pedrero, Gabriel Espinoza, Daniel Montes de Oca, Peter Winn, John Cyr, Natalia Valenti, and Peter Poole. I am especially thankful to Rosario Soto for her encouragement throughout the project, and for always raising the bar with her invaluable insights. The support of the New York Foundation for the Arts was most valued.

I am forever grateful to the cowboys for their generosity.

LUIS FABINI

EVERY BOOK of photography is a work of collaboration, and we'd especially like to acknowledge and thank Greystone publisher Rob Sanders, who was enthusiastic about this book from the beginning; our wonderful editor, Nancy Flight; our meticulous copy editor, Jennifer Croll; our eagle-eyed proofreader, Jennifer Stewart; and our talented and patient designer, Nayeli Jimenez—as well as the rest of the Greystone staff.

WADE DAVIS